Painting More Than the Eye Can See

Painting More Than the Eye Can See

Robert A. Wade

NORTH LIGHT BOOKS

Cincinnati, Ohio

94 93 92 91 6 5 4 3

Library of Congress Cataloging in Publication Data

Wade, Robert A.
 Painting more than the eye can see / Robert A. Wade.
 p. cm.
 ISBN 0−89134-324-5
 1. Painting−Technique. I. Title.
ND1500.W27 1990
751.42'2−dc20 89-38977
 CIP

Edited by Mary Cropper
Designed by Carol Buchanan

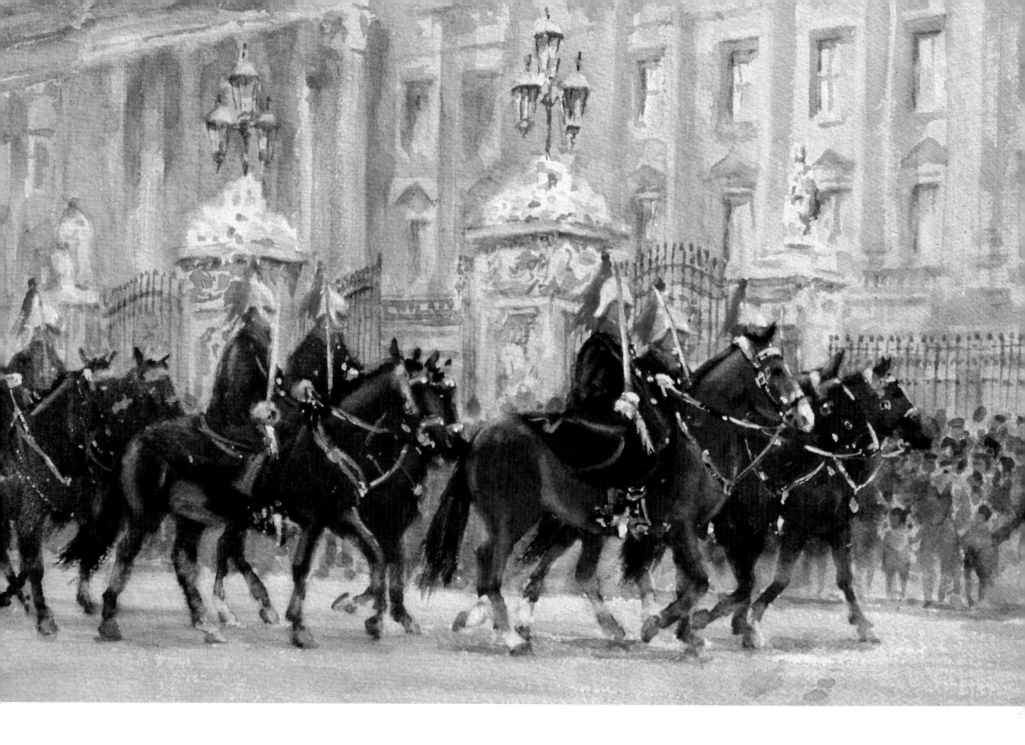

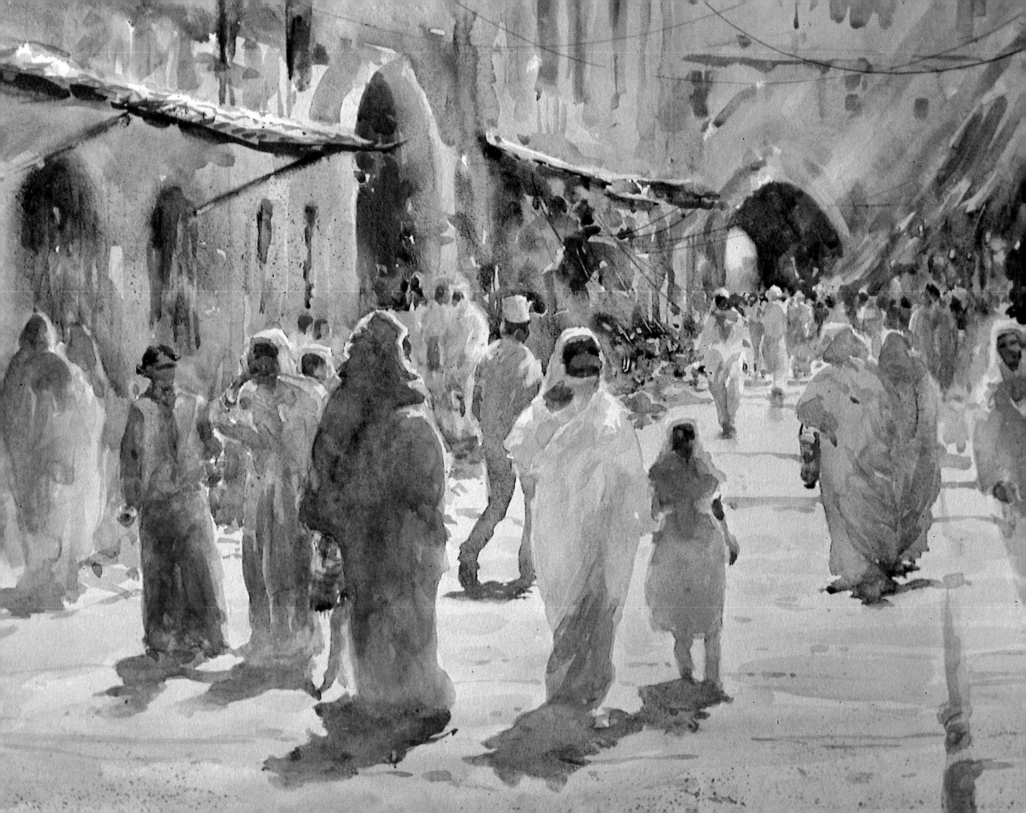

Dedication

This book is dedicated to:
Ann, my wife and best friend, for her understanding and tolerance of the countless hours I spend at my craft. Her faith in me spurs me on.
My family, all of them, for their interest and love.
My parents, who spared nothing, that I might have the benefits they never had themselves.
Gran, who provided the spark that kindled the fire.

Appreciation

To my editor, Bonnie Silverstein, who believed I could do it. Her infectious enthusiasm even comes across on international telephone calls.
To my collectors and friends, who own most of the paintings reproduced in the book.
To the artists, the many, world-wide, who have helped me get there, in particular, my Uncle Bill, Ewen French, and Robert Miller.
To Maurice Callow, whose love for watercolor is a great motivation for many.
To old friends, Betty Lou Schlemm, Tony Couch, and Charles Reid, who all encouraged me to write this book.
To North Light, David Lewis, who remembered me and gave me this chance; Mary Cropper and Carol Buchanan, who between them, brought it all together; and to the great team of professionals at North Light.

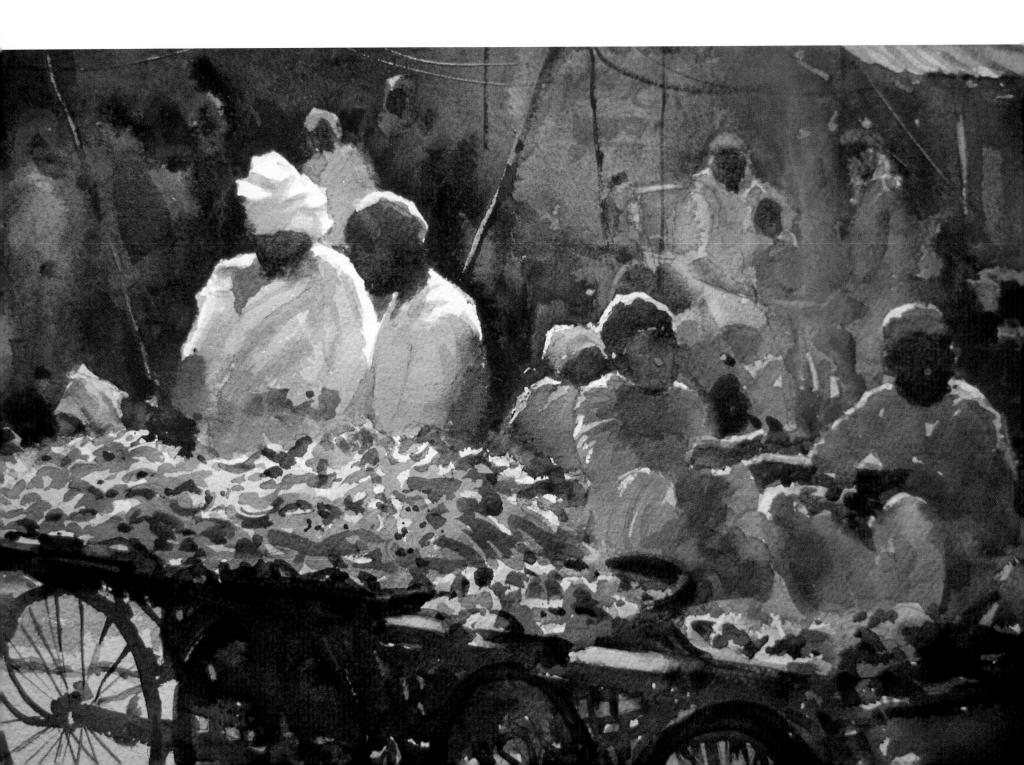

Foreword

As a good friend and fine painter,
Bob Wade has enriched my life.
Bob is a keen observer of nature
and all of his pictures have a
marvelous sense of "place" and
atmosphere. You can feel the
heat and clarity of Morocco, the
chill and damp of the Scottish
Highlands. This book is a must
for both the beginner and the
experienced painter.

Charles Reid

Perceptive Observation
is
Seeing with your Brain
Feeling with your Eyes
Interpreting with your Heart

ROBERT WADE

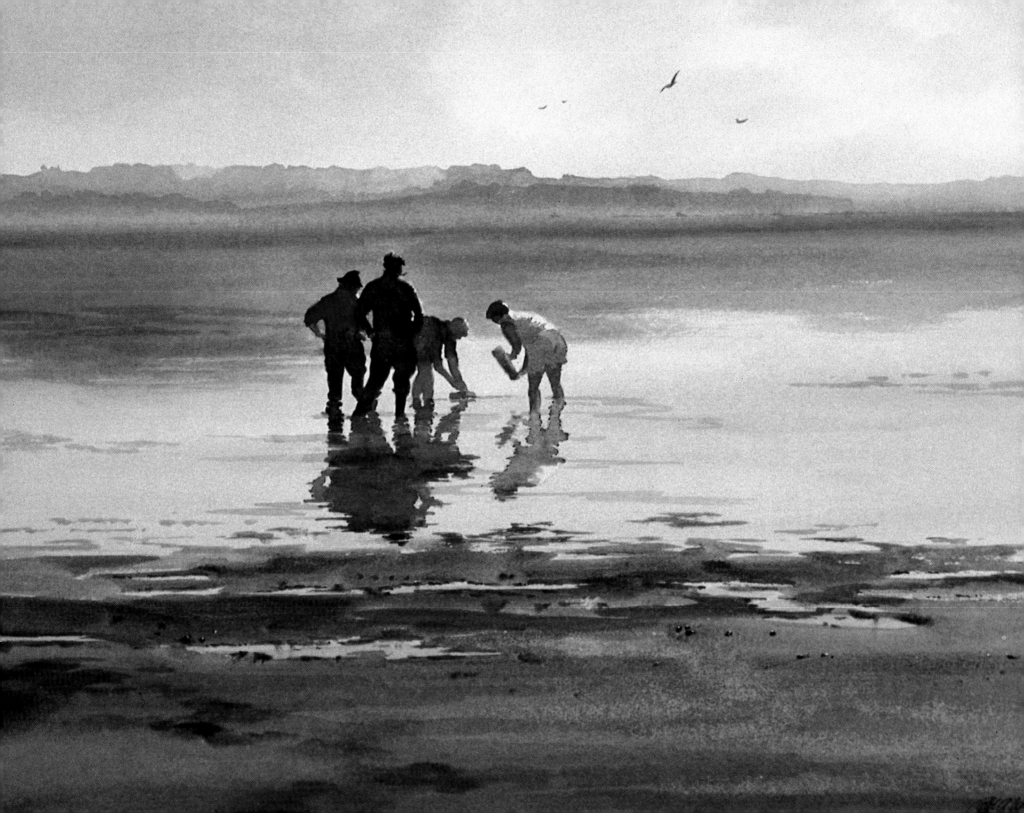

Contents

Dedication
Foreword
Epigraph
Introduction
The Beginnings

Chapter One:

See The Light 1
Perceptive Observation
and Light 2
Reserving Highlights 4
How Light is the Light? 6
Painting in a Different Light 16
Key Thoughts on Light 20

Chapter Two:

Effect of Light on Color 21
Sargent: Master of Color
and Light 23
Reflected Light Equals
Reflected Color 24
Color and Aerial Perspective 30
Taking Stock 33

Chapter Three:

Visioneering in Action 35
What's Visioneering? 36
As Above, So Below 38
Designing Your Paintings
with Color 40
Choosing Colors 42
Textures 45
Opaque Watercolor 48
Same Subject, Three Ways 52
Key Thoughts 54

Chapter Four:

From Sketch to Painting 55
Drawing is Fun 56
Good Drawing is Essential 58
Practice, Practice, Practice 60
Information, Please 62
More Than One Way to... 68
A Quick Review 76

Chapter Five:

Figuring It Out 77
Start Thinking Shapes 78
Perceptive Observation 80
Special Problems 86
Key Thoughts 96

Chapter Six:

Landscape Elements 97
Growing as an Artist 98
Skies 102
The Sea, Boats, and Water 108
Key Thoughts 120

Workshop 121
Ship's Painters 122
Sentinel Rock 128
Venetian Skyline 134

Conclusion 139

Index 143

Introduction

This is a no-nonsense book, suggesting ways and means of using the watercolor medium to produce better and more interesting paintings. Much pompous nonsense and impossible-to-understand language has been written in the name of art, but I hope this book reflects my down-to-earth attitudes toward watercolor. I use traditional methods developed during a lifetime's love-hate affair with this capricious mistress, and the information I give you comes straight from the shoulder—simply-stated truths to assist you in your efforts at art.

Of course, you'll need application, aspiration, perspiration, and total dedication, too. In *Man and Superman* George Bernard Shaw wrote, "The true artist will let his wife starve, his children go barefoot, his mother drudge for his living at seventy, sooner than work at anything but his art." Well, that's taking things a bit too far, but I think you get the general idea. Painting should be a very enjoyable experience, but don't think it's ever going to be easy. Every time you reach a new plateau, your self-imposed demands for excellence will become more severe. That's how it should be—otherwise we'd become self-satisfied and begin producing slick, facile paintings that may appeal to a certain type of buyer, but which would have absolutely no real merit as art.

I'm going to try my darndest to show you some pitfalls to avoid and point out painting thoughts and truths that, considered and used with care, may elevate your painting to a new level. Some of these ideas will suit you, others may not; but do seriously consider how they can be applied to your work.

If you aim high and set yourself standards and goals that now seem unattainable, perhaps one day you may get close. But if you set your sights low, that's just where you'll stay—back in the crowd. Seeking the highest goals brings its own rewards. Also, be professional in all that you do—in your approach to painting, your business dealings with galleries and agents, your transactions with clients. These all add up to your public image, and that's just as important to an artist as to any other business person!

In my frequent journeys around the world, I have the privilege of the friendship of many of the top artists in Asia, England, and the United States. Without exception, they are the most normal, humble, and delightful people one could ever wish to meet!

Robert Wade

The Beginnings

My dad's father was a professional musician, and his mother had been a high-wire walker, trapeze artist, and bare-back rider in her family's circus. Nan met my grandfather when he applied for a job as a cornet player in the circus band, hoping to get away from the Ballarat gold mines where he'd worked since he was twelve. He'd saved his meager pittance from the mines until he had enough to buy a battered old cornet. He taught himself to play with such skill that he won most of Australia's major competitions for solo trumpet and cornet. Of course he got the job—
and won Nan!

With all this talent, it was no wonder that their five children were taught to play musical instruments at an early age (but not to walk high-wires). Any who showed artistic ability were encouraged to pursue that particular interest. In the early thirties, we all lived together in a large rambling house. In every room there seemed to be someone drawing, painting, or practicing a musical instrument, and at mealtimes the conversation revolved around the activities of artists and musicians on the local scene. So as a child, it seemed there really wasn't much else in my life but art and music. Come to think of it, it's still much the same more than half a century later!

On my sixth birthday my parents gave me a large paintbox of Mickey Mouse watercolors and a coloring book of "King George's Coronation," which contained illustrations of British military regiments, the Coronation Coach, and so on. Almost as though it were yesterday, I vividly remember very carefully painting yellow between the lines of the illustration of a Royal Household Cavalry drummer. Being a little impatient, I came back with the red before the yellow had dried, and where the two touched, that wonderful fusion of color unique to watercolor began to happen right before my astonished eyes. The pigments were actually creeping into each other, moving without any assistance from me—a magic moment that I shall remember forever! That's how watercolor grabs you. I'm still hooked after a lifetime of trying to get the upper hand!

In the early thirties, motion pictures were really big time and there was a demand for huge hand-painted posters with portraits of the stars. It was a time of "the bigger the better!" My father and uncle were both display artists whose special area of expertise was producing front-of-the-house spectaculars for the big movie theatres. We were always taken to view the final results of the small sketches we had seen Dad produce in his garage studio. How vividly I recall some of them: for *Beau Geste* a foyer transformed into a desert fort, ushers dressed in uniforms of the French Foreign Legion, and the doors to the stalls were reached

My grandmother, Nan, was a daredevil on the high-wire!

Grandfather John Wade, resplendent in his band uniform.

Theatre poster of the forties created by my dad.

by walking across a drawbridge; for *The Plainsman* with Gary Cooper there were Red Indians, covered wagons, bison, huge hand-painted backdrops of rolling prairies. Wow! Can you imagine what adventurous flights of fantasy these sights inspired in the thoughts of a little boy? Is it any wonder that all I ever wanted to be was an artist like my Dad?

When my father died suddenly, I left school to take up running the family business. We had grown to encompass screen printing as well as producing displays for movie houses. I feel that I was so lucky to have had the opportunity of working with that theatrical background. Laying-in backdrops with three-inch brushes and buckets of color is a great way of learning to paint broadly and, with such a variety of subject matter, you have to learn to cope with whatever the

client demands, whether you have tackled the subject before or not. Gosh, it's all been great fun for me. Being paid to pursue one's hobby is really like being paid to eat candy!

I have always been lucky in the help and encouragement I've received from my peers, ever since I was a kid. I still need it badly—and get it—even after all these years. Perhaps it is the unforgiving nature of our chosen medium which brings people together in an atmosphere of mutual sympathy and understanding. Each of us knows such extremes of joy and despair,

satisfaction and hopelessness, often all in one painting. Yet we're still driven back to try again with an urge that refuses to be ignored.

So never be backward about seeking advice and assistance from artists at the top of the profession. They have all suffered and been through those early stages too. Nobody arrives at the top without beginning at the bottom and the successful artist never forgets it.

Please allow me to offer you some solutions and to share my painting thoughts and methods with you now.

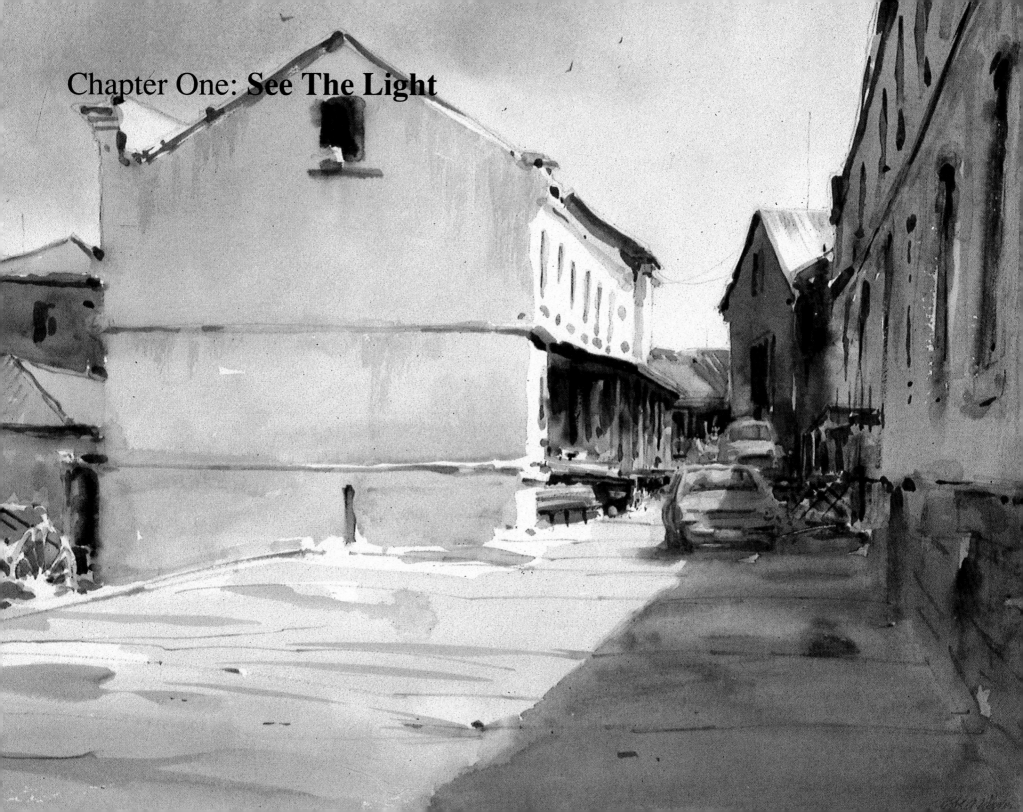

Perceptive Observation and Light

Let's think about how light affects what we see. How often have you stood at the doorway to an exhibition, been attracted to a certain painting, and without really knowing why, have almost been compelled to walk straight to that painting for closer inspection? The reason was probably the effect of light and the way it had been captured by the artist.

Once we have decided on a subject that moves us enough to want to put it down on paper, observation of light is our most important consideration. Form is visible only because of light. Through its intensity or its softness, light exerts the greatest influence of any factor on the subject, whether it is the natural light on a landscape or artificial light on an interior or a still life. Although I'll really be addressing the problems of outdoor subjects in this book, the same principles apply to any type of subject.

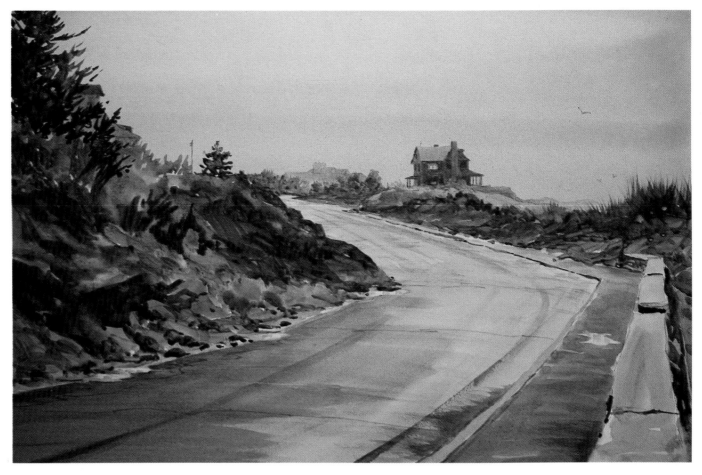

Welcome Light, Kennebunkport, Maine, U.S.A. (22x30).
PROBLEM: Is it possible to paint the feeling of dampness and general mistiness?
SOLUTION: Very cool grays are predominant, sky and horizon merge, and the only spot of color is the light in the distant window which I switched on in my mind. A puddle or a reflection will always tell the story that rain has recently fallen, and the absence of the horizon line will indicate that the air is heavy with particles of moisture. Again a limited palette is called for, and I'm using French ultramarine blue, raw sienna, and burnt umber. By the way, it was really a clear blue sky when I painted this subject, but this is the way I feel it rather than see it!

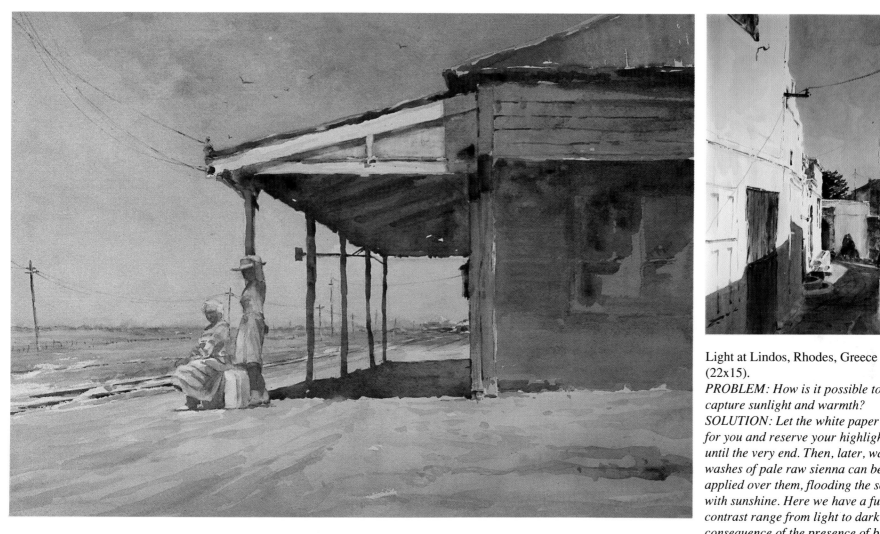

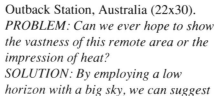

Outback Station, Australia (22x30).
PROBLEM: Can we ever hope to show the vastness of this remote area or the impression of heat?
SOLUTION: By employing a low horizon with a big sky, we can suggest air and space. A basic warm wash of raw sienna and purple was painted over most of the picture (with the exception of highlights on the figures and veranda), and warm colors were painted over this when dry.

Light at Lindos, Rhodes, Greece (22x15).
PROBLEM: How is it possible to capture sunlight and warmth?
SOLUTION: Let the white paper work for you and reserve your highlights until the very end. Then, later, warm washes of pale raw sienna can be applied over them, flooding the scene with sunshine. Here we have a full contrast range from light to dark as a consequence of the presence of brilliant sunshine. If you feel like it, strong colors could be used in this situation. Note the gradation in the sky—warm at the zenith, cool toward the horizon—giving the feeling of recession.

Reserving Highlights

The essential procedure I follow without fail before ever putting pencil to paper—and this is my only unbreakable rule in painting—is to determine where the highlights are, so that I'm sure to reserve the white paper for these areas. Once this is done and I've carefully observed the passage of light through the subject, I'm well on the way to establishing a good pattern and a successful painting.

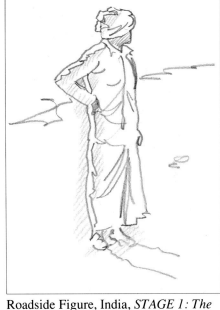

Roadside Figure, India, *STAGE 1: The Drawing. The contour line drawing, indicating areas of white paper to be reserved for highlights.*

Roadside Figure, India, *STAGE 2: The Neutral Wash. A warm wash of raw umber plus a little burnt sienna is applied right over the background, leaving the white paper for the highlights. We're giving it the feeling of India with this wash, but can you see how we've observed and recorded the passage of light? A pattern has emerged and now all you have to do is look for the mid-tones and darks and paint them in! At this stage it would appear that any colors painted over the top of the background wash would look muddy, but if you don't brush too heavily or keep going back into the wash, the result will be just fine!*

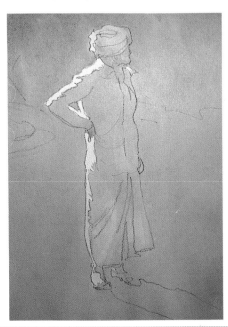

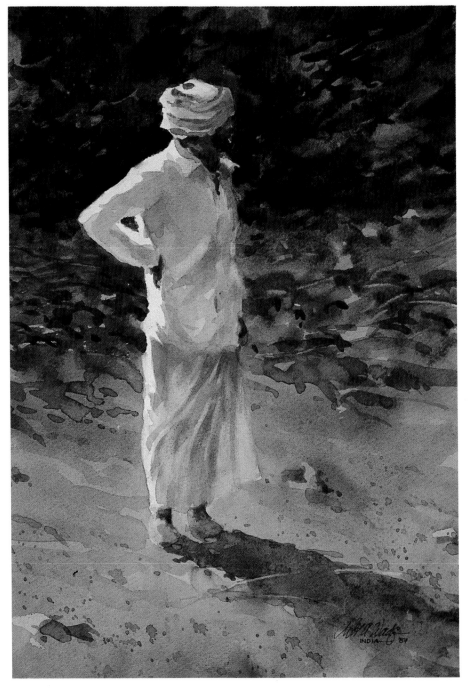

Roadside Figure, India (20x15). *The Finished Painting. Now it's obvious how the early establishment of the light pattern forced me into maintaining that all-important passage to take the viewer's eye through the painting. When the background wash has totally dried, work on the painting as usual. You'll achieve a striking result, because you've set it up yourself by perceptive observation of the highlights. A lot more work went into this final stage, of course, but the foundation of this painting—light direction—is actually quite simple.*

Just to prove it, walk out to your garden and select a spot you particularly like. Walk around your subject, looking at it from the front, back, and sides. (Or if you live in an apartment and don't have a garden, set up some flowers or a still life arrangement. But for this exercise, I'd prefer you to have natural light.) Observe the highlights and drink in the atmosphere of the surroundings. Let it all sink into the memory banks of your brain. Walk inside again, settle into your favorite chair, close your eyes, and project the image that has formed in your mind. If you concentrated hard enough on that highlight area, I'll bet it has been imprinted so vividly in your mind that you could produce a painting of it without reference to the subject. Try painting it, too. It's great fun.

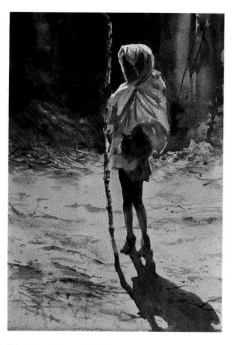

The Goatherd (9x6).
PROBLEM: How can we achieve a strong pattern and emphasize the figure, our center of interest?
SOLUTION: Just force the highlight pattern to provide that marvelous passage of light. A warm wash of cobalt, purple, and raw sienna was first painted over all but the reserved highlights, so the strong pattern would emerge.

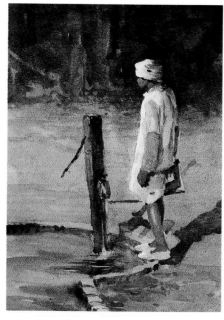

Waterboy (9x6). *Here's another example of how a pattern can give your paintings an extra punch. By making the top section of the background darker than the lower section, the contrast is increased, forcing the figure to pop out, with the darkest dark being played against the lightest light of the turban.*

How Light is the Light?

The next step is to evaluate the strength of light and relative scale of values created by its presence or absence.

If you start to think in terms of black and white whenever you look at a subject, it will be easier for you to translate colors into values. Let's take an example.

Imagine a little street in Portugal...a brilliant sun overhead, clear blue skies, white walls of buildings on either side, and the whole scene flooded with dazzling light.

Where light is present, then that will be our highlight area. Where it is absent, that will be our densest shadow. Well, that's very basic, isn't it? The difficulty comes in the assessment of how light is the light and how dark is the dark! On a bright day the full scale is there for you—all the way from white to black. On a dull day, the values come closer together, and the white will become a light value of gray and the black will become a dark value of gray.

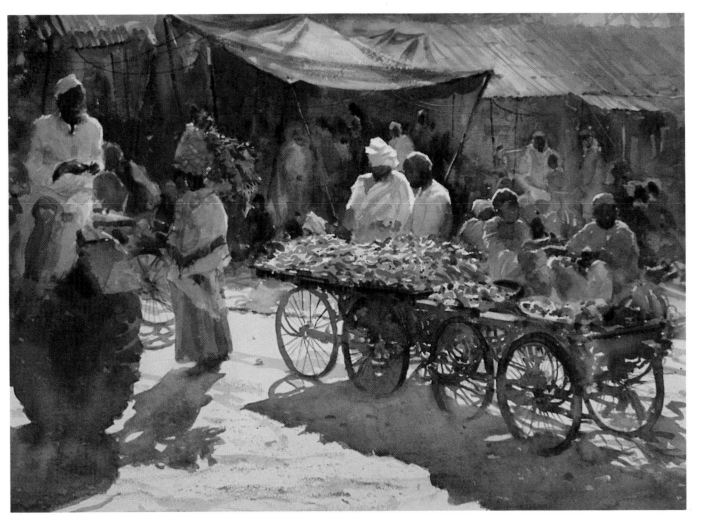

Bazaar at Meerut, India (22x30).
PROBLEM: There are so many dark areas here, I'm afraid the watercolor could easily finish up too heavy and muddy.
SOLUTION: Try to hit the darks with enough strength the first time. Do not go back into them more often than you can help or there will be mud. Make lots of color changes in them, too, to keep them interesting. Paint the cast shadows airy and clean, really let their transparency glow! We have the full contrast range to play with. What fun!

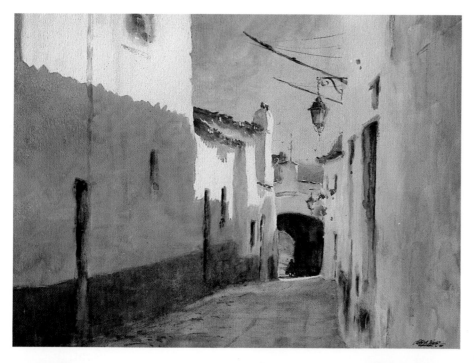

Estremoz, Portugal (22x30).
PROBLEM: How do I translate colors into values when I look at a scene?
SOLUTION: If you start to think in terms of black and white, it will be easier for you to do this. In these circumstances, the whole range of values, from white to black on the gray scale, will be present. Notice the warm color mixed in with the blue-gray shadow area. A small amount of salt was dropped into the wet wash to add textural interest to that big, boring wall shape.

Of course, the black is really only an arbitrary assessment; I would never have a dead black area in a painting. (You can see this if you look closely at *Estremoz*, at left.) I prefer to mix velvety darks that have a real glow and add much to the interest of the subject. I will discuss color at a later stage of this book, but for now I want you to think in black and white, as it is much easier to understand what I'm getting at.

Now, all the factors we've just discussed—running the full gamut of the value scale—happened because of the presence of our old friend, light. In the previous examples, there was brilliant light. What happens in subdued light?

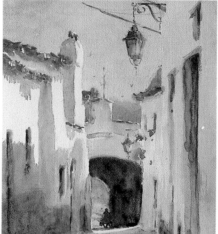

PROBLEM: My shadows are dead even though I always use Payne's gray.
SOLUTION: Payne's gray? There's your problem in a nutshell! Shadows are actually full of subtle color changes, varying from warm to cool. Look at the dark area under the archway. How many colors of similar value can you see?

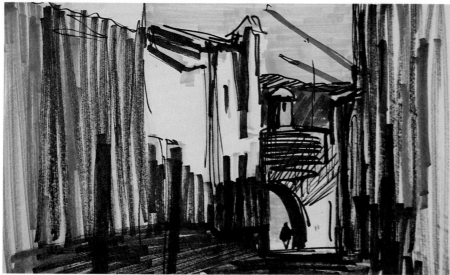

Value sketch for Estremoz, Portugal.
Remember, think in terms of black and white.

For this set of conditions, we're going to visit Staithes, a magical fishing village in Yorkshire, England. Here we have a soft light diffused by the clouds and, still thinking in black and white, all the values have moved in a couple of notches from both ends of the value scale.

Every painting doesn't need to knock your eyes out. In fact, an exhibition that only showed strong contrast paintings would be boring, just as too much of anything is too much. You can produce just as interesting paintings with limited contrast as you can with full contrast. Have you seen Whistler's *Nocturnes* at the Tate in London? Have you listened to "Clair de Lune"? Have you ever wept at the sheer beauty of *Swan Lake*? See what I mean? Limited contrast can produce the exquisite rather than the blockbuster!

Think you'd still prefer strong contrast paintings because there's such a lack of variety in a subject painted in the low contrast range? Wrong again, my friends. Just look at these examples to see what can be done.

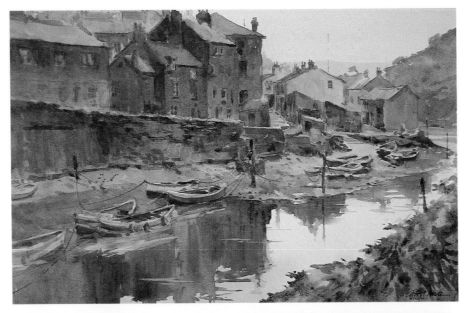

A Gray Day, Staithes, North Yorkshire (15x20).
PROBLEM: What happens in subdued light?
SOLUTION: You use a narrower range. No longer do we have white at one end and black at the other. We now have a case of palest gray at one end and dark gray at the other. Can you see what I'm saying? The contrast has been reduced because of the absence of strong light.

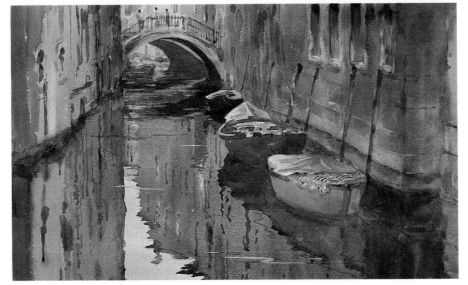

Reflections in a Venetian Canal (20x30). *Here's another example of subdued range. It's a different scene, but the same principle still applies.*

Barge on the Thames (12x18).
PROBLEM: Can limited contrast really produce interesting paintings?
SOLUTION: Yes! Here we have close values and limited contrast, but by introducing muted color into the boats and reflections, and by putting subtle color variations in the light-value sky, the painting works in a very subtle manner. It was awarded top painting prize at the Salmagundi Club. Is more proof than this needed to show that close-value paintings can be effective?

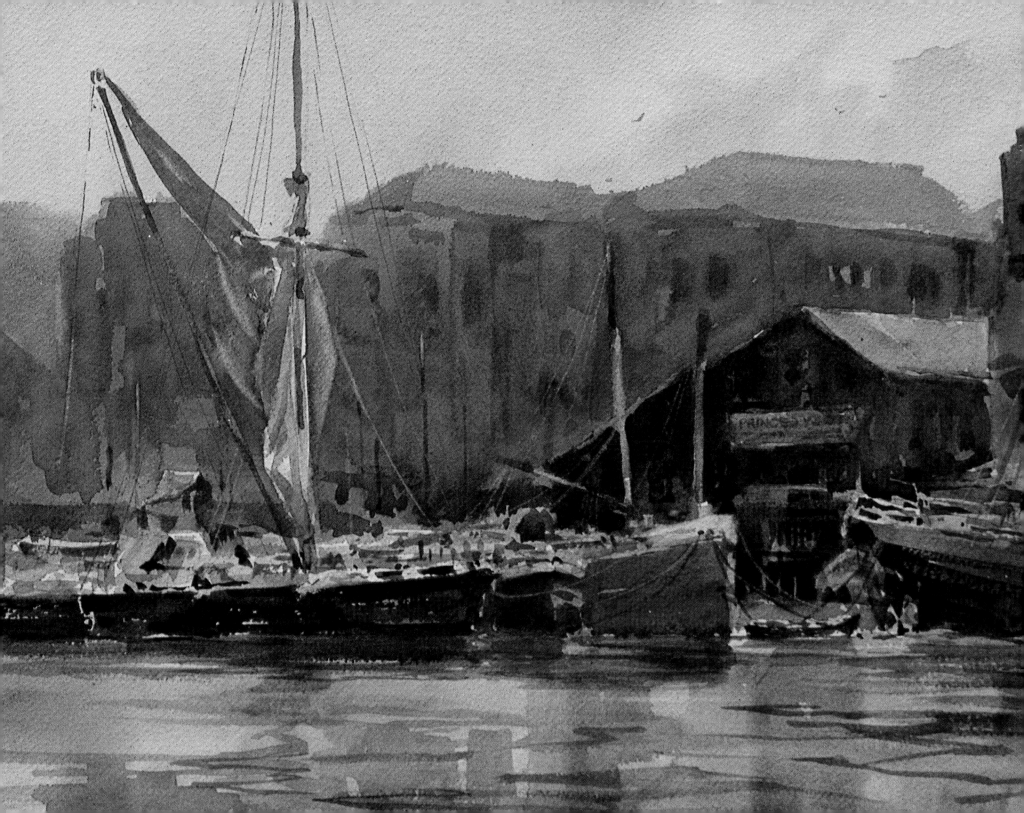

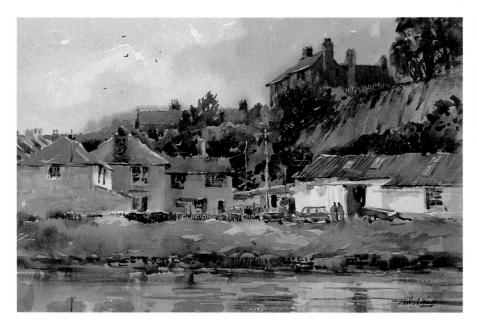

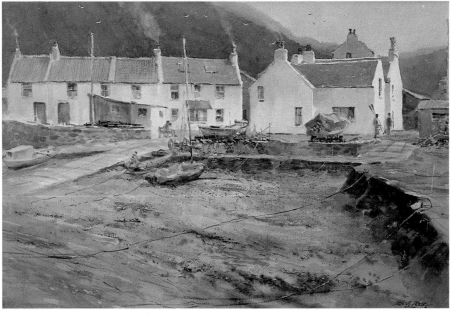

Welsh Grays, Pembroke (15x22).
*The hillside cottages lacked a focal
point, so making the sheds the lightest
value in the painting gave a balance to
the general flatness of the gray-greens
that dominate the painting.*

Fishermen's Cottages, Pennan, Scotland
(20x30).
*PROBLEM: How did you get the smoke
effect from the chimneys?
SOLUTION: I only wish that everything
were as easy as that! I just lit the fires.
(Sorry, I couldn't resist that!) I simply
took a brush full of clean water and
applied it to the spots where I wanted
the smoke, waited for just that right
moment and dropped in some white
gouache. But, to get back to the subject
of low value contrast, I decided to paint
the background hillsides a smidgen
darker in order to push out the white
cottages. Then to maintain balance, I
had to pay attention to the closer areas
of the sea wall, painting them corre-
spondingly darker where they are out of
the light. My final step was to lay soft
warm washes over the white cottages,
as I was quite aware that there would
be too great a contrast in this particular
set of conditions, which would certainly
have destroyed the validity of the
statement.*

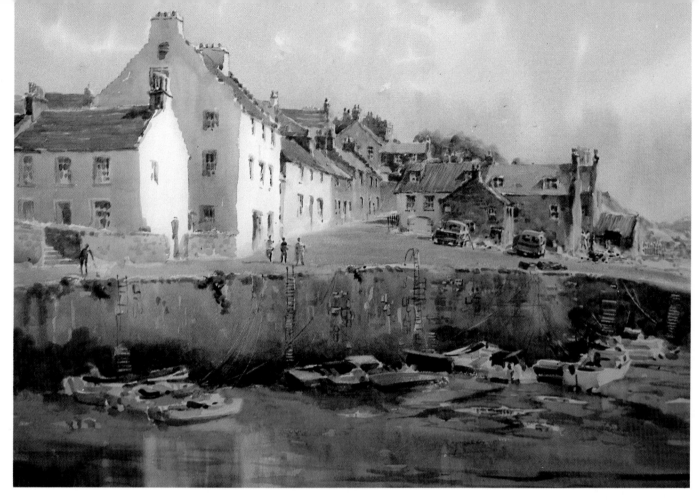

What happens with a day of clouds scudding across the sky and only occasional bursts of the sun? That description sounds like a typical Scottish summer's day, and here's that very day as I painted it—*Crail Harbor, Scotland* (right). A clouded sky diffuses the sunlight, and when the clouds are covering the sun, then it's really quite flat. It certainly offers some lovely choices for sensitive lighting, and it's not all that easy to decide which lighting variation to tackle—the cloudy quality or the sunny one.

I watched intently as breaks in the clouds let the sun stream through, changing the landscape completely. I was kept pretty busy, making little pencil studies and trying to make up my mind. At last I began to get the feel of the day and decided to make somewhat a mixture of all that was happening. The fronts of the buildings looked great when the sun shone on them—that was the overriding impression coming through to me. However, I needed to consider the value range truths, which can never be ignored, in order to maintain balance.

Crail Harbor, Scotland (20x30).
I decided to emphasize the sunlit fronts of the white buildings, with the rest of the village grayed-off in contrast. If you cover those highlight areas with a piece of paper, you can see that the overall value range is narrow. Because I cheated a little, in order to emphasize those white fronts at the top end of the value scale, I've had to make some adjustments down at the lower end as well. To preserve the balance, I made a few darks at the base of the sea wall a bit more intense. Once again, the changes I've made have been possible only because I've observed the basic truths of value ranges.

And there you have one of the basic tenets of painting: the stronger the light source, the wider the contrast range. The converse applies, too: the weaker the light source, the more restricted the contrast range.

Well, I sure hope I've managed to get that point across about value contrast and light. Don't read any further until you're sure you understand it well. All the teaching I'm about to do depends on it, so just read the section over until you know you have it firmly in your mind.

By now, you should begin to realize just how vitally important this light business is. To me it is the foundation of all art knowledge. I believe that if you understand the effect of light on form, even before you begin to draw, drawing becomes so much more meaningful and enjoyable.

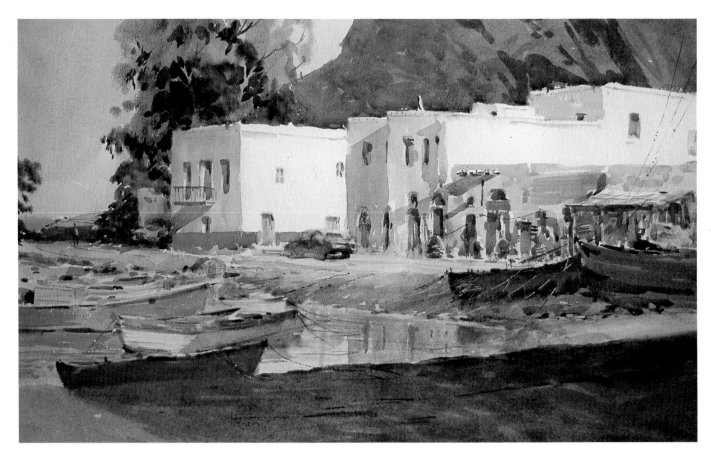

Waterfront, Patmos (22x30). *Look at the color, the sunshine, the feeling of warmth, the light in the Greek Isles! Here's a full range of hues. Can you find any dull grays? No way! All the shadow areas are affected by that strong sun, and the brilliant highlights grab the eye, drawing the viewer right into the picture.*

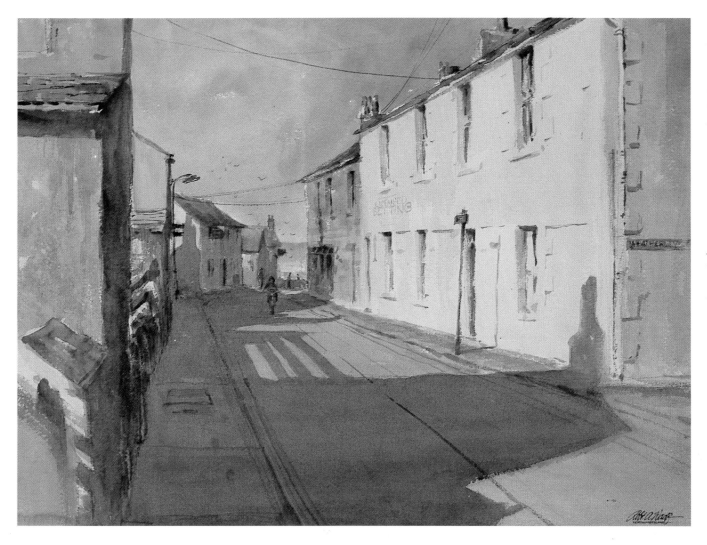

Seahouses, Northumberland (20x30).
PROBLEM: Is it possible to have sunny conditions and yet still have rather a limited value range?
SOLUTION: Certainly! This class demonstration of a street in the quaint English fishing village of Seahouses was done on an afternoon of very pale sunshine. Although we can see the sun, we instinctively know that it's not a hot, brilliant sun. Why? Because the contrast range is quite limited and the values are all high in key. Note the transparent shadows, influenced by the pale blue sky and weak sunshine. I added a couple of small figures to give life to the scene but stressed the basic abstract pattern of the shapes.

Let's return to Staithes, Captain Cook's old stomping ground. Look at my watercolor of the Estuary. You can see how the contrast range is not great because of the overcast sky, which diffuses and lessens the presence of light. Yet the painting still reads well because the relationships of tonal values are closely observed. Had I made the darks too dark or the lights too light, then I would have upset the balance by making it a lopsided and unnatural effect, which would have been hard for the viewer to believe.

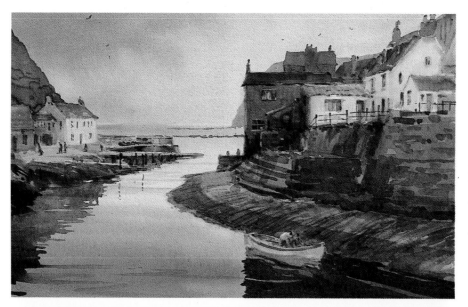

The Estuary, Staithes (15x20). *PROBLEM: Although there is a lot of soft light in the sky and on the water, it doesn't make for a strong contrast. Gosh, it's harder when the sun isn't shining!*
SOLUTION: There is an interesting sky and water shape, though, and the rather flat values of the banks and houses will emphasize it if we're smart. We'll shoot for a good shape contrast rather than a value contrast. (Since there are no white areas at all, all the values are now much closer together.)

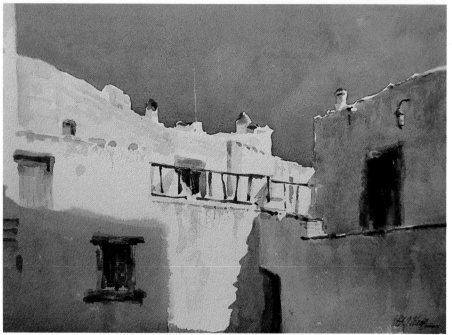

Greek Sunlight (8x10). *This small on-site sketch is a collection of simple abstract shapes, made to read correctly by the presence of strong sun, and, even though it's such a little painting, the full contrast range comes through. Light bounces back into the right-hand shadow shapes so that we almost feel the warmth of the Mediterranean sun. Compare the very different effects of sunshine in this painting with those in the painting of Seahouses. The sun is strong in this one and weak in the other. Had you ever really noticed that there could be such a difference in the quality (intensity) of light? Start looking now with perceptive observation!*

Now I'd like you to return to your spot in the garden and examine your subject with renewed interest in light of the information you have just gained. This time, search for the value range!

Walk around your subject, looking at it from the front, back, and sides. Looking at your subject from all sides, you'll be aware of the highlights, as before, but this time you'll notice how their location and intensity (brightness) varies according to where you're standing and where the light is coming from. Your position in relation to the light source will also affect the shadow patterns, which will change in size and shape. That's why it's possible to paint so many variations of a single subject. So here we've arrived at the next important factor—the direction of the light source—which must be kept firmly in your mind throughout every painting.

By observing the direction of the light source, the way it falls on the subject itself, and the

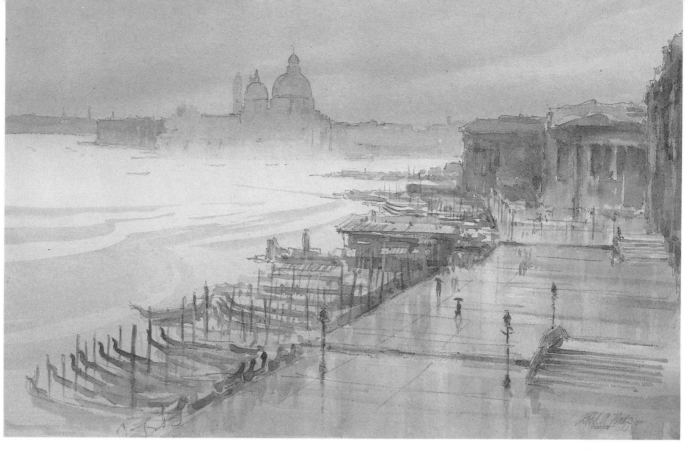

location and size of the cast shadows, you'll be able to paint any subject you care to, under any set of light conditions you wish to select. Now you can be the stage manager, author, producer, and star of your own production.

Misty Venice (15x20).
PROBLEM: There's not much light at all, and what there is, is hardly worth mentioning at any rate. I'm stumped!
SOLUTION: Great! Here's where we can produce something different and very moody. Don't let any light conditions get you down; use them to your advantage. We'll make this a low key, low contrast painting, almost a two-
value job. Notice that all the highlights have a gray wash over them. There's no white paper in evidence here; all the darks have moved toward a middle value and the contrast range is very limited. The colors are negligible, too, almost entirely muted by the atmosphere. The strong diagonal of the moored boats creates the pattern.

Painting in a Different Light

To see beauty where it isn't always obvious brings great joy to me, and I find that this beauty is brought out by the presence of light and of the magic tricks it performs in transforming the mundane to the marvelous!

The challenge I enjoy the most is altering the time of day and the light conditions from actuality to a set of conditions I invent to help me portray the subject in the most sympathetic or dramatic way possible. This is where the painter becomes the artist, not content with just a pictorial rendering, but searching for that indefinable something that is felt but not seen. This approach leads to some failures, but there's always a good chance that the next one might be a success. Who knows? It could even produce a masterpiece. At any rate, that's how I'd like you to think along with me. My whole purpose in writing this book is to try to help you achieve better results by thinking your way through your paintings.

Dolgellau, Wales.
PROBLEM: Here's the actual 35mm slide taken of the subject that I wanted to use as a reference photo. Could there be a more interesting way of portraying this rather drab subject?

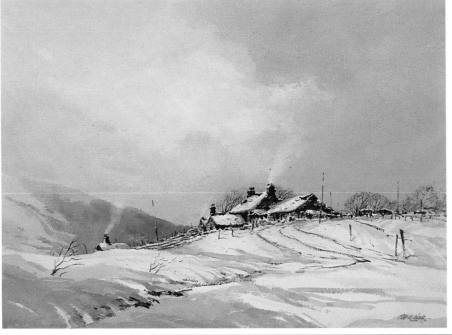

Winter Landscape, Wales (20x30).
SOLUTION: Why not imagine that it's winter? Let it snow, let it snow, let it snow (to borrow the words of an old song). Just look at how much more interesting it is. Remember, you've got to paint with imagination as well as your brush!

Tony Bennett, the fine American vocalist, visited my studio during his recent Australian concert tour. Tony is one of the world's greatest artists in modern music, and I'm a long-time fan. Tony sketches and draws everywhere he goes and is never without his sketchbook and pens. During a delightful afternoon together, discussing our mutual love of art and music, we came to the conclusion that we both work in a similar way in our respective fields! Seldom do we take our subject and perform it literally, just as is. We both present an interpretation of our personal reaction to our theme—in Tony's case the piece of music, and in mine the painting subject.

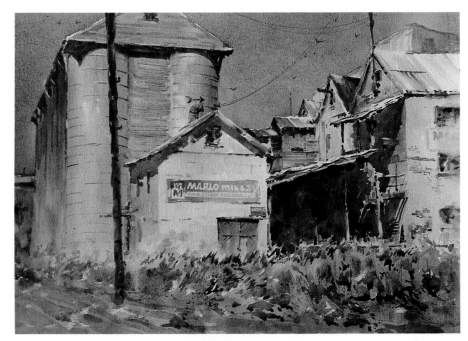

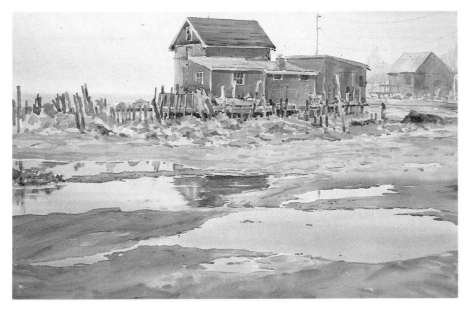

The Mill, Maryborough (18x24). *There's a full value range here (plus a major award from the Salmagundi Club). I've never seen a sky this color, but it was the way I perceived it, and that warm red-brown of the sky sets the mood and influences all the colors throughout the painting. You've got to paint the way you feel about a subject, or you'll never get to be an artist in the fullest sense of the word.*

Turbat's Creek, Maine (20x30). *This is a gentle, high-key painting, but I don't find it less appealing simply because all the instruments in our orchestra are not playing. It's a string quartet compared to a symphony. The light is weak, so the values fall within a very narrow range, and the darkest value is really only mid-value. It was necessary to apply a pale wash on all highlight areas to stop the balance from becoming lopsided.*

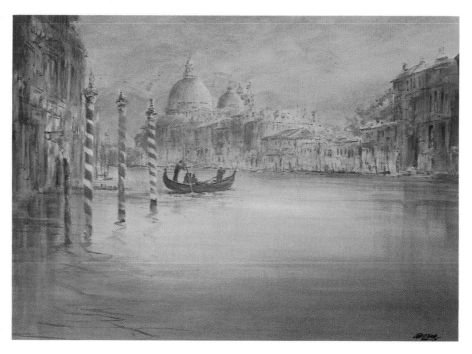

On the Grand Canal, Venice (30x40).
PROBLEM: If I want to change the actual local colors in a subject, how do I create a value range?
SOLUTION: Take a look at this invented atmospheric light effect. The day was really bright and sunny, but it looked rather "chocolate-boxish," and I don't picture this wondrous city like that at all. So I decided to use warm pinks and brown and, because of my awareness of contrast range truths, I changed the scene with a degree of conviction to suit my reaction to it. I rather think it has made a more interesting painting, too. Even though the range is so restricted, the subtle colors compensate for any lack of contrast.

I want to encourage you to become more imaginative in your approach to your own work, to think beyond the subject and beyond that piece of white paper, to imagine something that isn't there, but that you can feel.

We have a summer house down on Phillip Island off the coast of Victoria, Australia, where the famous Parade of the Fairy Penguins takes place every evening at dusk. These little birds suddenly appear in the sea, swimming strongly to the shore, where sometimes two hundred or so will stagger from the surf, and, heavy with food for their young, will slowly make their way up the beach, over the sand dunes, to the cries of hundreds of hungry chicks squealing for attention. Finally, in complete darkness and quite exhausted, they will arrive at their own chick as though beamed in by radar!

Lost you for a minute or two, didn't I? Your mind went off to that faraway island, and you were climbing over the dunes with the penguins, weren't you? See how wonderful the imagination is, if it's encouraged?

Never rush into a major painting. Give yourself heaps of time to consider all aspects of the subject. Now that you have developed a new awareness of light, you have a tool to help you to shape all sorts of different approaches. Suddenly it's in your power to manipulate the facts to suit yourself and the way you see and feel the subject.

On one occasion I was painting a full-sheet watercolor on site, at Melbourne's grand old Royal Exhibition Buildings. I envisaged the marvelous architecture of its facade to be floodlit at night as it may have been at the turn of this century, and so that's how I painted it—while standing there in broad daylight. Naturally it wasn't long before the inevitable spectator arrived. He stood and watched for quite some time without comment, and then sadly shaking his head he remarked as he walked away, "You artist blokes certainly are a weird mob!"

Don't be surprised if your bold perceptions confuse others. Even great artists have had their share of comments from passersby. One day, Whistler was painting outdoors when along came the usual onlooker. After watching him paint for a while, the onlooker remarked to the great artist, "I can't see any of those colors out there!" Whistler looked up from his work, gave him a long, cold glare, and retorted, "Ah! But don't you just wish you could?"

This is all great fun, turning a summer scene to snow, a day to night, opening the heavens and making the rain pour down, or transforming any condition of time or season to suit the subject. But first you need to get complete mastery of the principles of light, and then so many wonderful things become possible!

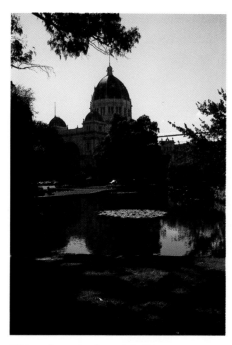

This is how the Royal Exhibition Buildings actually looked the day I painted them.

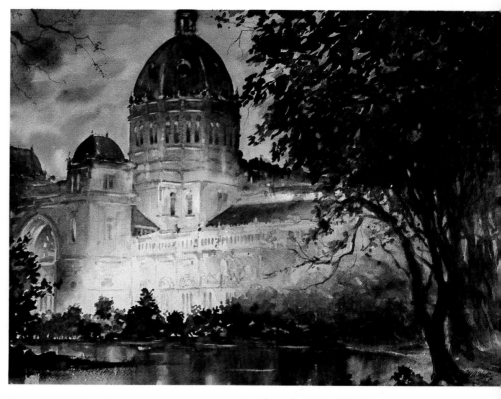

Royal Exhibition Buildings by Night (20x30).
PROBLEM: How can I portray night light in watercolor, and how can I see to paint outside in the dark?
SOLUTION: Here's a subject that needs to be tackled in the comfort of your studio and it becomes necessary to paint from your imagination in this case. It's not easily done, but by remembering our key thoughts—constantly keeping the light source direction in our mind's eye and follow-ing the principle of light source, subject, cast shadows—we are able to work out how subjects will look when lit by artificial sources. One of the most important things to remember is that most of the shadows will be cast upwards since the light will be coming from below. The other trap to watch out for is that there may be many different sources of light in the one painting. Oh, by the way, don't make your sky too dark. Keep it transparent and velvety-looking.

Key Thoughts on Light

Let's just repeat these basic truths we've discovered so far:

• The greatest influence on shape or form is light.

• The highlight areas should be observed first when looking at a subject with a view to producing a painting or drawing.

• The intensity of the light source controls the contrast range—the stronger the light, the greater the contrast; the weaker the light, the more restricted the contrast range.

• Controlling the light enables you to be in command of the situation.

• Putting these truths all together gives you the power of perceptive observation.

These truths are basically so simple that they should be stressed over and over. They are really "key thoughts"...the keys to unlock the doors to further revelations, and the solutions to so many of our painting problems.

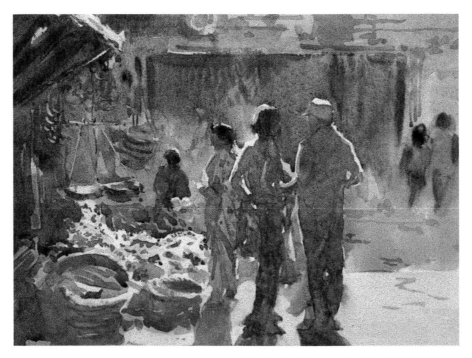

Market in Katmandu, Nepal (11x14).
PROBLEM: The most interesting viewpoint is contre jour—against the light—but all the shadows seem too dark.
SOLUTION: Because you're looking into the light, the shadows appear black, as your eyes automatically adjust to the glare of the sunshine. To paint this, just bring your darks up a value or two, making them lighter than they appear. Very appealing paintings result from this aspect—but it isn't easy!

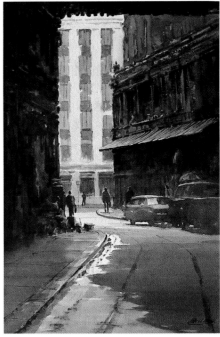

Leadenhall Market, London (22x15).
Here's a change! Although it's a dull day, the darks are strong and the lights have come back down the scale. The intense darks make you feel that you are right back under the covered-in lane, looking out to the light that is flooding down between the buildings. The highlights have been reserved for the gutter puddles, but even these have a pale wash over them to keep the balance. Because we've gone down the scale with the darks we must do likewise with the lights. Always be conscious of maintaining the balance.

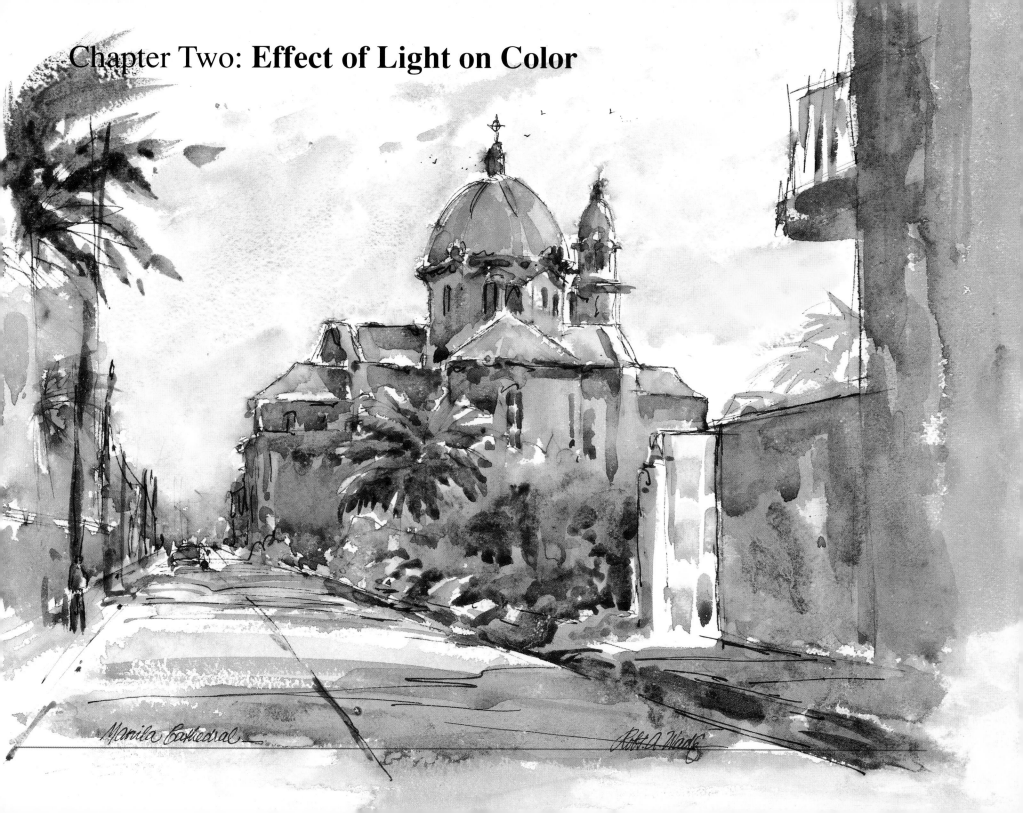

Manila Cathedral

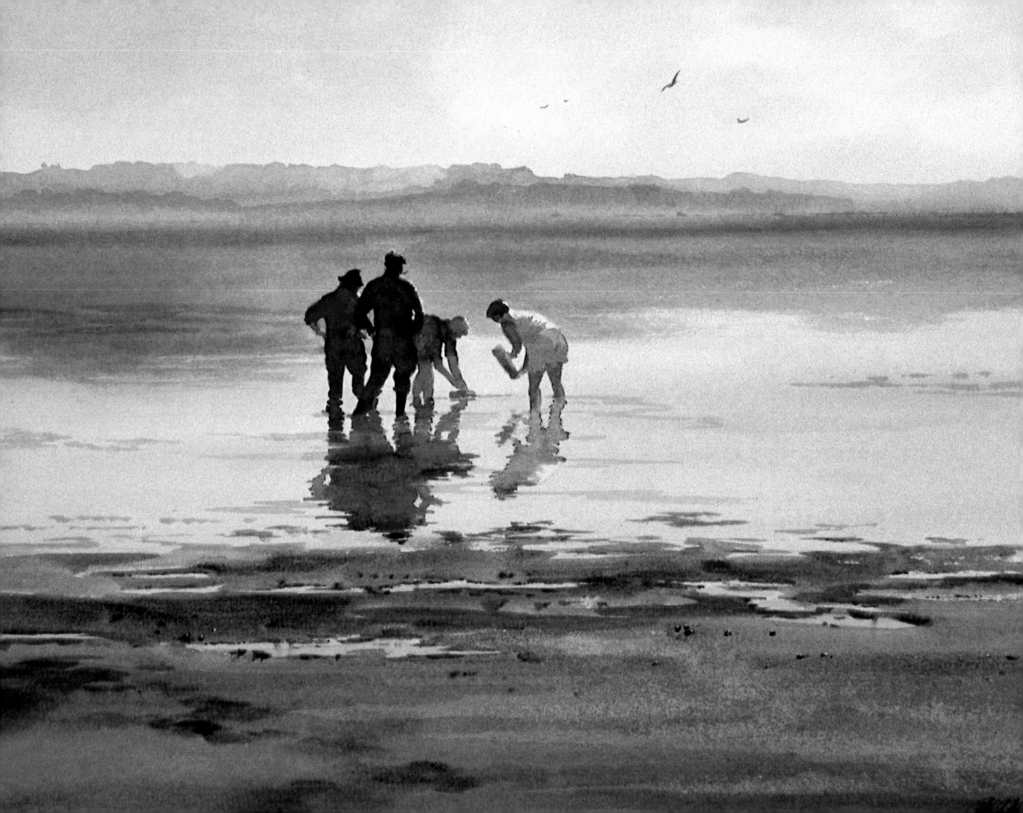

Sargent: Master of Color and Light

The Seekers, Queenscliff (20x30). *Here is a very "blue" painting. The early morning is so still, the water is almost motionless, and there is a wonderful atmosphere of peace and quiet. There is only one piece containing color and detail—the shape of the figures. Cover the shape with your thumb and you will see that a million colors are not needed to paint a good picture. You just need to place a few, well-chosen ones carefully.*

Now, we're ready to go into the effects which light has on color, another very important factor in portraying mood and atmosphere. Reflected (or bounced) light and aerial perspective are the two areas we will deal with in our search for watercolor solutions.

I must admit that on many occasions, I've drooled over the wonderful watercolors of John Singer Sargent. I really feel like giving it all up sometimes when I gaze in rapture at his juicy paintings of Venice, which sparkle and glow. Have you ever felt that way, too? *Santa Maria Della Salute, 1904* (at the Brooklyn Museum) is probably my favorite. When I was visiting Venice some years ago, I had the temerity to attempt to paint a watercolor from almost the same spot as Sargent—but the vision of his painting always seemed to cloud my thinking, and I finally admitted defeat.

If ever you are visiting New York, be sure to book ahead for a private viewing of his paintings in the Metropolitan and Brooklyn Museums, which house the world's largest collections of Sargent's watercolors. If this is out of the question, then visit your local library and read all you can. I frequently thumb through my copy of *John Singer Sargent* by Carter Ratcliff (Phaidon, 1983), always coming to the conclusion that I really have such limited ability compared to his. However, it's no use giving up flat! It's the time to take stock of what ability you do possess and make a commitment to work for its most meaningful development.

Seek out reproductions of Sargent's watercolors and study their freedom and spontaneity, their vibrant color, and the magic way he infused air into his work so that it lived and breathed. Note in particular his use of reflected light in the shadow areas. Sargent used light as his servant, bending it to suit the mental vision he had created for his subject. Even now his paintings appear as fresh as if they were painted yesterday, giving you the feeling that he was suddenly confronted with a subject and compelled to set it down in watercolor before it had a chance to escape! Your study of his work will be well rewarded by a heightened perception of light and color. Oh that we could capture this sense of immediacy in our own watercolors!

I believe that Sargent's spontaneous, on-site watercolors really demonstrate his mastery of reflected light, aerial perspective, color, and of course, every other skill in drawing, composing, and rendering. He would lightly sketch in the relative positions of the objects, then paint very rapidly. He used the white of his paper for highlights to create the texture of marble or a satin dress. You can see his power in his wonderful drawings, opulent color, and the glowing warmth he captures in sunlit scenes.

By the way, Sargent was a severe critic of his work, rarely satisfied. When Mrs. James saw his sketch, "Quarry at Chocorua," she said, "How delightful it must be to know that every time you work you will bring back something fine." Sargent replied, "But I hardly ever do! Once in a great, great, while!"

Reflected Light Equals Reflected Color

I'd like to try to clarify the term "reflected light" (or "light bounce," if you prefer). When the sun hits flat planes, reflections are set up that will bounce light back into the shadow areas, illuminate them, and inject color into areas that would otherwise be dull grays. For example, even if a wall is completely in shadow, it won't be just gray because light will bounce back into it to give it other colors. The same is true of cast shadows. We've got to look sharp to see it, however; a camera won't. Being aware of this phenomenon lets us paint all manner of situations in a believable and attractive fashion.

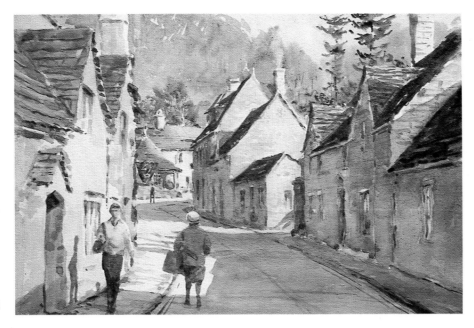

Castle Coombe, Wiltshire (15x20).
PROBLEM: The cottage walls on the right-hand side of the street are in deep shadow. Now is it time for Payne's gray?
SOLUTION: No way. The warm stonework in this Cotswold village (which, incidentally, was the setting for the film Dr. Doolittle) *sets up many areas of light bounce in the soft morning light. This is how reflected light works: Light bounces back from the walls of the left-hand side, which are in full sunlight, and it fills all the shadows with warmth. In turn, these shadows reflect back to the cast shadows on the road, warming them in turn. Oh dear, what a disaster had I used Payne's gray!*

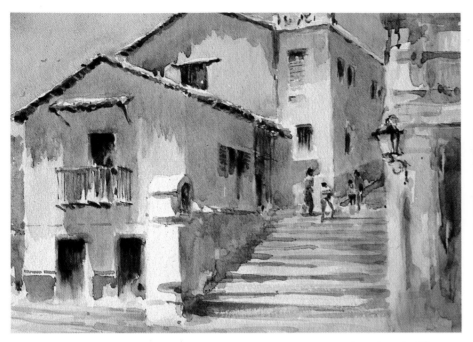

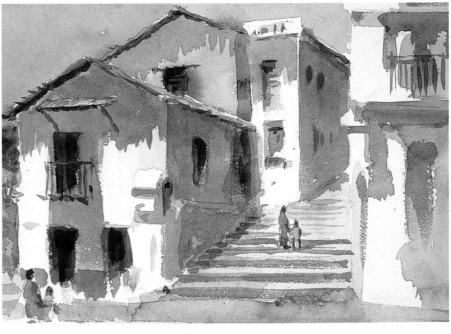

I believe that a mental image makes it easier to understand, so let's paint a picture in our minds, then I'll support it with a sketch. Let's imagine that we're in Taxco, Mexico, a jewel-like village in the mountains about a hundred miles south of Mexico City. Whitewashed walls, bright sun in clear blue skies, red-tiled rooftops, and the colorful dress of the inhabitants all add up to a wonderful array of paintable subjects.

Let's look at the sketch, Taxco Steps. There aren't any boring gray shadows; they're all mixtures of warm and cool colors. What a difference in atmosphere there would have been without perceptive observation of the influences of reflected light! Just look at my second sketch of the same place to see the difference.

Taxco Steps (10x14).
PROBLEM: I'm still having a hard time understanding reflected light. Can you show me how that affects my shadows?
SOLUTION: Let's take an example. In this painting, the shadows are warm where they are affected by reflected sunlight. Farther away from those reflections, they are affected by the cool blue sky instead.

Taxco II (10x14). *See the difference here? Going against all I feel in painting, I've used only Payne's gray for the shadows, and they are all dead! I just hated to kill the lovely little subject this way, but I wanted you to see the difference between the lively shadows in the first painting and the dead ones here. From habit, I even started to warm the shadows here and there because I just couldn't stop myself. Compare this with the delicate warm pinks of the other painting. See what an effect reflected lights have on the shadow areas? I hope this demonstrates the importance of searching for reflected light.*

It's essential when you are contemplating a painting subject to look for reflected light and observe the many effects it has. Now, let's take the same scene as before, but imagine other effects. For instance, if we mentally turned those steps into a grassy slope instead of stone, there would be a greenish bounce-back into the shadows. If we turned them into a red brick road, a reddish hue would reflect into those same areas. It all seems very simple and logical now, doesn't it?

Remember that subject I asked you to discover in your garden so you could conduct your own experiments into light effects? I want you to return to it, and this time observe the light reflections we've just talked about. When you're sure you understand how this works, then we'll get on with this book. But what you have just learned is another important watercolor solution, so don't rush into the next stage until you have this one firmly in mind.

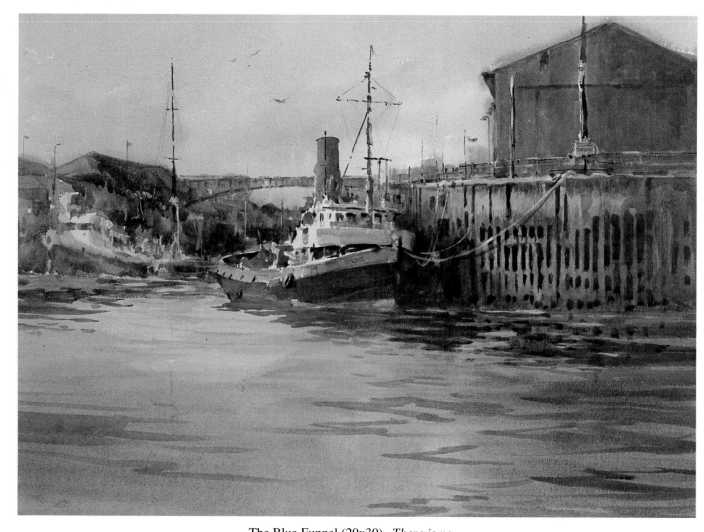

The Blue Funnel (20x30). *There is no unusual color in the sky, but when you see its influence on the color of the Thames, you'll realize what I've been going on about. The color of the sky is always reflected on the objects below.*

Now I can hear you thinking, "We're talking about color now, but earlier this guy said we should consider the subject in terms of black and white. I sure am getting confused!" Well, that is what I said, and it is true. What we really need is a sort of TV monitor system up in our thinking department. When you begin a painting, first switch on your black-and-white monitor to help you find your value pattern. When that's established, get it down on your sketch pad (like the one I did for Estremoz, back on page 7). Only then do you flick on the color monitor in your mind to start searching out your subject for reflected lights and color relationships. Now do you get the picture?

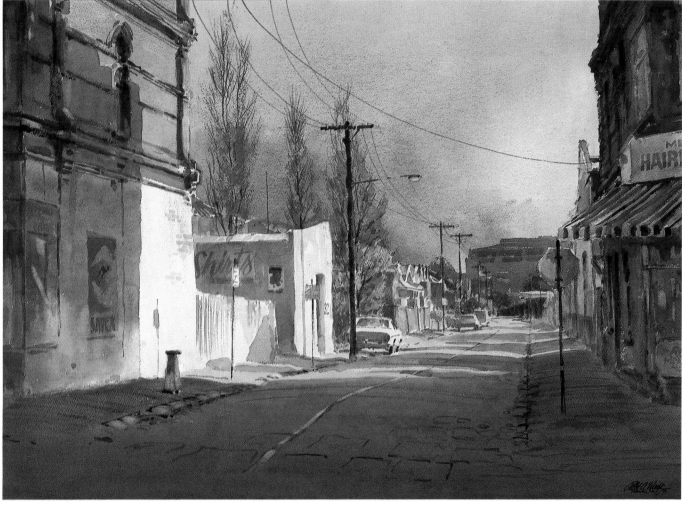

Afternoon Shadows (20x30).
PROBLEM: How do changes in the intensity of light change the effect of reflected light?
SOLUTION: Here's an impression of late afternoon sun. There's a feeling of warmth and light everywhere, and light is bouncing backward and forward like crazy. However, as it is that hazy sort of *afternoon light, the sun is not as intense, so our shadows are not that dark, although the lightest areas are almost at the top of the scale. Look how transparent I've kept them and how warm they are as a result of all that reflected light. See how the contrast range has narrowed, even though the painting is filled with sunshine?*

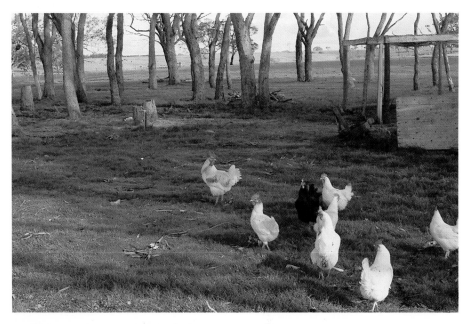

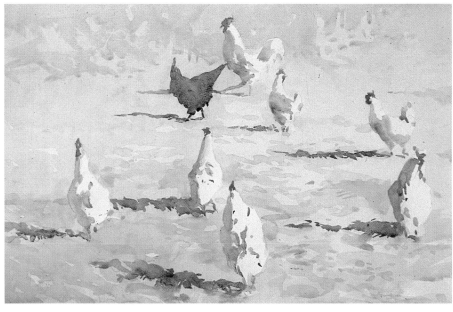

Once we've established the basics with our "TV monitors," we may make a multitude of personal decisions on our approach to the painting. It is possible to change the actual scene in many different ways, but any personal reactions can only happen as a result of making a critical analysis and evaluation of the scene initially.

I've used this analogy to modern technology to help you think your way through a painting. The thought process is even more important than the painting process. Always make sure your brain works harder and faster than your brush!

Reference photo for Dicko's Chooks—the actual day.
PROBLEM: Too much green can be dangerously boring in a painting, but the grass sets off the chooks nicely. Can I change the feeling of the subject by redesigning the color?

Dicko's Chooks (15x20).
SOLUTION: Yes, let's do away with the grass altogether. We can change the setting to a dry, old outback farmyard and keep the colors high in key to give the feeling of a hot summer day. Note the cooler blue in the background, and the warm light reflected up from the ground back onto the chooks. See the many color changes in the cast shadows? It's fun to be creative. Just remember, we can do as we please as long as we employ the basic truths of painting.

Thimi Village, Nepal (15x20).
PROBLEM: I'd like to spotlight those marvelous figures in their native dress. I'd also like to create a feeling of space behind them even though those background buildings aren't very far away.
SOLUTION: Great idea—that's exactly what I mean by needing to think your paintings out! We're going to get good value from both reflected light and aerial perspective in this one. In order to bring the figures out, we're going to make the background buildings darker than usual and keep them cooler to make them really recede, leaving the figures standing in space. Thanks to plain old geometric perspective, all lines lead the viewer's eye to the figures in the brilliantly sunlit area because of the darks that surround it. For example, look at the reflected lights on the left-hand side, then cover them with your hand. See how important the lights are in the shadow areas? Note also that detail in the foreground is very sketchy—we want the eye directed into the picture without much delay on the way. I like it—keep thinking!

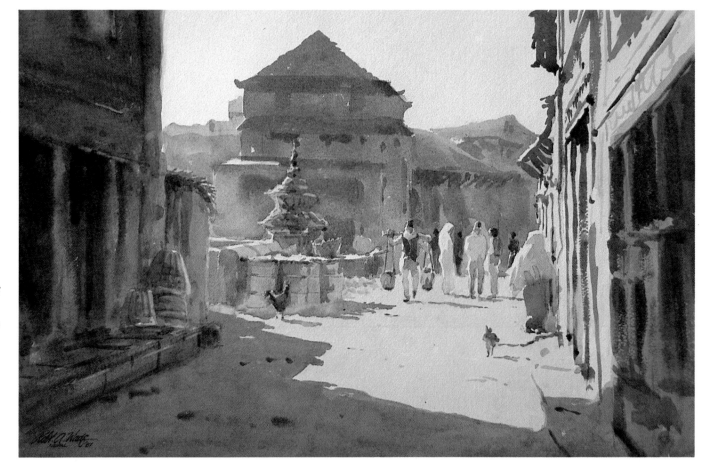

Color and Aerial Perspective

We are starting with a two-dimensional piece of paper—flat, but having length and width. We must try to build an illusion of depth into that piece of paper. That is, some shapes will come forward while some will recede, and by this device, we will arrive at a third dimension. This will, we hope, surround the shapes with air so that we feel we're able to reach into the painting and touch the objects or that we could even walk right on down that road we've just painted. How do we convey this effect of depth? Simply by observing the next set of painting truths:

Paler or cooler colors tend to recede.

Darker or warmer colors tend to advance.

This illusion is brought about by the presence of dust and moisture particles in the air around us which make shapes grayer and more indefinite the further away from us they are. Conversely, the closer the object, the more colorful and distinct it is.

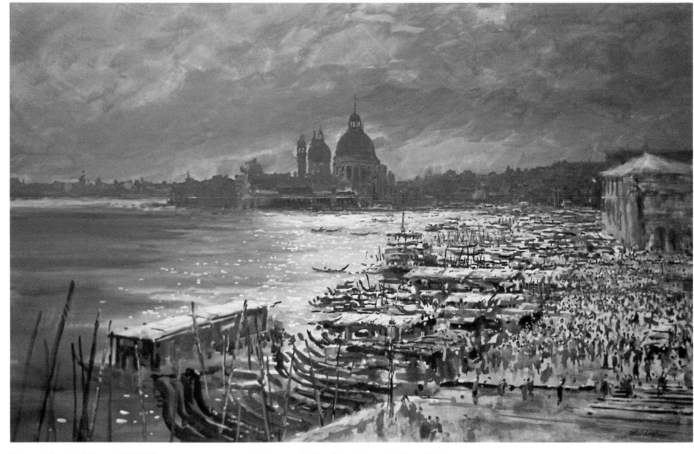

Towards the Salute (20x30).
PROBLEM: This is such a busy scene— boats, people, buildings. What can I do to create order from chaos and convey the effect of distance and depth?
SOLUTION: Bringing aerial perspective into play, we'll keep the background in cool mauve-blues, but as we come forward we'll drop in just a few bright splashes of color that will pull it all together. Note that there is a minimum of detail in the painting. It is suggestive and impressionistic...and to contradict what I've previously told you, here is a painting where reflected light doesn't play an important part for a change.

Here's how you can see it work yourself. Cut two small pieces of watercolor paper (using one of your old disasters would be a good idea), about 4"x4" would be ample. Paint one side pure cadmium red and leave the other blank. When the red has dried, cut a small hole from the center of each piece, about 1/2" square, then select a view where there are some distant red-roofed houses, some white walls, clouds, fences, and so on.

Hold the red square out at arm's length. Then look through the little hole, holding the paper so that one of the distant red shapes is visible against the edge of your painted square. Now you will see that the distant reds will seem to be rather brownish when compared with the cadmium red in the hand. Similarly, you'll discover that shapes that appear to be white actually have a blue-gray cast when compared with the white watercolor paper.

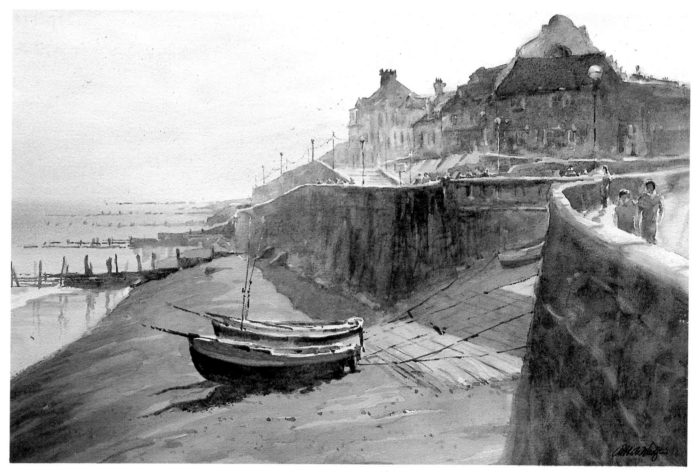

Sheringham, Norfolk (15x20).
PROBLEM: I'm really worried about the unattractive seawalls, and especially the ugly wooden breakwaters. I bet you're going to tell me to eliminate those, but what about the walls?
SOLUTION: Wrong again, my friend! Here's where we can use repetition to good effect. By making each breakwater a little paler as it recedes, our knowledge of aerial perspective is giving the painting a real feeling of depth. Now by putting warm darks into those dull, gray walls, they're coming forward. So you *see the minuses have become our pluses and are two of the most important elements in the picture. Just as in our lives, if we can recognize and work on our weaknesses, quite often they can ultimately become our strengths. By the way, the day I was in this English town there was a bleak wind coming in right off the North Sea. It was all very gray and murky, but the artist is the director of the show, so I did it my way!*

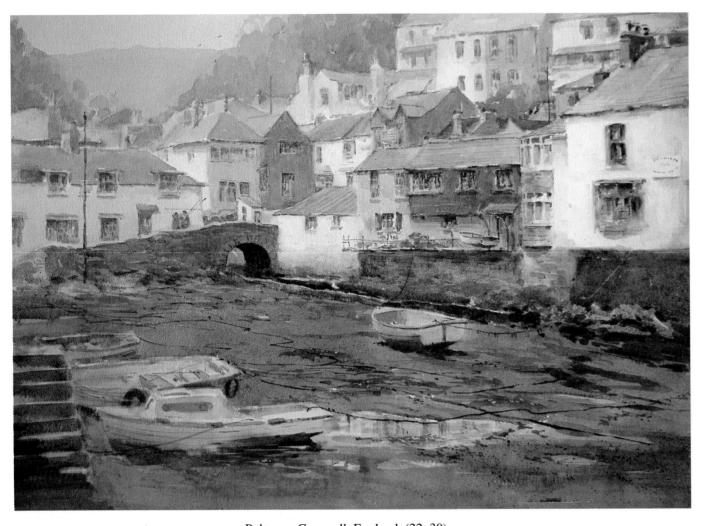

The effect of aerial perspective varies with the light conditions around the world. In Australia, we have a very clear, somewhat harsh light which enables us to see great distances without much graying-off from the atmosphere, so quite often we need to exaggerate aerial perspective in order to achieve a feeling of depth. In England, on the other hand, the atmosphere is so heavy that the trees and buildings just across a field are softened with a misty grayness, just like the magical fishing villages of the northeastern coast of the United States. I really love painting in Britain; everywhere one looks there seems to be a watercolor subject. No wonder watercolor was once regarded as the sole domain of the Brits, for the landscape just cries out for it!

Polperro, Cornwall, England, (22x30).
PROBLEM: Misty gray and soft light. How can we capture the feeling of this magic fishing village?
SOLUTION: Color is very subdued when these lighting conditions dominate, and with only cobalt blue, raw umber, and burnt sienna, we can mix a great variety of subtle grays in a limited range of values. Remember, restricted contrast under limited light.

Taking Stock

The truths we've discovered so far are the most important you'll ever learn in painting, as they are vitally concerned with the most significant influence on our work—light. From this point on, the information we glean will be more in the way of fine-tuning or refining the painting process. In no way do I want to denigrate these next solutions. I just want to stress how critical the initial discoveries were, and how necessary it is for you to understand them very clearly before going on any further. In fact, you could do no better now than to return to the beginning of this book and reread it up to this point.

If you try to incorporate these truths in your paintings and they don't seem to work for you right away, don't be too disappointed. How could we learn without failures along the way in order to help us find and fix our mistakes? What is important is that we keep trying new things and practicing them until we do them better.

Actually I always find that practice is the best fun of all. Sometimes we attempt things we'd normally be terrified to try in an actual painting session, and wonderful things happen because we're not inhibited by fear of failure.

Fortified by this experience, when we're confronted later with a similar situation during a painting session, we'll be prepared to "have a go at it" because of our previous practice session. It's very much like a golfer needing to sink a meter putt to win a match. If he hadn't spent countless hours on the putting green practicing that very putt, then he would have little chance of getting it. But because of his

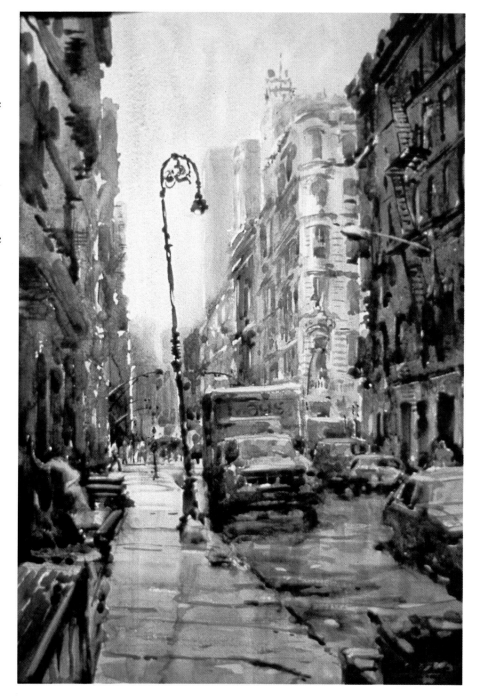

Soho, New York (20x15).
PROBLEM: This subject seems far too dull for an interesting watercolor, as it's a drizzling day and so flat in color. SOLUTION: I think it's far too good a subject to dismiss for that reason. Let's .use what we've learned. By getting those pale, cool colors into the background shapes, by varying the color in the buildings, and introducing warms and darks into the foreground, we have finished up with what I believe is quite a reasonable result. By observing the painting truths we've discovered, we've been able to produce a painting that is far more attractive than the actual site.

knowledge and the confidence gained from frequent practice, there is that much more chance of success.

I have been playing golf for some forty years and know only too well the value of thoughtful sessions on the practice fairway. Golf and watercolor are very similar in the respect that neither allows you to become smug and self-satisfied. The moment you get over-confident, then terrible failure is waiting just around the corner to restore humility with the reminder that success is only loaned to us for a short while. So, when playing or painting well, enjoy the experience! Now get out your equipment (painting, not golf!) and have a good workout with the knowledge gained so far. But never forget that it should be fun. We should always paint to enjoy ourselves.

I can't resist telling you a delightful story dear old Rowland Hilder, the doyen of English watercolorists for the last half century, related to me. Two artist friends met in the street and sat down for a chat. "Tom," the first artist said, "I'm so worried! The last painting I did was worse than the previous one, and that one was worse than the previous one, and so on."

"Well, George," Tom replied, "There's no cause for worry. Your painting's not getting worse...It's just that your taste is improving."

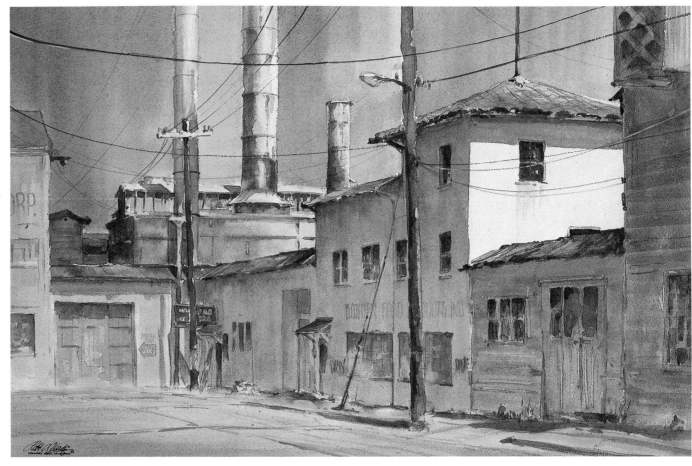

Cannery Row, Monterey (20x30). *California sunshine, but in early spring, so not quite as intense but enough to transform this old industrial site into a fascinating subject. A strong abstract theme of verticals runs through the design, and I've emphasized this by painting the sky in vertical strokes, too.*

It is possible to see reflected light in every shadow area, and the range is set by that wall which is bathed in full sunlight. I think that the wires play an important part in this painting, joining together the sky areas with their interesting shapes, don't you?

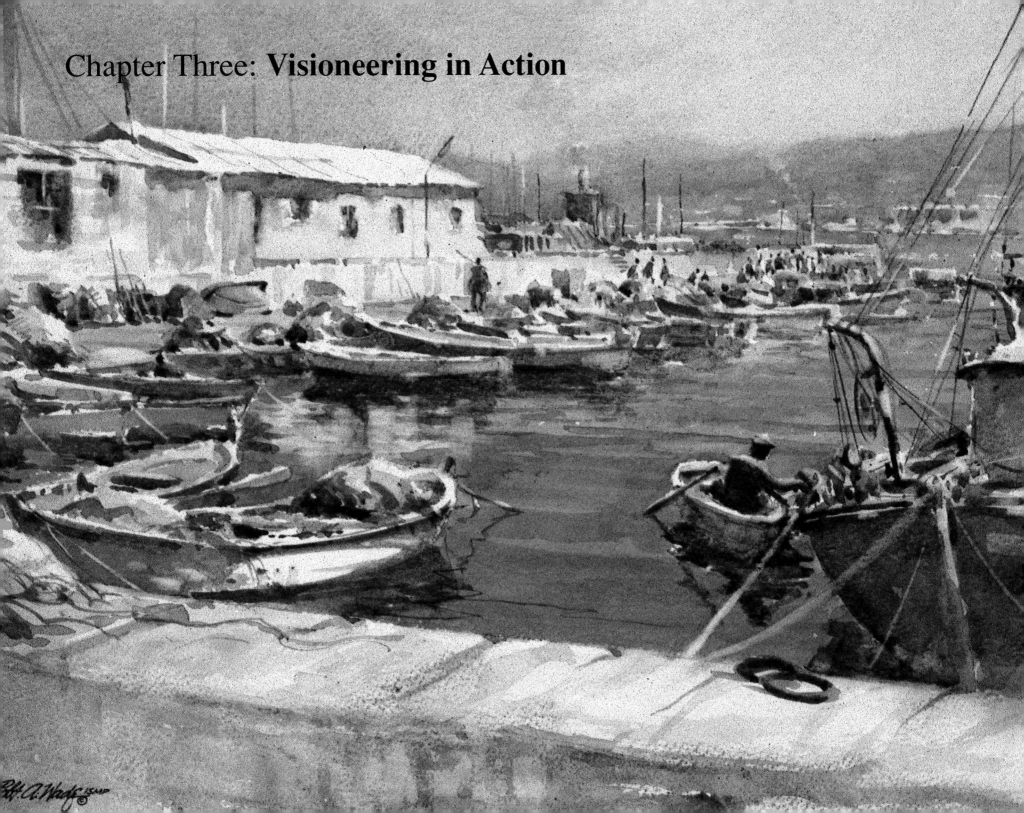

What's Visioneering?

How do I paint subjects in different ways, rather than as they appear? I call it visioneering. I just close my eyes and imagine how to portray the subject in various ways. At times it is obvious to me right away, but at other times I find that I have to work at it. I usually just start fiddling with these small 7x10's and let them happen as I go. It's playing the game by feel, really. If, for instance, I feel that a glaze of raw sienna, cobalt blue, rose madder genuine, or any other color might help, then I go right on in and try it. I might foul the whole thing up; on the other hand, I might make an exciting discovery! Whatever happens, I'm learning.

I might try a variety of papers, too. I might try a variety of textures as well—rough, hot pressed, cold pressed ("not"), or tinted. There's no way I can help you to decide which make or type of paper you should use for particular subjects—it's purely a personal feeling, like selecting the colors on your palette. My only guideline is not to use the same

I started with a close-up view and complementary colors. Very soft edges on the sailboat avoids conflict with the Opera House sails.

I reversed the values to silhouette the shapes against the sky and Sydney Harbor Bridge.

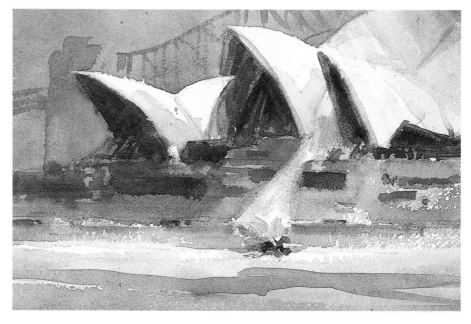

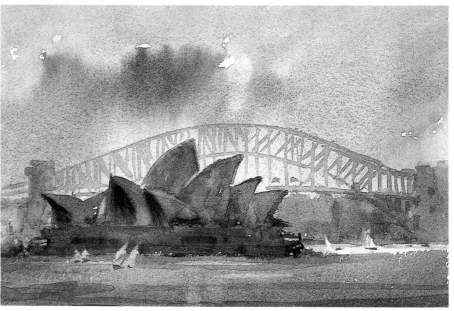

paper for too long. Keep a stock of assorted papers so that you don't become too comfortable with the one you prefer. I always feel there's a danger in becoming too confident with any materials or tools. You start taking things for granted, and it usually stops you from thinking creatively.

Here's a 7x10 series of the Sydney Opera House. These little sketches were painted on-site during a workshop, and I allowed myself about thirty minutes each. You can see how interesting and how easy it is to make a number of very different paintings from one subject. Remember, having the ability to imagine is where the artist differs from a camera, a passive recorder. So keep all your options open, then paint your own personal reaction to the scene to make your very own personal statement. You could go on forever interpreting light, time, color, season, and focal point just by becoming a visioneer.

I altered the time of day. Here is a weird sort of night effect. The lights were flicked in with gouache.

Although it's very bold with lots of contrast and good potential for developing later, it really isn't all that different from the rest. Maybe I'm getting stale, so I'll go home now...but it has been fun!

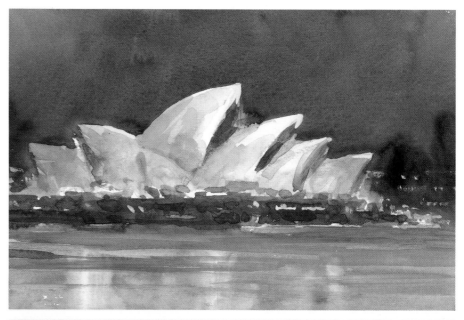

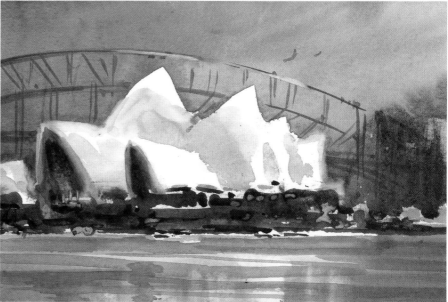

As Above, So Below

The light source that concerns us is the light of the sun. We'll now concentrate on what happens as a result of this light from above. I remember once reading a book that stated most definitely that "the sky must always be the lightest part of the painting." I certainly can't agree with that rule (remember I said I don't have any rules). Instead I'd like to interpret the statement as "Sometimes the sky is the lightest part." See how that rewording leaves our options open? This means, then, that we may make the sky the darkest part if we should so desire. To me, always keeping options open means freedom to exercise perceptive observation—seeing and painting things our own way in order to present our individual reaction to our subject.

Let's try some visioneering.

How about a village in the Greek Isles with white-washed walls, brilliant sunshine, blue skies? Would you make that sky the lightest? I'm sure I'd be making that very blue sky at least mid-value in order to play up the white shapes of the cottage walls.

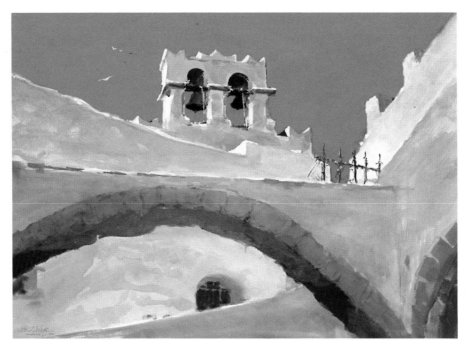

The Bells of Patmos, Greece (18x24). *I needed an intense mid-value Mediterranean sky to show off that super bell tower, so I used gouache to give the effect that the sky was so velvety thick you could cut into it with a knife. Visualize a light-value sky in its place, and you'll see that there just isn't enough contrast then to push the bell tower out as I want it.*

These arbitrary decisions can be made with ease while you're in the "visualizing mode," provided there are no inhibiting rules running through your mind as an impassable barrier to creative thinking.

The way you eventually treat your sky will have a powerful influence on your painting's mood and atmosphere, so you must be alert for any changes you'll need to make in other areas of the work in order to preserve the validity of your statement. Remember, what happens up there in the heavens must go on down here as well. This is very evident in seascapes. We've all seen amateurish attempts that completely ignore the sky conditions. Even though the dull sky has been painted with many clouds and the light is very diffuse, they'll paint the sea bright blue. You know the theory: grass and trees are green, skies and seas are blue, and so on....

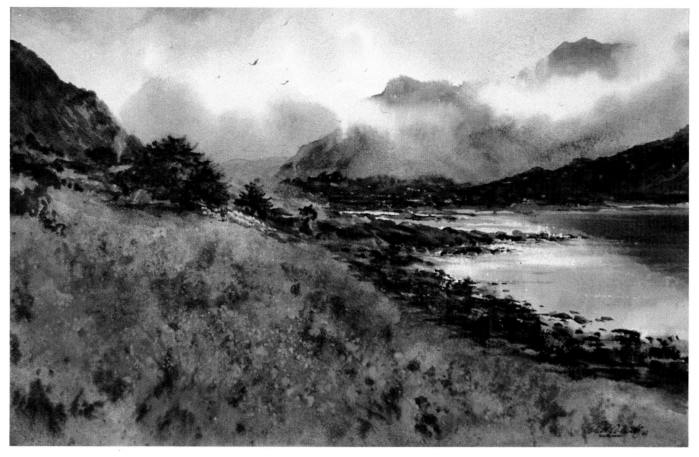

Just for fun, I want you to tune in your visualizing mode again and imagine a seascape with a purple sky. This sky would change the colors of the sea and all other areas into mauves and other purplish colors and, what's more, the painting would work because you maintained a good deal of truth. Similarly, had the sky been painted red, green, orange, or whatever, that color must be present right across the landscape or seascape. So another major truth emerges: The light and color of the sky exert the greatest influence on the light and color in the painting.

Knowing this, you now have the power to make limitless interpretations of your selected subject. If the sky is clear and full of bright light, then you have the options of an unlimited value and color range. If the sky is dull and cloudy, the value range and the color range will both be limited because the dull atmosphere neutralizes every color. Simply change the look of the actual sky and all the rest of the scene will fall into place.

Towards Ben Attow, Scotland (15x20). *I chose a very muted palette of French ultramarine blue, raw umber, and burnt sienna for this moody watercolor of the Highlands. Since French ultramarine and raw umber in combination produce a lovely granulation, I knew I could use this mix to good effect in the mountains and the rocky terrain. The three colors give a wide range of beautiful, subtle grays, and are ideal for a subject of this kind. However, after I had completed the watercolor, I wondered how I could make it give an immediate impression of Scotland. "Heather" was the obvious answer, so I sprayed water over the foreground and splashed some purple gouache around on the hillside. At once there was the feeling I'd been trying to capture.*

Designing Your Paintings with Color

You have endless possibilities for arriving at a very personal interpretation of your subject when you use light in conjunction with color. Again, I stress that our imagination and sensitive response to our subject is unique to each of us. One hundred artists fixed on a single spot would produce one hundred variations. Some would be so different that viewers of the finished results would wonder if the artists had really been at the same place! That's what is so fascinating about this art business. We all react so differently!

We can certainly learn from the study of better painters, but we must never try to mold our style around them, or we'd just become tame shadows of others. So if you've been strangling your development by trying to be someone you're not, forget it (even if it's me you're copying)! Have a look at yourself in the mirror, realize that you are unique, and from now on, "let it all hang out" and do it your own way. I paint my way for myself and nobody else! I paint a subject because I want to paint it; in fact, I'm usually bursting to get at it since in some way I've often been so mentally or spiritually excited by the subject.

So paint what you see the way you feel it. But always remember that we'd like people to look at the painting, even if the subject depicted doesn't stick to the facts, and say, "Yes, sir! I sure have been there!" What does all this have to do with designing with color? Let's take an example.

Polperro, Cornwall, is an enchanting old smugglers' village, almost untouched by today. I remember the screech of the gulls as they swooped through the inaccessible cove and over the narrow lanes and streets. A smell of coal fires pervaded the air, waves crashed on the rocks at the entrance to the cove, and a keen wind off the sea made us draw our coats around us for warmth! Do you get a feeling from my word-picture? That's what I wanted to evoke in my painting.

Now look at it. The atmosphere here is basically gray, except for rare days of sunshine, so the exquisite grays produced from cobalt blue and burnt sienna are admirably suited to this subject. As the overall effect was cool, the blue was the dominant partner, varying in intensity to give a warmer or cooler gray. Do you think this painting would have worked had the burnt sienna been dominant? I don't think it would, as all the grays would have been warm—and that's not the feeling of Polperro.

Polperro, Cornwall (15x20).
PROBLEM: What's the least number of colors I can work with in a painting? SOLUTION: Would you believe a two-color palette? Two colors is the absolute minimum, unless you want a monochrome. For this class demonstration I restricted myself to cobalt blue and burnt sienna, probably to astonish the disbelievers. I'm happy that this palette worked for me. Otherwise my class would never have believed anything else I told them! Because the values have been closely observed and maintained, even this extremely restricted combination of colors works to convey the atmosphere of this village almost untouched by today. The blue was the dominant partner because the overall effect was cool. Making burnt sienna dominant would have cast Polperro in warm gray overtones, which wasn't the feeling at all.

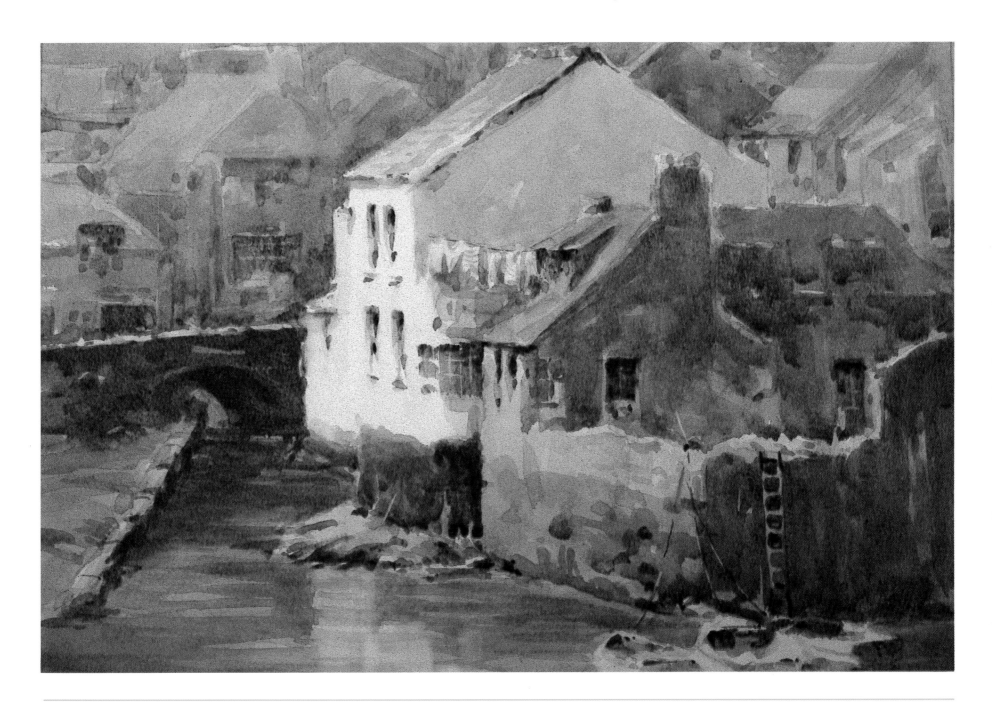

Choosing Colors

Think about your subject and what you want to say, then select the colors that will allow you to say it. Like everything we do in watercolor, it must be thought out first. It's not necessary to have thirty colors to paint an interesting picture, you know. When too many colors are used, color unity is often lacking. When you work with a limited number of colors, your colors are automatically harmonious since they all get combined with each other creating that color unity. Try a limited palette yourself. You'll probably be surprised and delighted by the purity of your washes and the simplicity of the finished watercolor. A limited palette will force you to work only with what you have—like living within your means. Though at times it may seem too restrictive, most times it pushes you into being more thoughtful and creative.

I always use a limited palette when I paint. The colors I use most are cobalt blue, French ultramarine blue, alizarin crimson, light red, vermilion, rose madder genuine, aureolin, raw

sienna, raw umber, and burnt sienna. These are my "Top Ten," though I probably wouldn't use more than six in a painting. It's amazing how many variations can be derived from a few basic colors. If you can discipline yourself to give up all the manufacturers' fancy colors and begin to mix greens, purples, oranges, and grays yourself from just a few colors, you'll see an immediate improvement in the quality of your work.

Simplify your palette so you can get to know the colors you've selected. Your palette is personal, and you must select your own colors from experience, but to begin with don't pick more than eight. The best approach is to start by using just three colors. The three primary colors—red, yellow, and blue—will produce a very satisfactory watercolor! Using only three, getting to know them thoroughly, finding how to mix them together to obtain cool or warm grays, and discovering how they react with each other, will prove to be an invaluable exercise.

I can hear you saying, "I don't

A dull London day, but look what artists can do to create their own conditions!

know which three to choose. Is there a formula to assist me?" Many combinations will give a good result, but a pleasing starting combination could be raw sienna (yellow), burnt sienna (red), and cobalt blue (blue, of course). This trio will stop you from getting too dark, and as they are all quite transparent, they'll help prevent "mud." (Mud is caused by mixing too many pigments in a wash, by mixing earth colors together, or by going back into a wash too many times.)

You might also try a very transparent trio—aureolin yellow, rose madder genuine, and phthalocyanine blue. It's almost impossible to make mud with these, but it's also difficult to obtain a satisfactory dark. Some colors, such as yellow ochre, burnt umber, cerulean blue, and light red are slightly opaque and need to be handled with great care. Never mix them together, unless you need a small area of opaque color. Once you experiment, you'll soon discover which colors will give you the color range you are seeking.

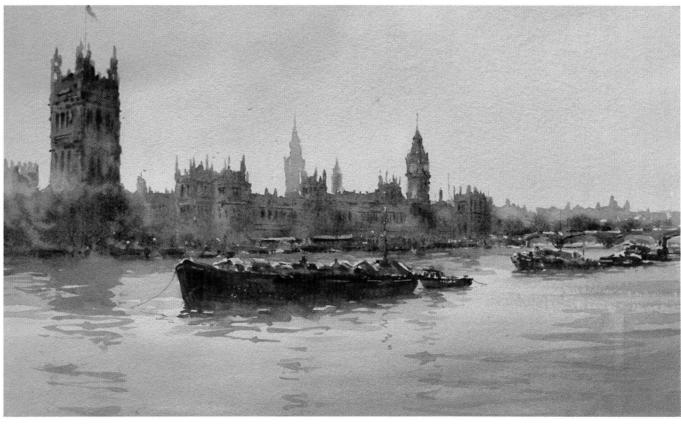

Westminster (15x20).
PROBLEM: My colors look as tired and boring as this weather. How can I freshen them up?
SOLUTION: Try mixing washes using just two—at the very most, three—colors. Suddenly you'll notice that the white paper is shining through again, restoring life and sparkle to your watercolors. Here I've used a limited palette with washes of cobalt blue with cerulean, blended with aureolin and rose madder genuine for sky and water, with more pigment added for the foreground. There's very little detail in the painting, just big shapes. Maybe "Old Father Thames" has never looked so clean, but I hope you'll agree that it's a more interesting result than the way it looked that day!

For *The Telegraph Station, Alice Springs*, I chose cobalt blue, raw sienna, and light red. Why these colors? Cobalt blue is one of the purest blues, useful in creating atmospheric effects, and mixes superbly with all other colors. (It's the most used color on my own palette.) Raw sienna is a beautifully transparent, grayed yellow. I much prefer it to yellow ochre which tends towards the opaque side, encouraging mud. Light red is another handy color. It is slightly opaque and requires care in mixing, but it combines well with most colors and is useful when you need a bit of body in a mix.

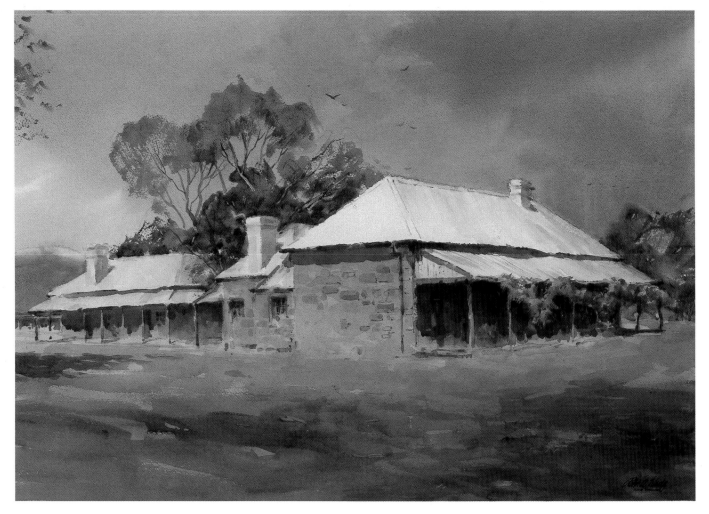

The Telegraph Station, Alice Springs (20x30).

PROBLEM: But what if I have a full value range and need a lot of different colors, especially grays? Can I really do that with only three colors?

SOLUTION: To render the clear, bright Central Australian light and the intense pure color that abounds in this region for this class demonstration, my palette was only three colors—cobalt blue, raw sienna, and light red. It's hard to believe so many subtle grays can be obtained from so few basic colors. I don't think I could have improved this one much even if I'd added a hundred colors to my palette. I hope you're ready to try a limited palette now yourself. Think about your subject and what you want to say, then select the three colors that will allow you to say it!

Textures

In most painting subjects there will be textured areas of some kind which will add interest, variety, and validity to the work. Textures are a lot of fun to do, but unless your subject is specifically about textures, don't become entranced with them to the detriment of your original concept. As supporting actors, textures are great, but you don't want them to win the Academy Award at the expense of your star. So keep reminding yourself what the most important part of your painting is and why you want to paint it.

Corrugations of tires on a dirt road, rusty iron roofing, old stonework and masonry, foliage and bark of trees, and so on, can add interest and charm, but only on rare occasions will they become the major interest in your work. Consequently, they really need to be treated quite broadly, and suggested rather than spelled out in minute detail. In most cases, it's better to indicate texture on the edges of shapes than to go into detailed rendering within the shape.

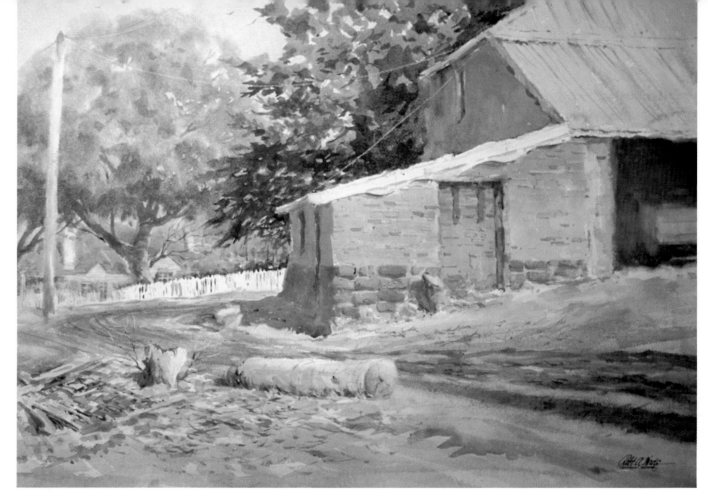

Muntham Barn, Casterton, Victoria (20x30).
PROBLEM: Such a variety of textures: brick and stonework, foliage, picket fence, logs and chips, iron roof, and dirt road. There's a bit of everything here but the kitchen sink. How do we handle all this?
SOLUTION: It's not easy to decide what to include and what to leave out. But the most important thing is never to lose sight of our principal interest, the barn *(reputed to be the first brick building ever erected in my home state, this fine barn is situated on my brother-in-law's property). So we'll only indicate all those lovely textures so they complement but don't compete with our center of interest. Note the variety of soft and hard edges. Those lovely, strong reflected lights on the walls in shadow grab the eye like magnets. I wish all my class demonstrations worked as well as this.*

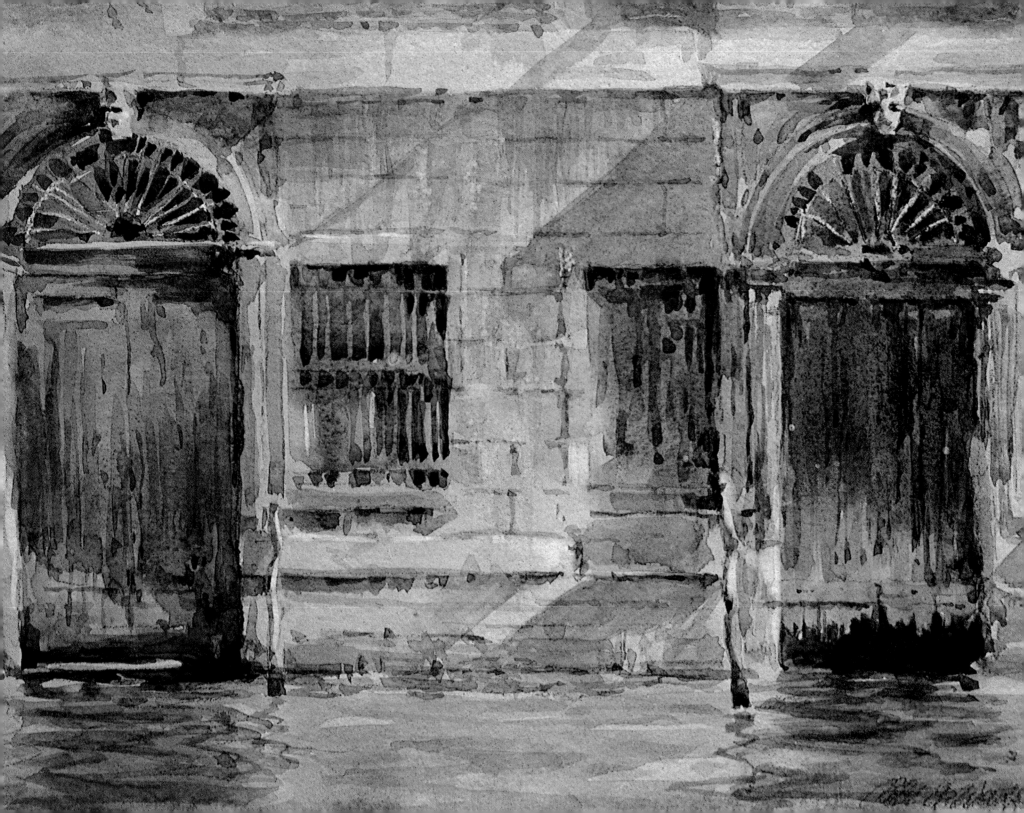

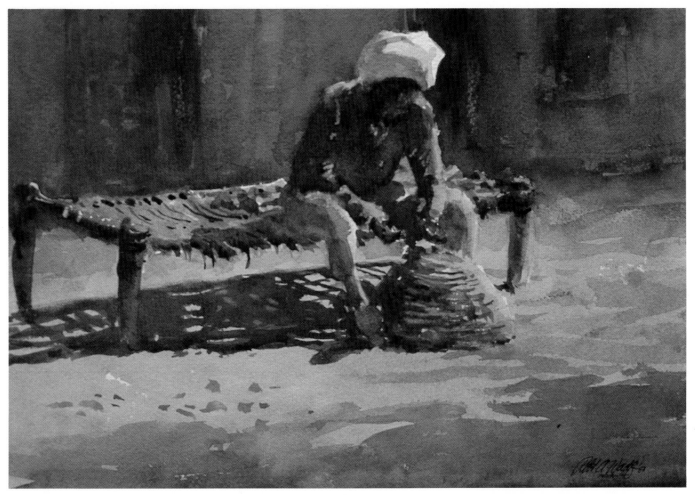

You'll be surprised just how few well-placed brushstrokes are needed to give a credible interpretation of some of the most complex areas of texture. It's the sleight-of-hand again. The audience believes that it's all very complicated and exact, whereas in fact it's the essence of the subject that makes it appear that way.

Here's a good exercise on textures for you to try right now. Line up a dozen or so of your paintings, step back, then critique them. Ask yourself:
• How many textures have I indicated?
• How many are convincing? Why?
• How many are overworked?
• Where is the center of interest?
• In the light of our discussion about textures, how would I handle this painting now?

Weathered Doorways, Venice (11x14). *I just loved these two weathered doors and their surroundings. I covered the entire surface of my paper with a pale wash of aureolin and rose madder genuine. When that had completely dried, I covered that wash with a glaze of pale cobalt blue and burnt sienna. The warm underpainting gave a lovely glow to this cool gray glaze, establish-ing a velvety feel before I even began the subject. The brushwork required great delicacy of touch in order not to lift those two underwashes. Study the textures closely and discover how they are suggested broadly.*

The Charpoi, India (10x14).
PROBLEM: Is there a simple way to convey textures?
SOLUTION: Usually it's best to try to show textures on the edges of objects. Look at the charpoi (sofa) made of bamboo and woven raffia. See the rough dark bits hanging down from the edge, and also the sun holes in the cast shadow? You won't find much detail anywhere else.

Opaque Watercolor

So far I have been discussing transparent watercolor. Now I would like to devote a small section to opaque watercolor or gouache. Gouache is available in a full range of tube colors from most manufacturers. You can also transform transparent watercolor into gouache by adding Chinese white to it.

Gouache can be used as a medium in its own right or to render aid to an ailing subject. When a watercolor goes off the rails and the result of some hours of work lies before you with no joy in the result, think very carefully before you give up all hope and tear it to shreds. Quitting is the greatest failure of all. It means you have totally failed to assess why you went wrong. Instead, look critically at your work, maybe putting it aside for a while until you can be more objective.

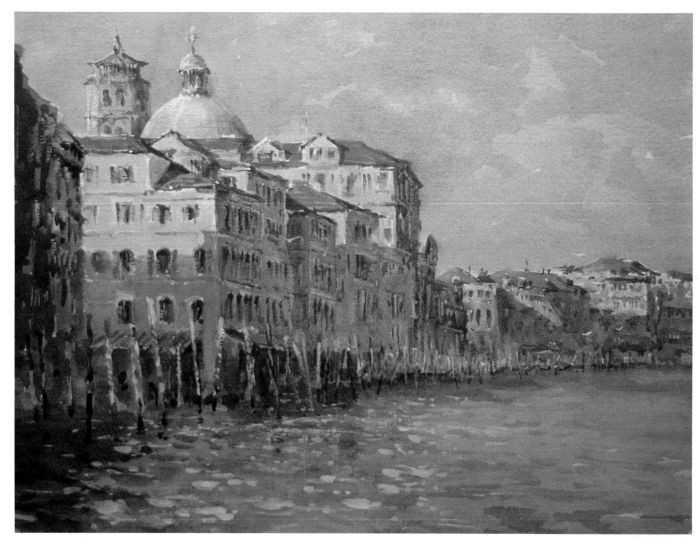

The Grand Canal (14x17).
PROBLEM: My watercolor started out great, but now it looks dead and boring. Can I do anything to save it?
SOLUTION: Disappointed because my small on-site sketch had been a real little gem, I stuck this watercolor away from sight in my drawer. A couple of weeks later, I pulled it out again, and realized at once that my reflections were too dull, so I plonked down some gouache into the dark areas, and Hallelujah! it worked right away.

When you really analyze your work, you should have little difficulty recognizing the source of your problem. When you've located the error, you may be able to correct it by washing out the area with a natural sponge, or rubbing it out with a piece of steel wool or sandpaper, or by overpainting it with gouache. You could also try working over the area with pastel, colored pencil, or another medium. The purist may recoil in horror at that statement, but even an artist like Turner—considered by many to be the greatest of all time— scratched, scraped, and used any means or medium at hand to achieve his desired result. So why can't we do it, too? I don't believe that anyone has the right to ask how a result was brought about; they should only ask why.

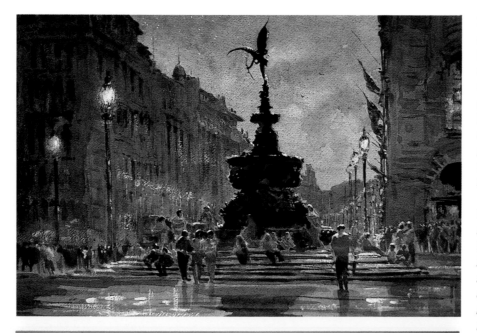

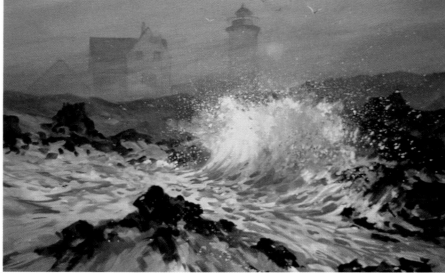

Eros, London (15x20). *I tried for an evening effect, as I always seemed to be in Piccadilly at that time. The only way I could get a sparkle on the lights of the street lamps was to scumble some gouache around them using an old, hard-bristled oil fitch. It was then apparent that I'd also have to use gouache highlights on my figures, so that I didn't isolate areas of a different medium.*

Nubble Light (20x30). *There have been many paintings of this famous American landmark, including one by Edward Hopper, and it certainly is a dramatic sight. I felt that if I could paint it half-enshrouded in fog then it would be even more so. However the foreground rocks looked shocking the way I painted them! I then used gouache to invent a rough sea, creating a good deal of movement against the simplicity of the top part of the painting.*

Is a painting any less accept-able because you've used another medium to help pull it off? I don't believe it is. Sometimes a very exciting painting may come about because you've exercised your skill and right as an artist to make the decision to use another medium that has brought about a successful result! In any case, I want you to try gouache for yourself. It's a lovely medium in its own right, and a pleasure to use.

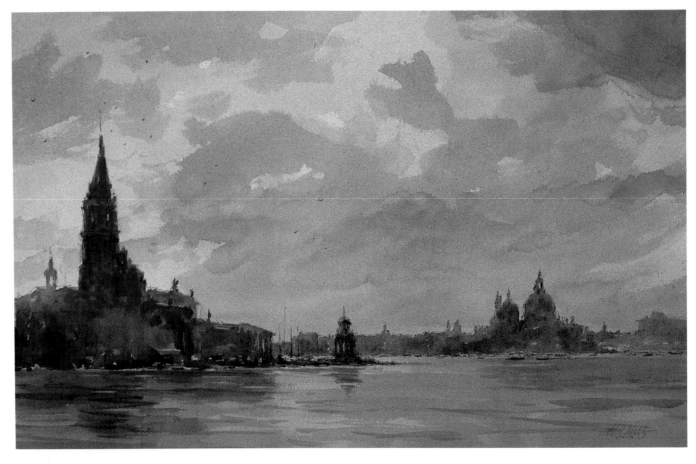

Venetian Skies—First Attempt (15x20). *PROBLEM: This started out as a normal transparent watercolor, but somewhere along the way I lost what I tried to do.*

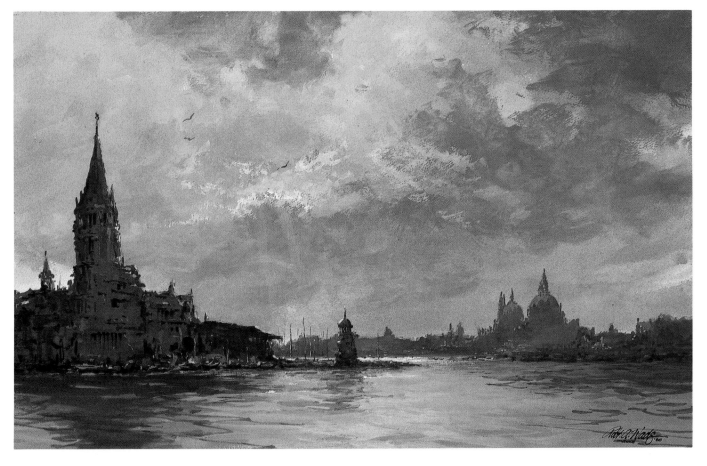

Venetian Skies—Finished Painting (15x20).

SOLUTION: After deciding to overpaint the sky in gouache, things got back to where I wanted them. I'd captured the Venetian light, but it was now a hotchpotch. What I needed now was to overpaint the rest in gouache, too. Then it all worked; instead of a rip-up, it turned out to be a ripper!

Same Subject, Three Ways

Now, I want to show you one subject and how it can be varied. Color can create many different moods and effects, and emphasis can be shifted to suit your individual interpretation of your subject. I've selected a couple of Thames barges for this exercise. They make wonderful subjects. I only wish I could have been around the Thames when they sailed up and down constantly. Long replaced in the work force, they now have to be hunted out by artists. Thankfully there are a number of enthusiasts who have formed Thames barge clubs and sail their lovingly restored craft for pleasure. They are to be found in estuaries around the English coast, particularly in the area from Essex to Norfolk. Go to Pin Mill to find some of the best.

Have you ever tried to invent a variety of effects from one subject? It's fun and a real challenge to your creativity. It could be another solution for you if your work has become tired and predictable lately.

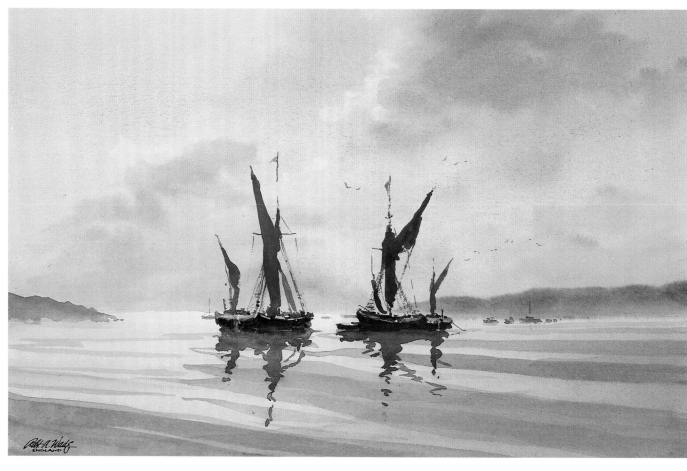

Red Sails (15x20). *Two barges at rest with equal attention given to both vessels. My palette is aureolin yellow, rose madder genuine, and phthalocyanine blue. These are probably the most transparent pigments of all. I wanted to create the quiet, peaceful feeling of watching the sunset, so I decided to give the whole scene a gentle, golden glow. I began by putting a pale wash of aureolin, plus a touch of rose madder genuine, over most of the paper. Because the pigments are so transparent, they allow the paper to sparkle through the wash, one of the intrinsic charms of the watercolor medium. The sails were painted in one hit, when the underwash was quite dry, with a stiff mix of the three pigments. One hit ensured that the darks would be clean and there would be a feel of light coming through the sails. The boats have been painted directly to keep things as simple as possible.*

Barge Nocturne (11x15). *Here are the same boats, but this time I've shifted emphasis to the boat on the right-hand side. I've chosen a tinted paper, "Turner gray," which is a pale blue-green. The effect of tinted paper shining through the washes gives unity to a painting and is helpful in creating a mood. Since the feeling of the paper suggested early evening, I finished it off by putting a couple of daubs of opaque gouache to indicate lights on the dominant vessel. I used just two colors—cobalt blue and burnt sienna, plus gouache for the lights—and it has resulted in a pleasant, restful sketch. When you first look at the paper you'd think that all of your colors would need to be much more intense on that substrate, but that's not really the case. You could get the same effect by putting down a wash of similar color over the entire background of your usual watercolor paper; but then you'd be faced with the problem of putting down further washes on top of the original one without disturbing and lifting it in the process.*

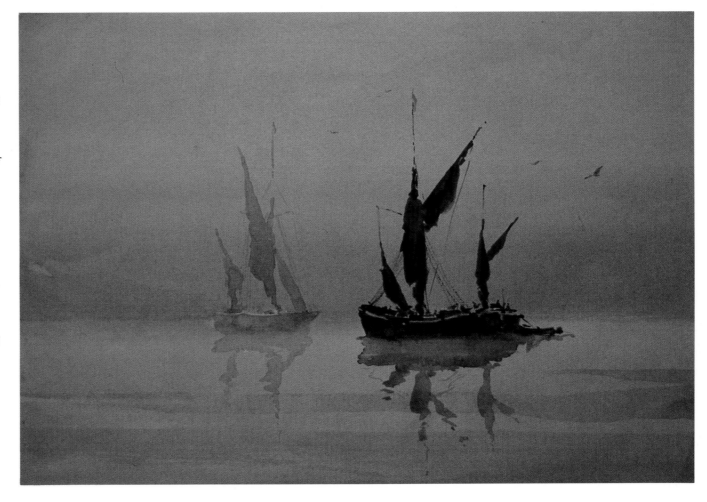

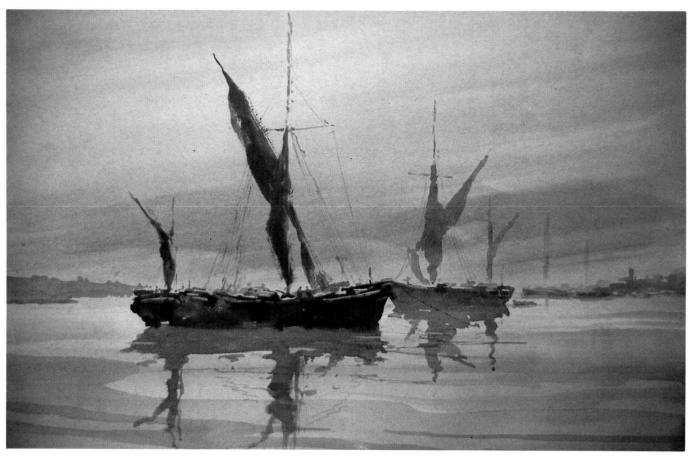

Key Thoughts

Join the "Visioneering Club." You need only close your eyes to dream up your very own vision of any subject.

• Do it your way. Use the subject and the light to create your individual interpretation.

• Use color to interpret your reactions to the scene. For example, if it's happy and exciting, use bright colors; if it's soft and gentle, use muted colors.

• If the sky is present in your painting, its color must influence all other parts of the painting.

• Don't overdo textures until your painting becomes just a technical exercise. Don't lose sight of your original reason for doing the painting.

Misty Grays (11x15). *Here are my favorite boats once more. I've used just French ultramarine and raw umber, shifting the emphasis this time to the boat on the left. The variety of warm and cool grays created by the washes in the sky and water create a rather mysterious air. I'm using a tinted stock called "De Wint"—an oatmeal, sandy-colored paper, a little like that wonderful old David Cox paper, which hasn't been manufactured since the late 1950s, much to my sorrow. (I still have about six sheets I've been saving for thirty years. I want to do something special on them, but I suppose I never will!) Go back to the first painting in the series again, and then look at all three. Each one is entirely different in concept of color and the point of interest but all came from the one subject.*

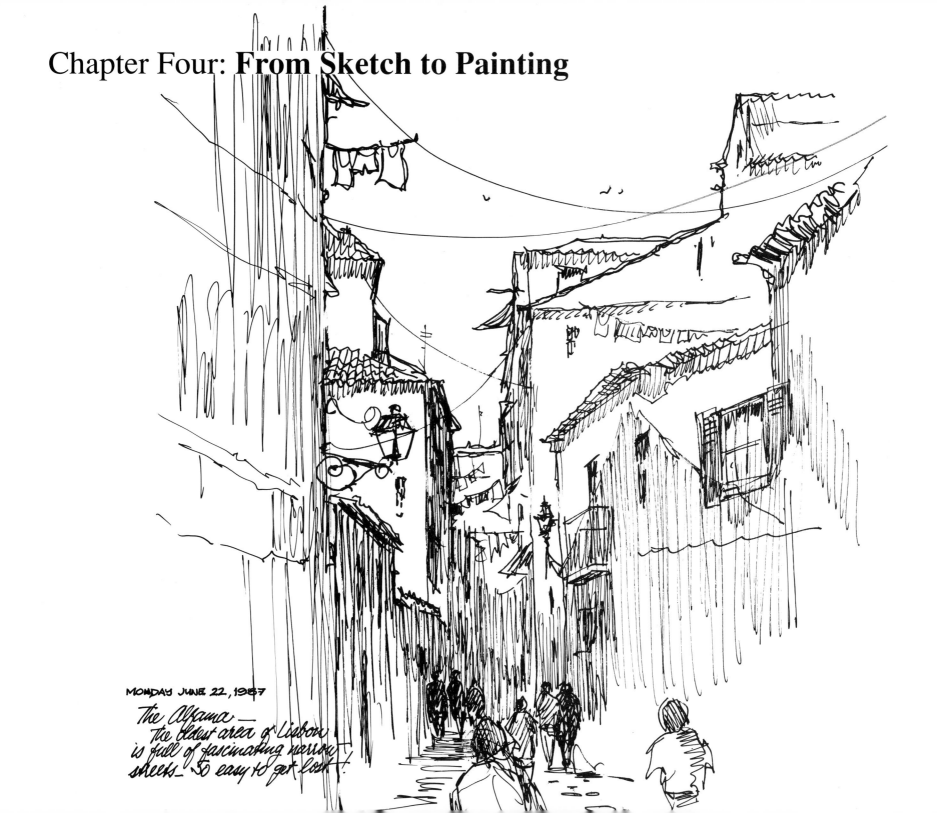

MONDAY JUNE 22, 1987

The Alfama —
the oldest area of Lisbon
is full of fascinating narrow
streets — so easy to get lost!

Drawing is Fun

Why is there so much disregard for drawing skills with pen and pencil? I think it stems from our early days at school. Pencil drawing was all very tedious: cubes, rhomboids, cones, and an occasional plaster cast or spray of leaves. In a word—boring! That's how it felt to us eight-or-nine-year-olds, and after all these years, that's probably how most people still consider drawing—boring!

Now I want to correct that old impression that drawing is boring. Drawing is fun! A pencil, felt pen, or fountain pen and a sketchbook can be carried at all times. I have carried my small 6x4 sketchbook in my hip pocket to places like Egypt, Jerusalem, India, and Nepal, and have been able to work away without being noticed. As a matter of fact, I've discovered that most people are rather flattered to be drawn, though the sight of a camera focused on them is something else!

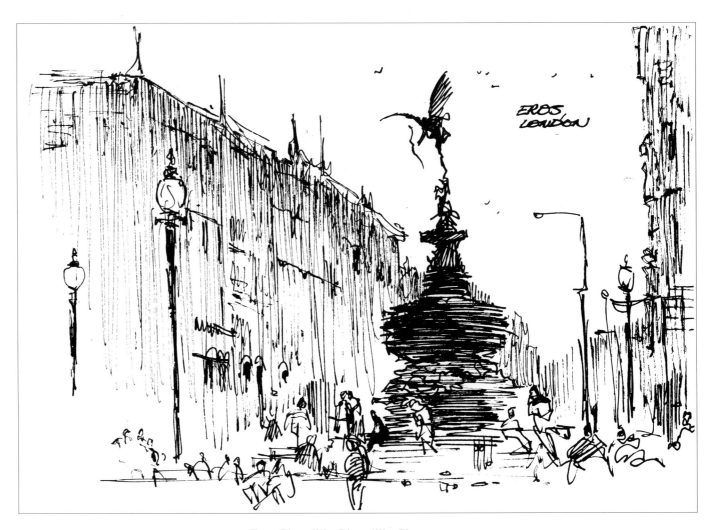

Eros, Piccadilly, Piccadilly Circus ($6^{1}/_{2}$x$9^{1}/_{4}$). *I did this in my sketchbook with a felt pen. Notice how the figures are conveyed by only a few quick squiggles. It's rather an historic sketch as the statue has now been moved a short way from this site.*

On one occasion in Katmandu, Nepal, I took out my small sketchbook and began to sketch the local people as they went about their business. I was totally fascinated, oblivious to time and all else except the job of recording these colorful people. Suddenly I became aware of a small Nepalese boy at my left elbow, another at my right, then several more. Within a matter of minutes, I guess there were close on a hundred of the cutest kids you'd ever see watching my every move! They spoke not one word of English, I spoke not a smidgen of Nepalese, but we all understood each other perfectly through the international language of art. One of the little boys quickly caught on to the sort of subjects I was seeking, reached up (I'm six-foot two, and most of these kids were about three feet tall) and gently tapped my arm, pointing to an old man hobbling up the street, drawing with his index finger on the palm of his hand. As I finished that and other rapid sketches, I would hold it up over my head for them to inspect, which usually resulted in hand-clapping and laughter. Isn't wonderful that we all laugh in the same language? It was such fun for me...an experience I'll treasure all my life.

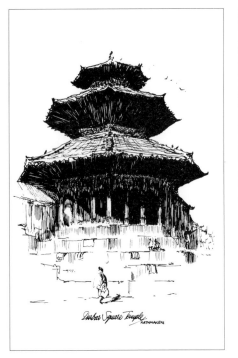

Durbar Square Temple, Katmandu (9x6¹/₂). *I did this sketch with Rapidograph pens. I wanted to produce some screen prints of this scene for my fellow travelers, so I made a quick on-site sketch and finished the drawing back home.*

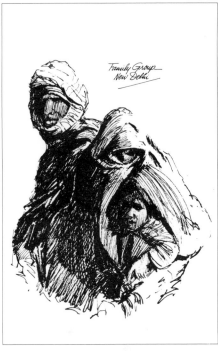

Family Group, New Delhi (9x6¹/₂). *Although I've seldom had anyone object to my sketching them, I always try to work quickly to disturb them as little as possible. Here I just "put down the bones" of the sketch and finished it later at home.*

Good Drawing is Essential

Students often tell me, "I don't draw very well, but I'm really a painter. So it doesn't matter, does it?" Yes, it does matter! If you expected me to give you an "out," bad luck, my friend. You've asked the wrong guy. In all my lectures, demonstrations, and workshops, I always stress that good drawing is the solution to many painting problems. And the only way to improve your drawing is to keep on drawing, and the better you draw the better you'll paint because, when all is said and done, painting is drawing with a brush.

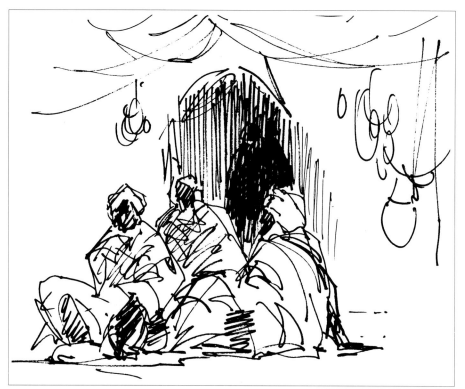

The Bazaar, India (6½x7). *Sketchbook drawing with nylon-tipped pen of the wonderful sprawling shapes in Agra.*

In the Nepalese Market (5¼x10). *Sketchbook drawing with nylon-tipped pen. I drew only the foreground figures when I was there. I drew the seated figures and the background later from memory.*

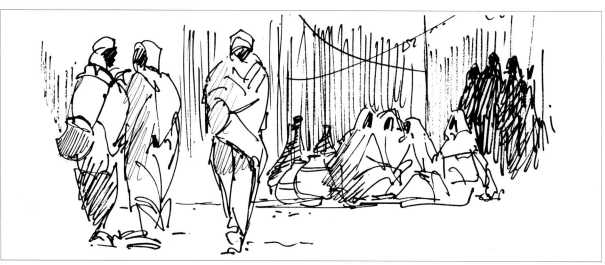

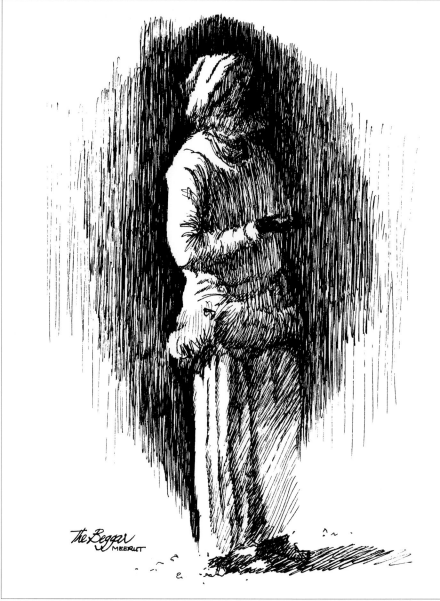

The Beggar, Meerut (9x6¹/₂). *Highly finished drawings can be very satisfying in themselves. This one, meant for reproduction by screenprinting, is effective because I've applied perceptive observation to it. The pattern of* *highlights gives the sketch its punch. There's strong contrast between the dark background and the highlighted side of the figure, less contrast between the shadowy side of the figure and the background.*

Even if you do want to alter reality, you need to draw accurately and with some degree of confidence in the initial stages of your picture. This is particularly true in transparent watercolor where you have only one chance of pulling it off. In oils and other media it is usually possible to correct mistakes without too much worry, so you may get away with a second or third chance. But watercolor? Seldom can you correct badly-drawn areas without that alteration standing out like a country bus stop! With years of experience you'll be able to salvage a painting by sponging out areas like skies and foregrounds, correcting it with gouache, rubbing off errors with sandpaper or steel wool, or applying other methods of emergency resuscitation. However, even if you're successful in your first aid (or even major surgery), you'll always feel in your own mind that somehow or other everyone can see how you cheated on that job.

I believe that, with dedication, anyone can learn basic drawing—even if you think you don't have any natural ability. We can't expect to turn into Da Vincis, of course, but I never knew anyone who was totally hopeless and devoid of any ability whatsoever. So we can expect that reasonable competence may be achieved through practice and observation. Besides, even the most talented and naturally gifted artists must work at their drawing constantly.

And if you think you're too busy at this stage of life to learn, that's okay. Just give up painting right now, because you are never going to improve. On the other hand, if you're really sincere in your desire to grow in art, then you'll find the time to foster your drawing skills. Don't tell me that you can't find at least five minutes every day that could be used to very good effect with pencil and paper. In life you can find time for lots of things if you want to do them badly enough.

Practice, Practice, Practice

Whether you live in Great Falls, Montana, U.S.A.; Stow-on-the-Wold, Gloucestershire, England; or Wooloomooloo, New South Wales, Australia, there will be enough subject matter on your own front doorsteps to keep you drawing for the rest of your lives. You can doodle while you're on the phone (you should see my desk pad!) or watching TV. Sketch the kids, the dog, the cat, Grandma's hat, or the objects in the kitchen. Never mind the subject—keep on drawing. Catch the sketchbook habit—you'll really enjoy it—and watch your paintings improve!

And if you don't think they're good enough to show to others, don't show them. After all, would you let other people read your "Dear Diary" entries? No? Well, what's the difference? Your little sketches are your "Art Diary" entries, so do them for your eyes alone. Keeping them purely personal and not worrying about what others will think of them (and who cares anyhow?) will free you of some of your inhibitions.

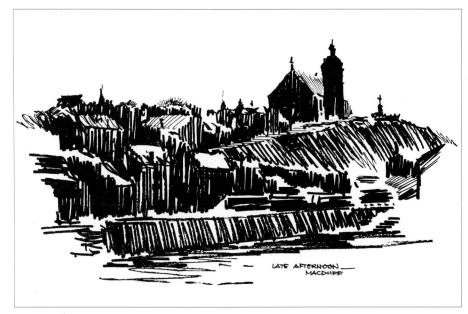

Late Afternoon, Macduff, Scotland (6x9½). *Sketch with felt pen. Here my concern was to get down the pattern of light and dark, plus all the interesting angles.*

If you're worried about fitting your entire drawing on the page, you're not alone. Lots of people seem to run out of room. An easy cure is to use the "invisible pencil" trick to lay out the subject before starting to draw. Simply turn the pencil point end up and use the unsharpened end to indicate roughly where the shapes will fit on the page. Once you determine that it fits, reverse the pencil and start drawing. If you're still not completely sure, just mark a dot where the shapes are to be drawn so that there is a visible guide to assist you.

If you're on location and don't have time to draw much detail or get any shading or finish into the sketch, don't even attempt to make a finished rendering. Just get the bones of it down. Try to capture the essence and the gesture. While traveling, I put finishing touches on my sketches while waiting for planes, buses, and trains, or in the hotel room at night, working either from memory or inventing detail. Once again, this takes years of practice—so the sooner you get started, the sooner you'll become proficient in this joyous activity.

Contour drawing is particularly helpful if you're a beginner. Just pretend your drawing instrument is resting on the outline of your subject, and trace it out on your paper as your eye travels around the edges of the shape. Ideally, the point should not be removed from the paper as it traverses slowly around the subject, forcing you to make connections and helping to unify the composition.

Above all, don't forget— drawing is great fun!

Brownstone, Soho, New York City (10^1/$_4$ x 7^1/$_2$). *Sketchbook "diary" drawing with Edding Profipens. This subject says "New York" as soon as you see it—and I just had to draw it.*

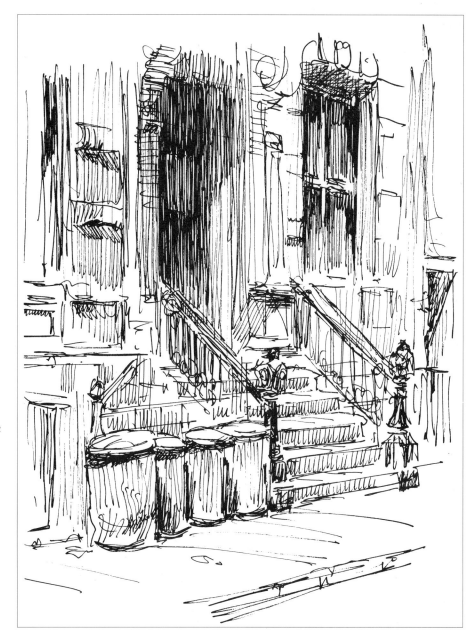

Information, Please

To translate a sketch into a finished painting, you'll need to have enough information in your sketch to work from. This is why photography is such a great aid. Whenever possible I back up my sketch with several 35mm slides I can refer to later if needed. (I just can't work from photographs; they're very inhibiting. That small image seems to encourage small thinking and niggling brushstrokes.) I don't use the slides for color reference because I usually prefer to invent my own colors and lighting conditions. But for accurate architectural details and such I find them invaluable.

I project my slides on the wall so they fill six feet by four feet or larger, recapturing the feeling of actually being there. Then I can recall exactly how it felt, how it smelt, the bite of the breeze, the screech of the gulls, and the sighing of the wind through the trees. In other words, it gives a total awareness of the reason I felt compelled to record that particular subject.

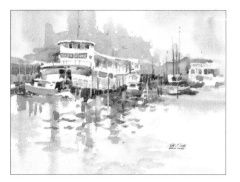

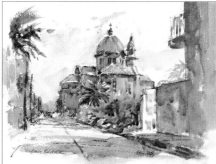

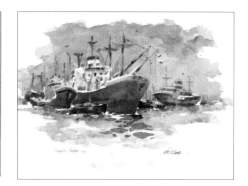

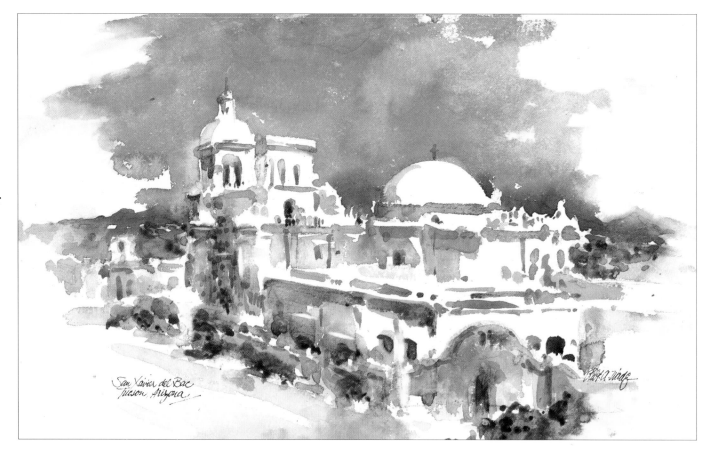

San Xavier del Bac
Tucson Arizona

Goolwa, South Australia

Manila Cathedral

Singapore Harbor

San Xavier del Bac, Tucson, Arizona

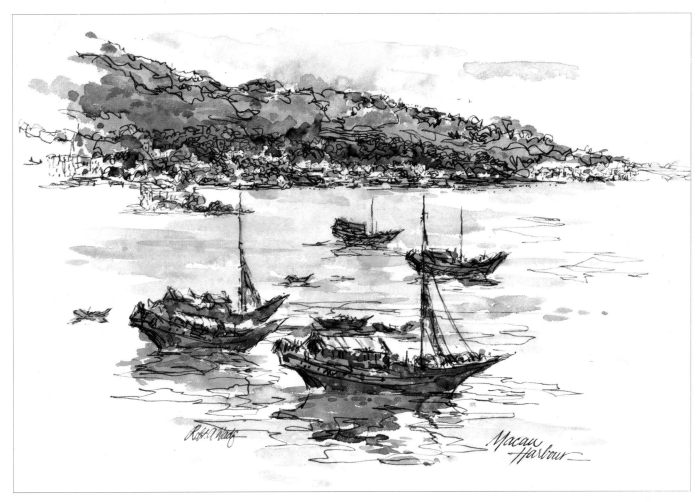

Macao Harbor

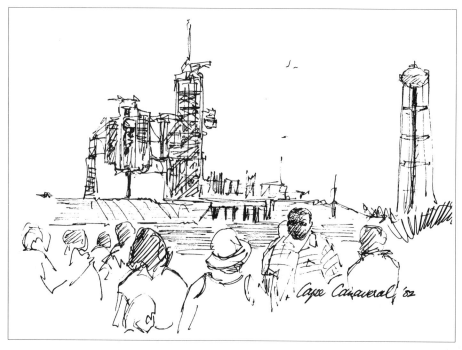

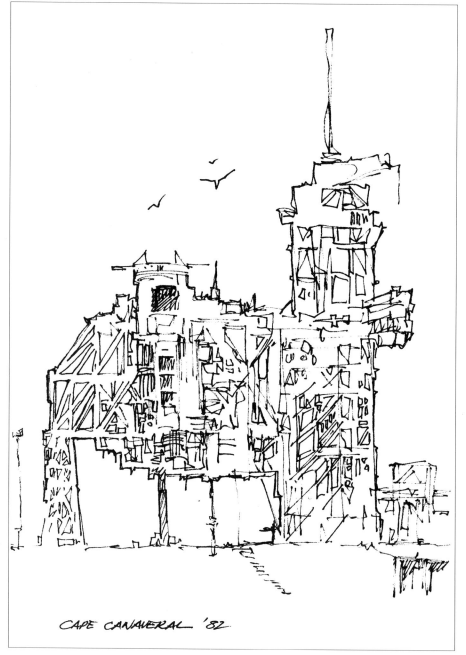

I began my painting of the launching pad at Cape Canaveral with a quick pen sketch of the scene, "getting the bones" down—just enough to be able to expand on it later. Since I was on a tour, I didn't think I'd have the time for anything more, although I would have my slides for reference, too.

I found I had about ten more minutes before our bus departed and began this more detailed contour drawing. I finished it while traveling back to Orlando on the bus.

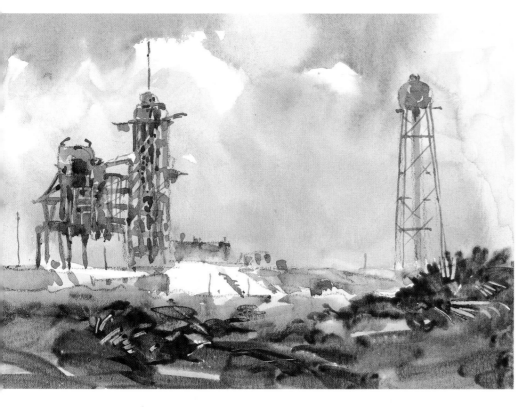

In my hotel room that night I painted the quick watercolor sketch just to get something down while it was all fresh in my mind.

Some years ago en route to Mexico, we were staying in Orlando, Florida, visiting Disney World with my 23-year-old son, who lives in New York. (Talk about three big kids!) My wife, Ann, suggested that we should visit Cape Canaveral, since it was only about an hour's drive from Orlando. Peter and I really aren't into that space or science fiction scene, so we voted against the trip. However, Ann thought that we should go and, as the vote was two to one against the motion, we went! (We're nothing if not democratic in our camp!)

I decided not to go with a negative outlook, but to look at it with an artist's eye—in other words, with perceptive observation. And, in fact, I did find it very exciting. When I saw the launching pad of the Columbia Shuttle, it instantly struck a chord with me. The vertical thrust of the tower, rising from the surrounding scrub, seemed to symbolize man's reaching out for the heavens, and the contrast between the scaffolding and the scruffy growth below pointed up the difference between the artificial and the natural growth from the Earth.

I had to draw rapidly since we were on a conducted tour. In this case I was only getting the bones down, recording just enough knowledge to be able to expand on it later. I made a quick pen sketch then, and as I still had about ten minutes before our bus departed, I began a more involved contour drawing. I completed it from memory while traveling back to Orlando on the bus.

That night in my hotel room, I painted a quick watercolor sketch just to keep my act together while it was still all fresh in my mind. Finally, back in Australia some months later, I painted a half-sheet watercolor, *Launching Pad, Cape Canaveral* with all this information on hand, needing my slides only for structural detail. It had been almost cloudless on our visit to the base, but I painted a sky with some character—one that would be evocative of the billowing masses of smoke from a blast-off. I also added the puddle of water so I could put in a reflection of the tower to echo and emphasize the tower's vertical thrust.

The watercolor won a major award from the Royal Institute of Painters in Watercolours, London, in 1983—so this was a case of "Mother knows best"!

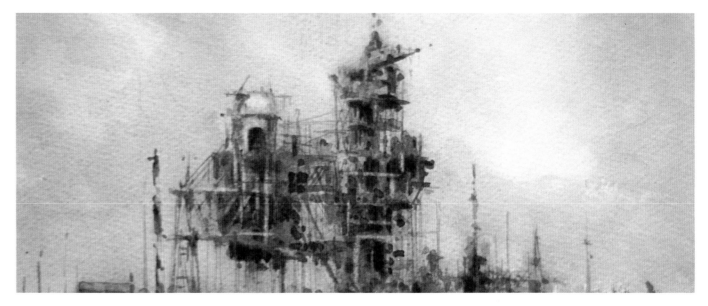

Detail of The Launching Pad, Cape Canaveral. *The impression of involved scaffolding and tower is handled very broadly. I've simply made a checkerboard pattern of contrasting dark-light, warm-cool areas, lost some edges with a blur, found some edges with crisp brush lines, and generally had a very happy time with my rigger! This is your basic confidence trick: make the viewer believe that it's as complicated as all get-out!*

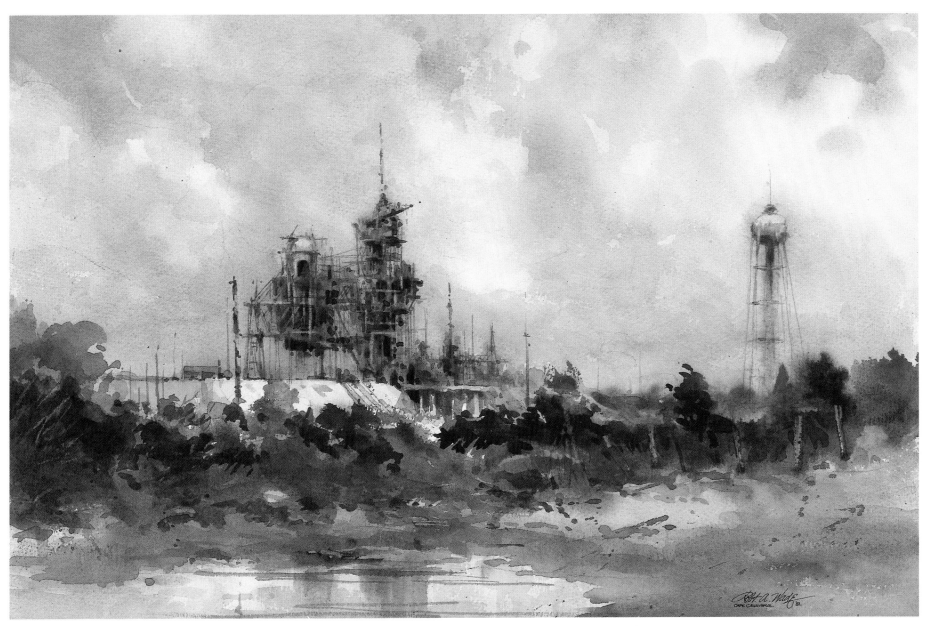

The Launching Pad, Cape Canaveral (22x15). *I painted a sky with some character that would be evocative of the billowing masses of smoke from a blast-off. The thrust of the tower, rising from the surrounding scrub, seemed to symbolize man's reach for the heavens. I added the puddle of water so I could put in a reflection of the tower to emphasize the tower's vertical thrust.*

More Than One Way to...

Here's another way to convert a sketch into a painting. Look at the sketch of Whitby, then compare the painting with the drawing. The pencil drawing was quite a finished rendering, which simplified the transition to paint. I had also taken a half dozen slides, but I didn't even bother to refer to them in this case, as I preferred to invent anything that wasn't perfectly clear in the drawing. In fact, should any of you visit Whitby and look for this spot, you would never be quite sure if you'd seen it or not since the painting is based on my own reaction to that subject. However, I believe it is very evocative of this historic York-shire fishing port.

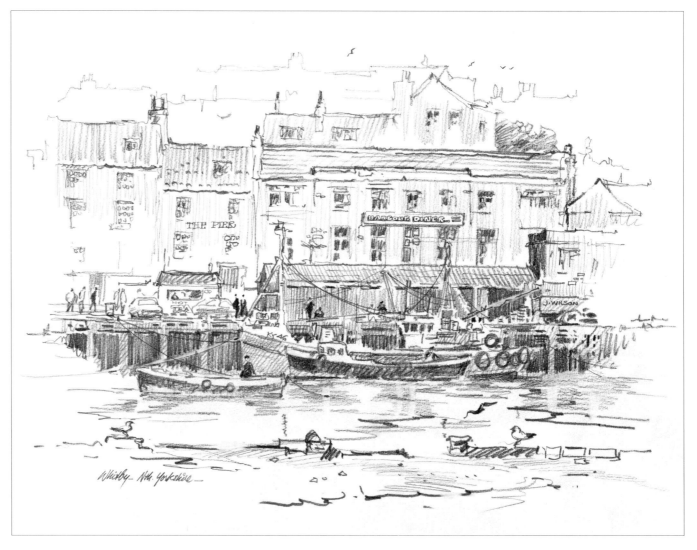

"Whitby Skyline" (15x10). *This detailed pencil drawing using 4B and 6B pencils on Kent drawing paper could stand on its own but also made a good beginning for a watercolor. You can see the highlight and shadow areas quite clearly to build on them. A finished sketch like this one makes the transition to painting very easy.*

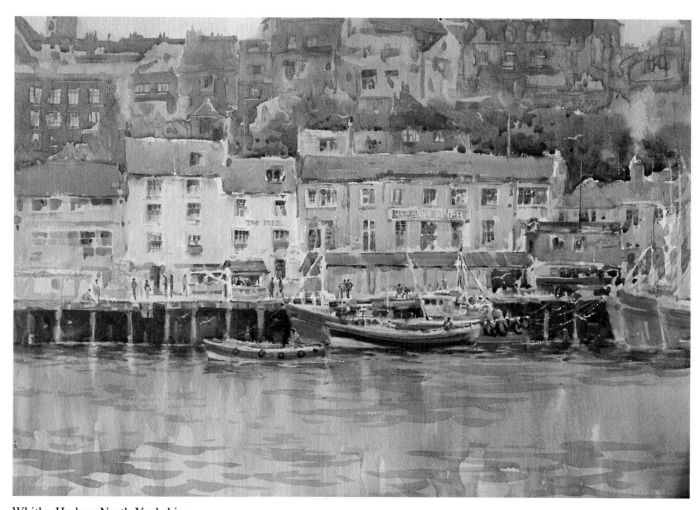

Whitby Harbor, North Yorkshire
(22x30). *I invented anything that*
wasn't clearly there in the sketch since I
wanted to capture my reaction to that
subject. It may not be exactly what was
there but is very evocative of that
historic fishing port.

Another effective and fun alternative is to use a combination of pencil and wash. This preserves some of the feeling of the original sketch, but has a more finished result.

Leadenhall Market in London is a wonderful source of subject matter. I happened upon it one April day, quite by chance, and spent the rest of my afternoon sketching the fascinating sights of the various merchants and their wares. It was quite dark inside the market and my camera was loaded with very slow film (64 ASA) so no photographs were possible. I had to rely heavily on good old memory when I produced this one! I first did some separate little drawings to work out the figures. Then, since I had the feeling that graphite pencil line would convey the mood very well, I drew directly onto a mounted Arches board with a 6B pencil. Next I added the subtle washes, taking care that the pencil lines remained obvious and the shape vignetted.

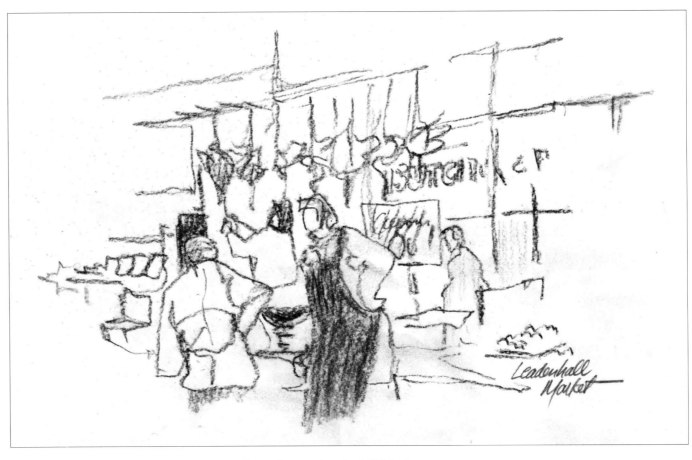

Game Season, Leadenhall Market, London (7x10). *After I made this sketchbook drawing, I felt that graphite pencil line would convey the mood of this fascinating market very well, so I drew directly onto mounted Arches board with a 6B pencil. I also made a few preliminary sketches to work out the figures.*

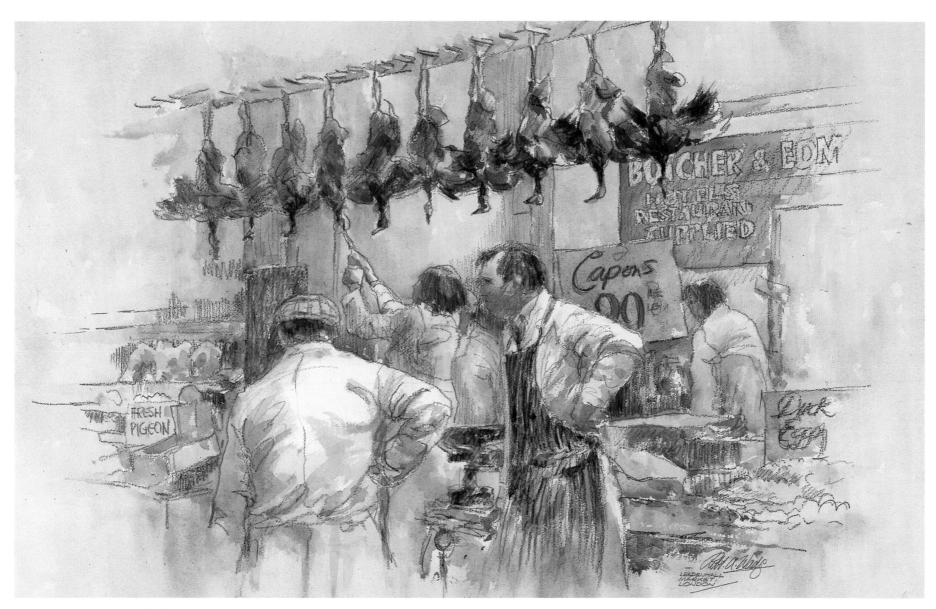

Game Season, Leadenhall Market, London (20x30). *I then added the subtle washes, taking care that the pencil lines remained obvious and the shape vignetted. If you look closely at both sketches, you can see how one evolved from the other.*

Street scenes are great for recording travels in foreign lands, as the indigenous architectural styles can instantly identify the locale—China, Japan, and the East, for instance. But, because of the hordes of people in some places, it may be necessary to record "photographic sketches" just as a matter of convenience. I've always preferred sketches but if that's not possible, take photographs or slides. By the way, I can't work from other people's photos, only from my own personal shots. I know what prompted me to want to take that subject, and any time I view that slide, my response to the image brings total recall of the atmosphere, the place, and my reaction to the scene.

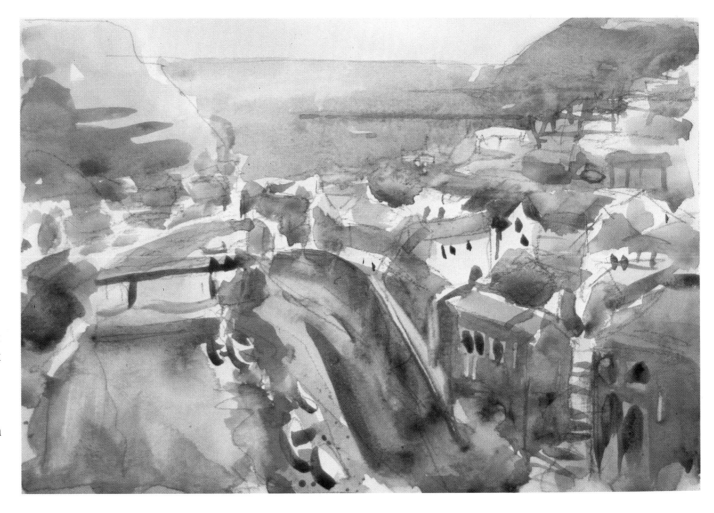

Watercolor Sketch for Staithes, North Yorkshire (12x10). *Rowland Hilder told me that I must not fail to climb the steep hill that overlooks this village on the north coast because the view was well worth the effort, and it was!*

However, I was almost floored by the drawing problems: the buildings were erected in a higgledy-piggledy fashion with no regard for artists' perspective problems at all! However, I made a pen drawing in my sketchbook, did a quick little watercolor sketch, took heaps of slides and hoped for a good result back in the studio.

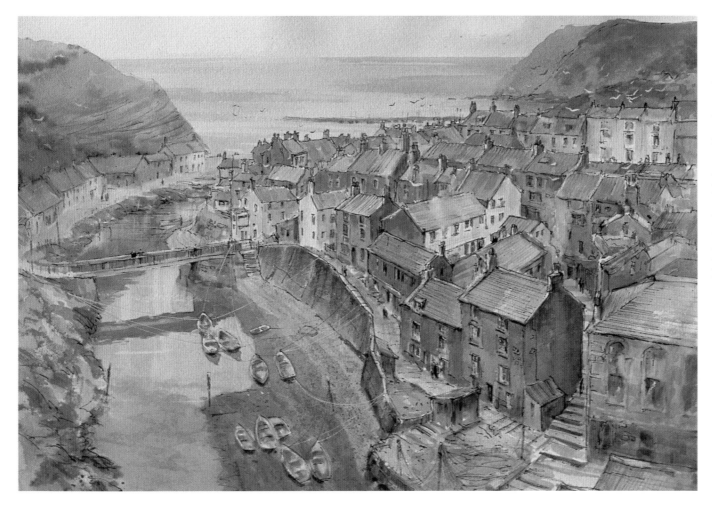

If you're weak on perspective, there are numerous books on the subject. Find one that covers the basics but doesn't step up to mathematical formulas. Stick to artist's perspective and that will put you on the right track. Once you understand the basic principles, it becomes only a matter of observation and constant comparison of angles and shapes to produce drawings that are valid.

Staithes, North Yorkshire (22x30).
I decided that pen and wash would suit this predominantly architectural subject, so I did all the preliminary drawing in pencil (an absolute nightmare), put down the washes, and finally proceeded to put in detail with a dip pen and waterproof drawing ink. Here's where it's possible to let the pen have its way and let it wander around almost of its own volition. This was the fun part, and it's easy provided that your preliminary drawing is good. About halfway through a painting like this one, I almost yell, "Why on earth did I ever tackle a thing like this?" The answer, I believe, is that I want to prove to myself that I can do it.

So when tackling these street scenes, keep in mind that there are other problems besides perspective. Remember highlight reservation, light bounce, value range, atmosphere, figures, and all the other topics we've been through together. These all add up to perceptive observation and that, good friend, is what will make you and your work stand out from the crowd.

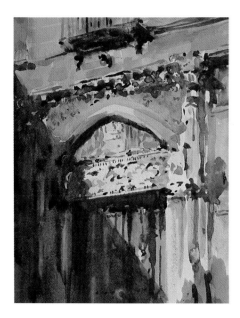

Cathedral Doors, Toledo (14x7).
Light and shade transform even ordinary subjects into something special, and when the subject is already special—look out! At first glance, this painting appears complicated, but if you look closer you'll see no detail at all. Note particularly the warm spot of reflected light under the transom (just above the marvelous old doors).

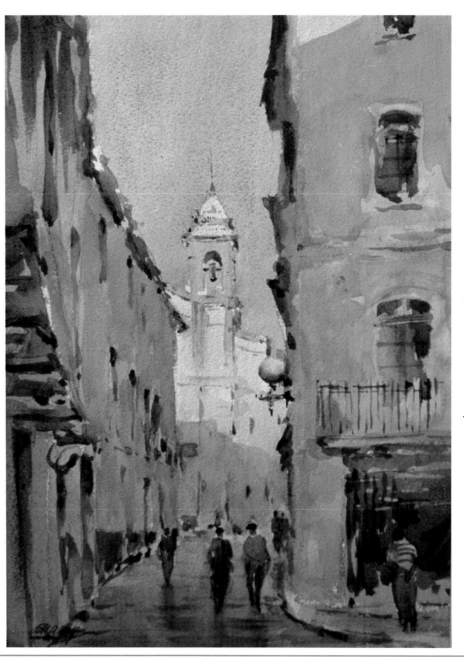

The Belfry, Elvas, Portugal (15x10).
An ordinary subject, transformed by light, then translated from dead, dull grays into warm pinks and yellows contrasted with cool mauves. "Perceptive observation" recognized warm light bounce into the buildings on the left, kept darks to mid-dark value, made the figures sketchy, then created directionals to take the eye to the tower.

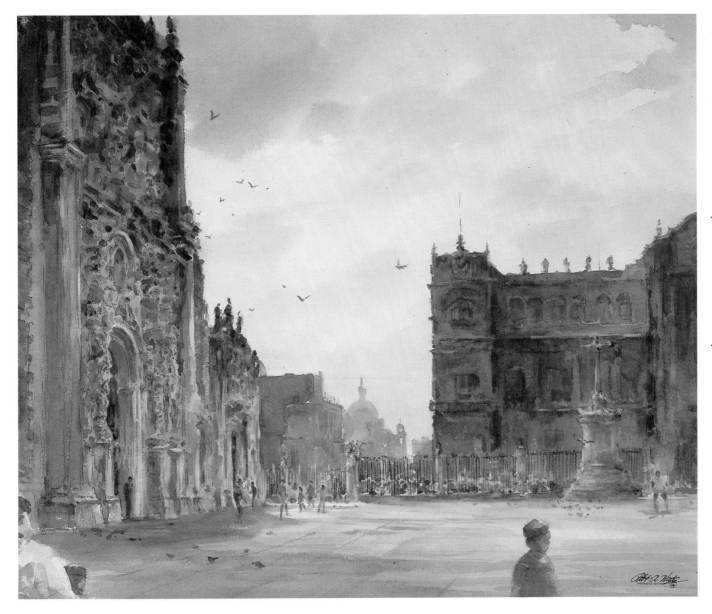

The Basilica, Mexico City (20x30).
PROBLEM: I don't feel comfortable moving buildings around. Shouldn't I try to make paintings of real places as realistic as possible?
SOLUTION: I made numerous changes in this painting to suit my feeling for the subject. Instead of a dreary gray facade, I gave the Basilica a golden glow, changed the sky to a warm yellow-orange, and switched the gray of the square to warm brown-grays. I moved the National Palace 100 yards or so to fit it in, and also eliminated hundreds of people. In fact I took so many liberties, I thought I might soon face a Mexican firing squad! Amazingly the Mexican Watercolor Society made me an honorary member instead.

A Quick Review

Just to refresh your memory, three ways to translate a sketch into a painting are:
• A finished on-site drawing plus slide reference for further information.
• Several quick sketches, plus reference slides, and a working color sketch.
• An extension of your original drawing or sketch into a line-and-wash work.

Finally, we can use our imagination combined with perceptive observation to produce a very personal statement.

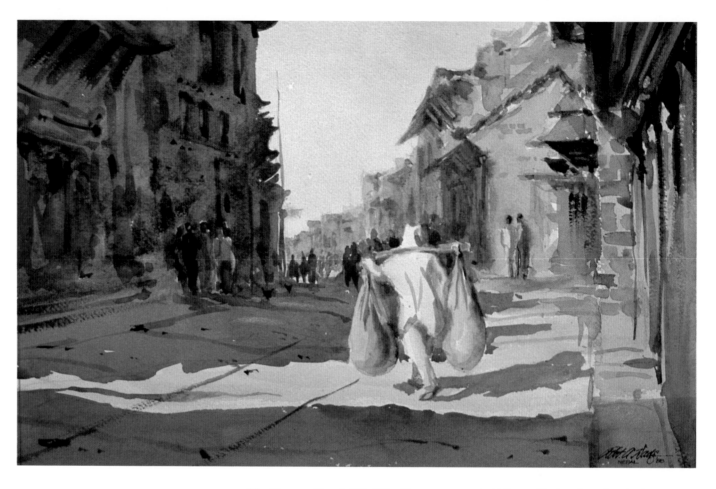

The Bearer, Nepal (15x20). *You can see a real change of atmosphere here in a village in the foothills of the Himalayas. The characteristic upturns on the ends of the roofs signify Eastern architecture, but there's almost a complete absence of detail in the rendering of the buildings. Notice that the shadows are very transparent. I first painted a warm wash over the entire roadway and when it was dry, put the shadows on in one hit. No fiddling and poking back into them!*

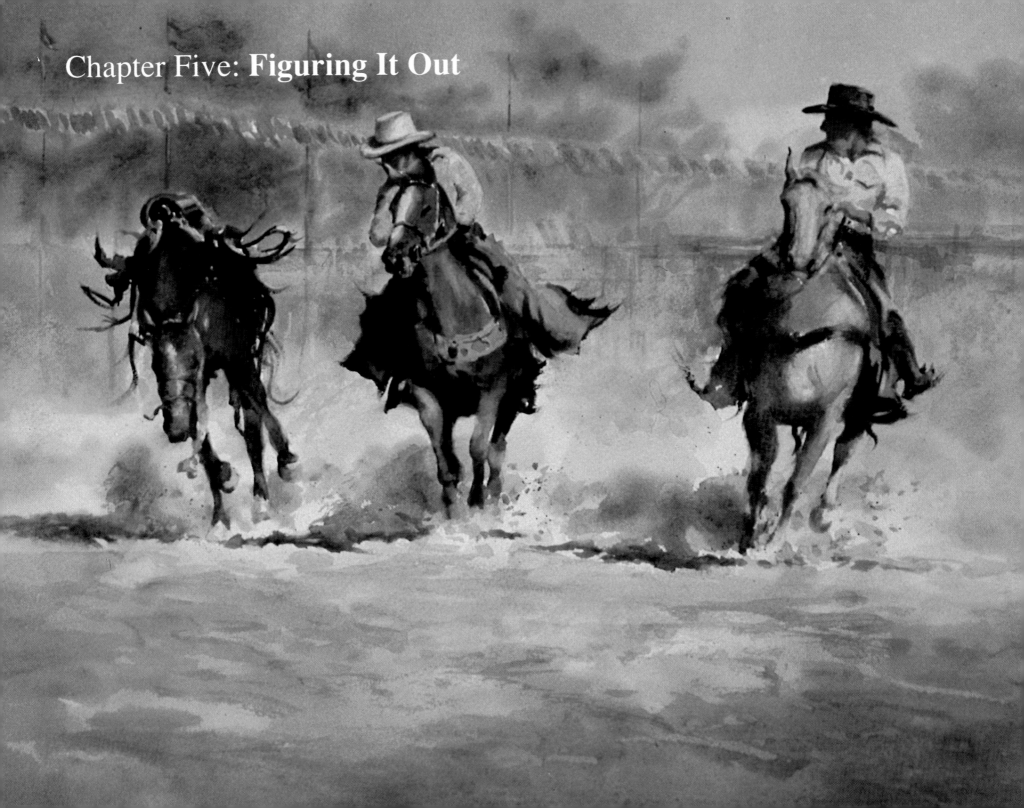

Start Thinking Shapes

Putting figures in your paintings will add a feeling of reality and give movement to the composition. Figures provide a scale by which the viewer can gain an impression of the relative sizes of all other objects in the watercolor. And in paintings of foreign countries, the style of dress helps the viewer determine the locale.

Many painters are afraid to paint figures and, when they attempt to do so, tend to make them look like wax dummies or cut-outs. It is essential to consider them as shapes, not figures. It is so much easier to draw and paint shapes than objects with names like "man," "woman," "horse," "dog," and so on. That's because it's often inhibiting to identify a shape with a name, but an anonymous shape becomes simply another element in the total plan.

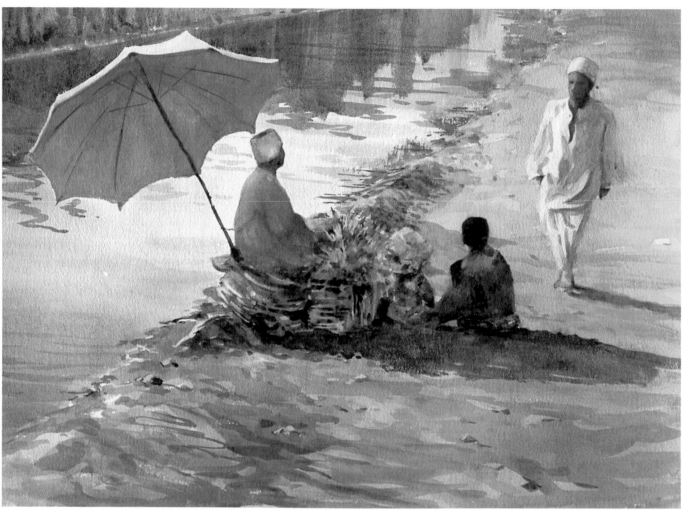

The Yellow Umbrella, Cairo (20x30). *PROBLEM: The color of the umbrella in strong sunlight is what grabs me most, but it isn't really interesting enough without some support. How can I handle this without introducing areas which will compete for attention? SOLUTION: If we keep the figures in the shade of the umbrella joined together to make a simple, dark shape linked with the cast shadow, this will act as a foil to the brilliant glow of the umbrella. Then let's take a figure from a sketchbook and put it out in the sunlight to accentuate the effect of the light to balance that large dark, and the dark area behind the umbrella (which would pop out your focal point). We're not getting into involved facial detail or personality—we've merely indicated presence.*

Remember how we used to draw stick figures at school? Well, they're still the basis of all figure drawing. To practice you should do thousands of little doodles of figures running, jumping, walking, and sitting in any pose you care to invent. Once you're getting the proportions correct, you'll find it easy to start turning them into shapes by adding a few broad brushstrokes to put meat on the bones. It's really heaps of fun, and you'll get a surprise at how good some of them will look. Then when you come to a painting you need to populate, you'll be able to slip some of these shapes into your painting with a degree of confidence and a painterly look.

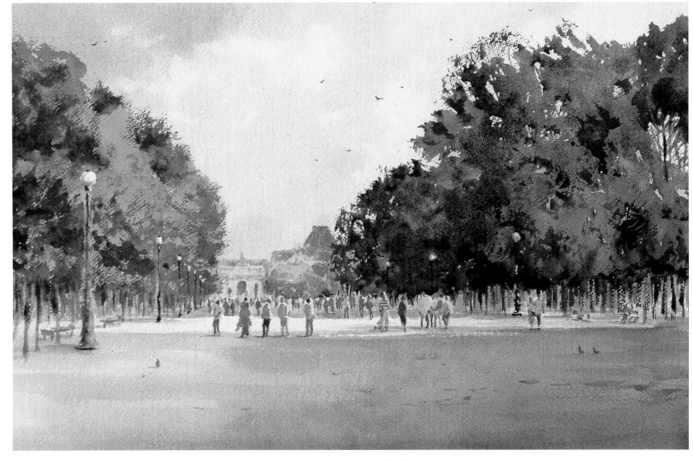

The Tuileries, Paris (15x20).
PROBLEM: How can I fit a number of people in and not make them too individual?
SOLUTION: Look at them here. Just blobs of colored shapes woven together to give an impression of a crowd. The wonderful "people" paintings of that American master Maurice Prendergast were also just pieces of color forming a mosaic that pulsed with life. The contemporary New York artist David Levine also conveys a great feeling of life in his beach paintings. Don't get labored. Just plonk the brush down where you want it and the shape will suggest to you where to indicate the head and limbs.

Perceptive Observation

The object of this part of my book is to alert you to the countless subjects you are missing if you are not confident in tackling figures. An artist must always be on the alert for subjects. If you stop looking, you might miss the best subject in the world! They do bob up in the most unexpected places. When you chance on a top subject that you badly want to capture, get it at any cost! That subject will never present itself to you again. Like the fish, it's the one that got away that you'll always regret.

The road between Agra and New Delhi is one of the most fascinating but dangerous stretches of road I've ever seen. One lane wide each way, it is used by buses, trucks, cars, tractors, camels, donkeys, elephants, horses, pedestrians, and countless bicycles—none of them following traffic rules and regulations! After surviving the first hour without a heart attack, I decided that there was no future in trying to be a back-seat driver. So I left the bus-driving to Mr. Singh and

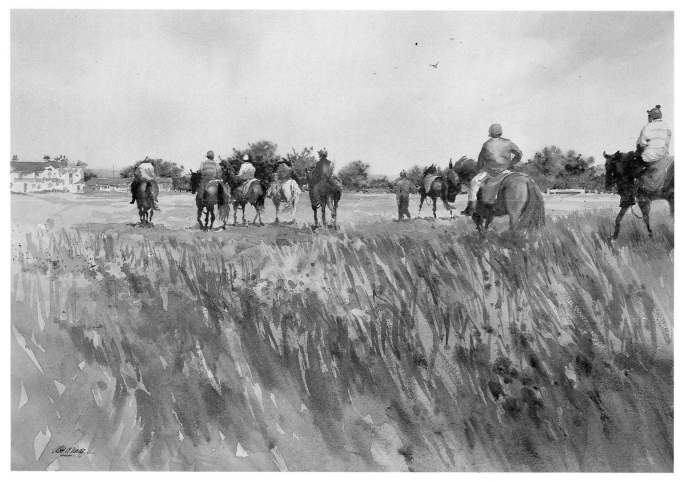

Morning Riders, Epsom (20x30).
PROBLEM: I often see interesting or unusual scenes I'd like to paint but I can't figure out how to get them without making a fool of myself.
SOLUTION: When you chance on a top subject you badly want to capture, be innovative, reckless, or mad, but get it. To get this unusual view of horses moving away from the viewer I took a series of slides of the race horses returning from their morning exercises and made a number of felt pen drawings. There was a road running right by the track, so I drew rapidly from my car, drove a bit to catch up, drew some more, drove some more, and so on. I managed to record enough action to compile this studio watercolor.

looked to the side. It was like the ostrich with its head in the sand, but I found it more restful, believe me! I also found many interesting subjects along the way, so I sat with camera poised, pressed against the window to avoid reflections.

There was only time for a very quick shot through the bus window as we passed an old truck on the road (see *The Gravel Truck, New Delhi*, at right). Back home in my studio, I projected the slide onto my wall to about six feet by four feet. Sitting back about fifteen feet from the image, I drew the shapes onto my watercolor paper, rearranging the elements to make an interesting composition. I didn't allow myself to become too involved with facial features. The textural qualities were exciting, the back lighting interesting, the men's clothing indicative of the locale—all combining to give a feeling of India.

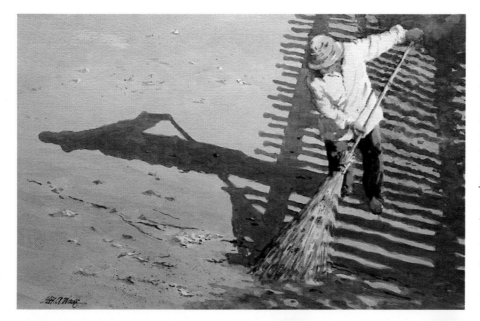

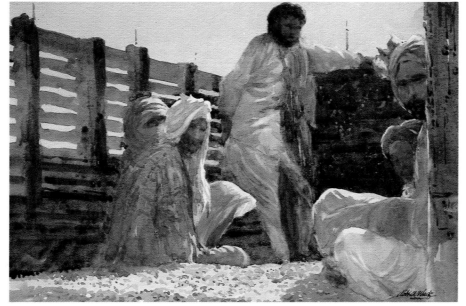

The Sweeper (15x20). *Intending to draw a neighboring building, I stepped onto my balcony. When I saw old Ahmet below me, I had an instant change of plans. What a subject! In just a few seconds I was at work. From my high vantage point, looking down, the figure was quite foreshortened, and I had to be careful in keeping the perspective correct. I made the painting very simple. The picket fence shadows worked well as a foil to push out the denim hat and the pale jacket. The shadows really tell the story here, also helping to show the roundness of the "Witches's Broom." The busy area on the right is offset by the empty spaces on the other side.*

The Gravel Truck, New Delhi (15x20). *PROBLEM: I see a lot of good pictures when I travel, but I just can't stop the car or bus, can I?*
SOLUTION: In this situation, I only had time for a very quick shot (just hope it turns out!) through the bus window as we passed this truck on the Agra Road near New Delhi, India. Back in my studio, I projected the slide on my wall—to about six feet by four feet—and sat about fifteen feet away from it. I drew the shapes onto my watercolor paper, carefully observing the high-lights. I didn't allow myself to become too involved with facial features. I just wanted to create a good feeling of India.

When you've had plenty of practice with little figures on scrap paper and you're used to dropping them into your work, you can begin to create paintings with figures like these. My painting, *Meeting at Meerut* (see the next page), is a combination of reality and make-believe. I took figures from different sources in my sketchbooks and knitted them into one painting. I drew the figures accurately in pencil and noted where I needed to reserve my highlights. Initially I work in large shapes and soft edges.

Don't start nit-picking detail until the very end; work as big and as broadly as you possibly can. It's good thinking to paint:
- soft to hard
- large to small
- pale to dark

as you work through your watercolor—not rules, remember, but helpful tips. After the washes are dry, it only remains to refine the figures, observe the highlights, and refrain from getting too detailed.

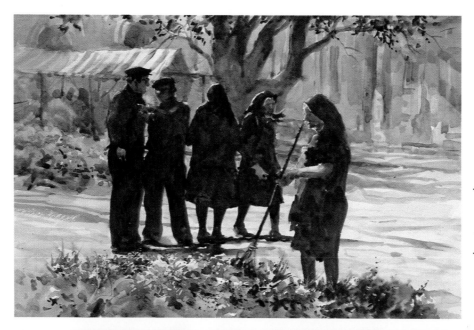

Flower Market, Portugal (15x20). *PROBLEM: What do I do if I feel a scene needs people to give it life but no one's there at the time?*
SOLUTION: The men came from a sketch at Nazare and the ladies from three different sketchbook drawings. I fitted them all into the flower market of Caldas da Rainha. As the locals all wear black, I thought I'd join them into one large shape, almost silhouette fashion. It's rather an unusual picture, I suppose, but I enjoyed piecing it together. You see, there's more to art than sitting in front of a subject and turning out a facsimile. It's being able to put down on paper what you feel and the way you see it from within yourself that counts.

Detail from Flower Market, Portugal. *This was the fun part! Those stark figures in the traditional black needed some light relief, and that's when I decided to put some flowers in front of them! I just invented them (instant flowers while you wait) by allowing the colors to flow and suggest a mass of blooms. They really painted themselves, while I merely assisted with some spatter and dribbles.*

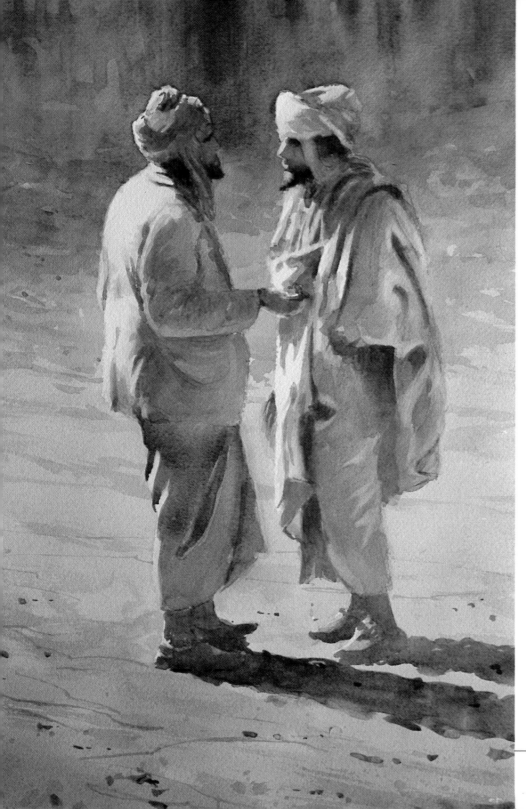

Meeting at Meerut (30x20). *Once again I've knitted the figures from two different sources in my sketchbooks into one painting. After drawing the figures accurately in pencil, I carefully noted those critical highlight reservations. I put down a wash of raw umber with a touch of violet and cobalt blue, covering the complete surface except for the highlights. While this wash was still damp, I painted the top section wet-in-wet to get softness in the distance, still cutting around the figures to maintain my highlights. Only rarely do I use masking fluid because I prefer to test my control over the brush—yet another challenge to overcome!*

Detail from Meeting at Meerut. *Once that big, overall wash and the background were on, this super pattern was emerging. After these washes were dry, it only remained to refine the figures, observe the highlights reserved on the edges of the forms and on the garment folds, and refrain from getting too detailed. A very satisfying result, particularly when people remarked to me that they felt as if they were almost intruding on a private conversation between the two Indians.*

Pencil sketch for The Derelict.
I sat and drew this pathetic person one Sunday morning in Sydney, using black and gray felt pens. He was quite oblivious and, as he dozed, made a great model for me.

Preliminary watercolor sketch for The Derelict. *I converted the felt pen sketch to a small watercolor sketch. This enabled me to make the decision to use a vertical format for the final painting, and also to evaluate the colors I'd be using.*

One Sunday morning in Sydney I was walking to Circular Quay, when I came across a pathetic derelict, already boozed to the eyeballs at 11 a.m. and probably carrying all of his worldly goods in his old cardboard box. The sight of this forlorn character affected me greatly—a case of "there but for God go I." The painting won a Gold Medal, and I wondered as I accepted my award if that unfortunate individual to whom I owed my success was still dozing on some park bench as I attended the glittering formal dinner.

This is a good example of what I call perceptive observation. I define it as seeing with your brain, feeling with your eyes, and interpreting with your heart.

Detail of The Derelict. *There's a very important lesson in this small section. Look at the various shapes and the way they join with each other. You can't actually tell where the left shoe starts and the right one stops. They join with their shadows and the other shadows, too. Remember, you're painting shapes, not separate objects.*

The Derelict (20x30).
PROBLEM: I've applied perceptive observation to this subject and my heart is heavy with compassion for my fellow man. If I were to paint the subject the way it tells me, it might be so poignant that nobody would ever buy it. What should I do?
SOLUTION: The essence of perceptive observation is allowing your feelings to dictate how you will portray a subject. Who cares whether it will sell? Selling paintings is not what we're all about! Paint it with sincerity, humility, and honesty, and let's hope that the painting will stir similar emotions in the viewers. If the tears should come while you're painting, then what an unforgettable experience it will be for you—knowing that you are caring so much for another human being.

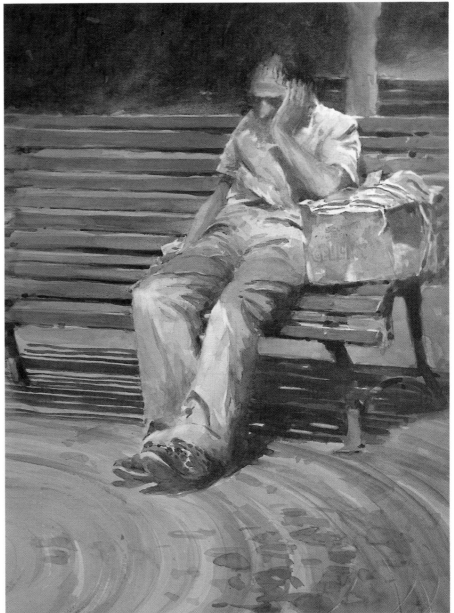

Special Problems

If your painting is predominantly a figure study, then apart from capturing the pose, you must also try to indicate the form. In other words, you must suggest a dimensional impression, that there is a body that has roundness and shape under the garments. This is achieved with light and shade on the form.

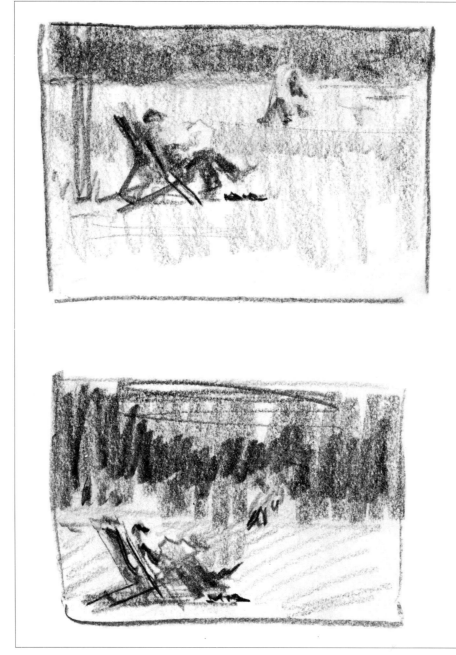

Pencil value sketches.
I decided to walk to the National Gallery from my club in Mayfair, London, instead of being bottled up in the Underground. It was a late spring morning. The birds were singing and the freshly-mowed grass smelled great. When I caught sight of this gent in Green Park, taking in the sun and catching up on the news, I had my camera out in a flash. With a zoom lens, I was able to take a few shots on the sly, then resume my stroll. In planning the watercolor, I eliminated many deck chairs and figures, but I invented the couple passing in the middle distance. These two little thumbnails are only to allow me to decide on the placement of the various elements in relation to the horizon.

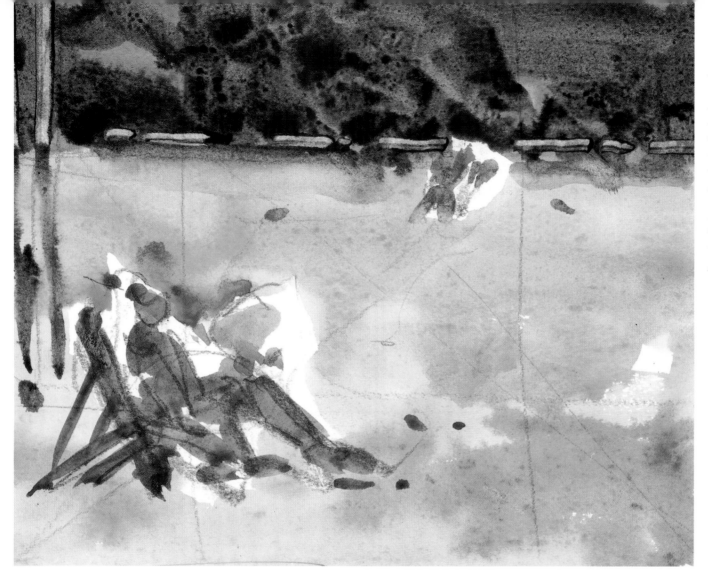

Quick color sketch.
I did the quick notes first, before tackling the painting. It's essential to get your thinking sorted out in the early stages of the game. I tried to give myself a bit of a head start by deciding on the colors I wanted to use. This little bit of a scribble, strange as it may look to you, did give me sufficient information to set out with some confidence. That's the advantage of working on major watercolors in a studio environment where everything is at hand to help you pull it off.

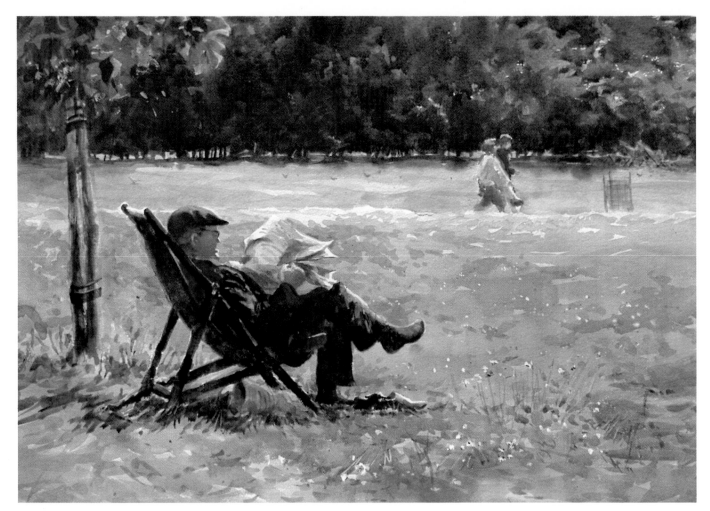

Green Park Morning, London (22x30). PROBLEM: *I happen to know this area very well. There are literally hundreds of deck chairs for hire lying, standing, piled all over. What happened to them?* SOLUTION: *The little sketches convinced me that I was only interested in the relaxing gent in the deck chair.*

Everything else in the painting had to support that figure, so the distant trees were simplified and the passing couple just suggested. And those deck chairs? Well...maybe the wind blew them away just long enough to keep them out of my picture. Cotman said, "Leave out, add nowt!"

Pen sketches for The Water Lady, Tangier. *I made very quick felt pen pattern drawings searching for the best design for the painting.*

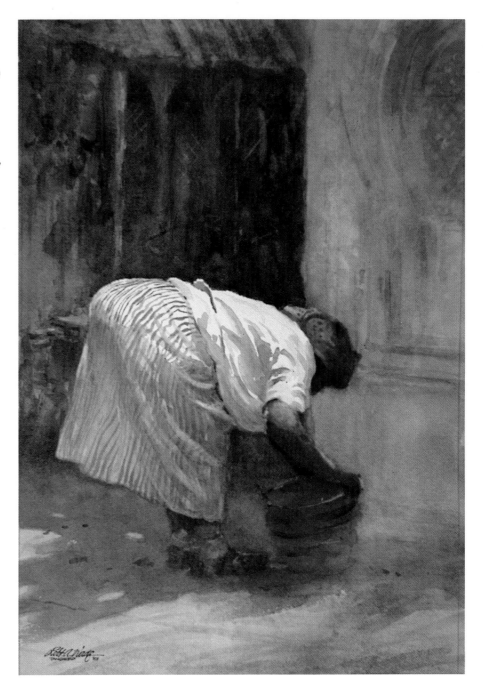

The Water Lady, Tangier (20x15).
In a figure study like this, in addition to capturing the pose, you must also try to indicate the form. In other words, you must suggest a dimensional impression, that there is a body that has roundness and shape under the garments. This is achieved with light and shade on the form, but in this instance, I also got assistance from the stripes that turn in and around the form.

I particularly like painting Eastern and Middle Eastern people—oops!—shapes. When drawing them I try to let my pen or pencil glide with the same sort of flowing lines as their clothes—not short jabs and pokes—so much of their character is retained. Their flowing attire folds so beautifully and seems to catch the light in such attractive patterns. Through perceptive observation, I can pick up the pattern of light traveling around and through the painting.

Portraiture is tough! Apart from the difficulty, the person who commissions a portrait usually has a pre-conceived idea of how it should look. John Singer Sargent once said, "Every time I paint a portrait I lose a friend!" And the Pre-Raphaelite artist Sir John Everett Millais admitted that the only part of portrait painting he really enjoyed was putting the highlights on the boots.

From Kalamazoo to Katmandu, kids are so cute. They're the same the world over.

Kids make wonderful subjects but terrible models, because they can't stay still for ten seconds flat! Here's where you can use your camera for reference, but do

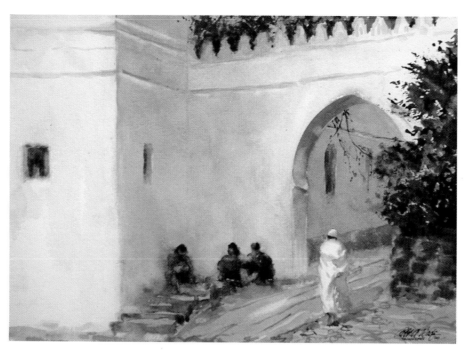

The Casbah, Tangier (11x14).
The gesture of the figure, hands behind back and leaning forward, gives a lead into the painting, taking us up the path and under the arch. The edges of the figure are worth noting—hard edges on his left where the light hits the form, cool and soft on his right joining with the shadow color to tie him into the picture plane.

Detail of The Casbah. *Here you will see that these shapes are little more than blobs. But the gesture is still there, legs akimbo, squatting in the corner. The two Arabs on the right become one shape, the left-hand man is joined to the shadow on the wall, where the warm reflected light on the wall has a subtle influence on the truth of the figures.*

Jenny (15x10). *Aged two at the time, Jen was a gorgeous little pet (24 years later she still is, and just as cheeky, too!). The drawing took quite some time because she kept on wriggling around, so she'd had enough before I really finished. I painted it from memory after the drawing was done. I painted her on Plate Bristol board to get the softness with which I wanted to convey the cuddly little charmer. Paintings of children should be light, bright, and breezy in keeping with their characters, so this is a high-key painting. The emphasis here is on Jen's bright eyes. The gentle light falling on her through the window helped emphasize the softness and roundness of her little shape. I've accentuated this by losing some edges in the highlights and also in the shadow area of her hair, which I have simplified as much as possible. Look how I used her clothing as a means to show the roundness, too, especially the way the straps curve over the shoulders. Jen has the painting, and we both treasure it some twenty years later.*

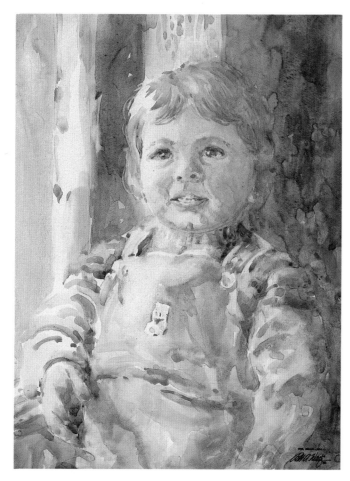

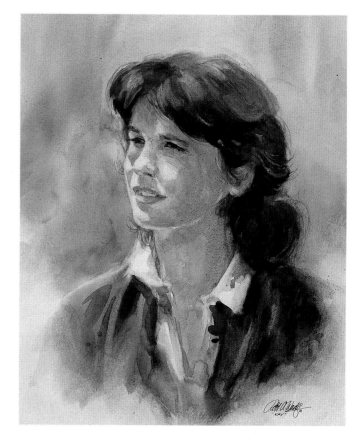

Kay (20x15). *I only paint members of my family. This portrait of my step-daughter Kay was done as a Christmas present for my wife. Ann loved it, Kay didn't, and I thought it wasn't too bad. When it comes to portraits, two out of three ain't bad. Notice how I've introduced lots of soft edges to give a feeling of femininity. In fact almost all edges have been worked on gently with a clean wet brush to remove any* sharpness. *Note that there is a crisp edge on the collar which brings it forward, while the other peak turns away. The eyes, nose, and mouth are defined and in focus, which gives the likeness and the character. See how the soft edges of the entire vignetted shape draw attention to the facial features? I hope that Kay's thoughtful, caring nature comes through to you.*

have a go at sketching as well. With experience, you'll find that as long as you get the essence of the form down, it's possible to finish off the drawing later, using your knowledge and memory. Again, it's the pose you must capture; just try for an impression. The more you draw kids, the better you'll get.

Like the human form, drawing animals requires practice and observation. It's useless putting them in your work unless you have done your homework. If your horses look like wombats, or your dogs look like kangaroos, then forget them until you've done a heap more practice. But we can get away with a certain amount. By losing edges in some places and showing a little detail in more critical areas, we can pull a big confidence trick and lead the viewer to believe we've painted animals with some authority.

Domestic pets provide endless opportunities for practice drawings. Seated or sleeping, they tend to be reasonably still for some time, which means you don't have to rush your work.

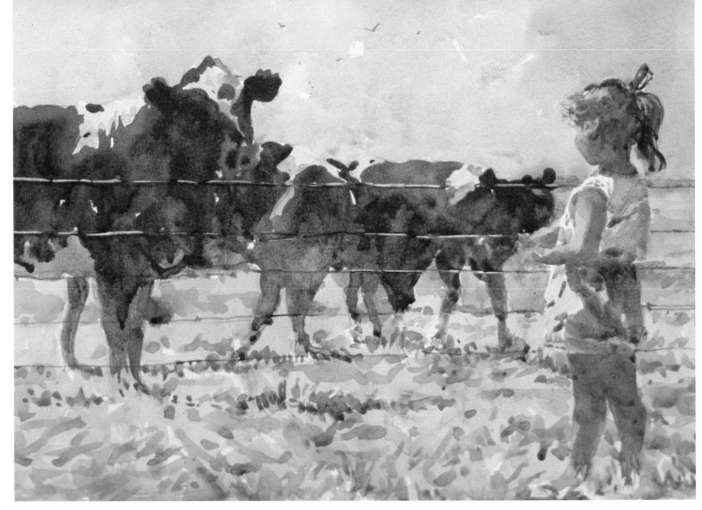

Uncle Bruce's Cows (10x15).
PROBLEM: You said this was a study of your daughter, Sue, when she was about five years old. So why does she only just manage to get in the picture?
SOLUTION: It's strange how sometimes we do things which we normally wouldn't, because we almost seem compelled to do so! I felt that I just had to place the figure in that position so close to the edge of the paper. Maybe because of her lovely nature: never pushing herself in but always there with a smile and a helping hand. Sue's characteristic stance identifies her— that's my Sue. I thought that the cows would provide the necessary balance for the little figure. By joining the cattle into one shape (who knows where one stops and another begins?) I let their silhouette define them. Note the lack of detail, which might otherwise overpower my center of interest, Sue. This way they all fit in well and the picture has an interesting story to tell. I'm glad I followed my perceptive observation.

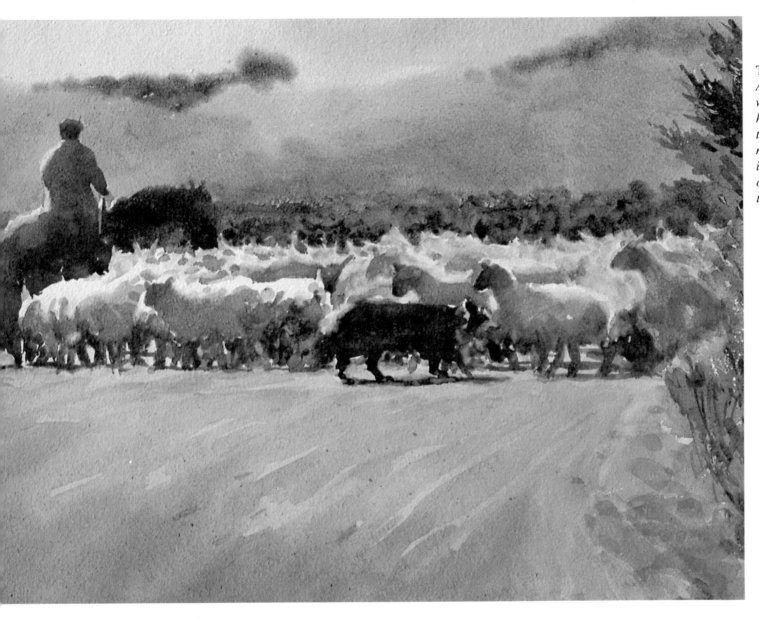

The Flock, Northumberland (12x18).
Another big con job! The flock is a white shape with a half-dozen sheep's heads thrown in, but the viewer is tricked into believing that there are many of them. The power of suggestion is more interesting than spelling it all out, crossing the last "t" and dotting the last "i."

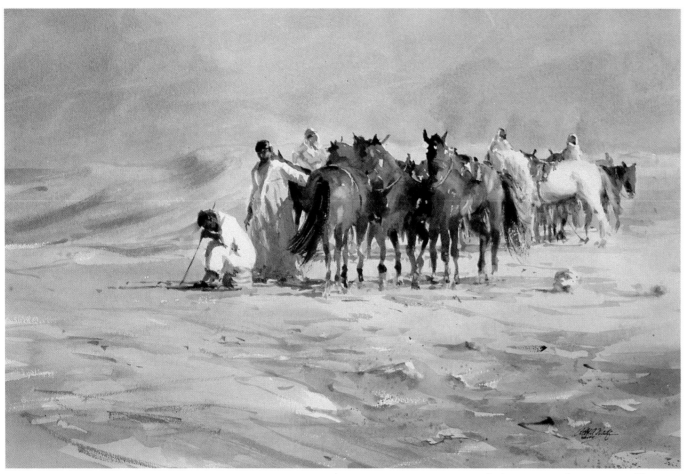

The Arabs, Egypt (20x30).
PROBLEM: Horses are wonderful subjects, but very difficult to draw individually.
SOLUTION: When horses are grouped like this, however, we can trick our viewers into believing they are seeing what they are not! Their heads must be recognizable as horses, but with a few correctly drawn legs and tails, we can make it appear to be a group of horses. That's what I did here, but if you count the legs, you'll discover that they don't match the number of heads! I'm the only one who knows that it happened, and I'm not telling anybody but you!

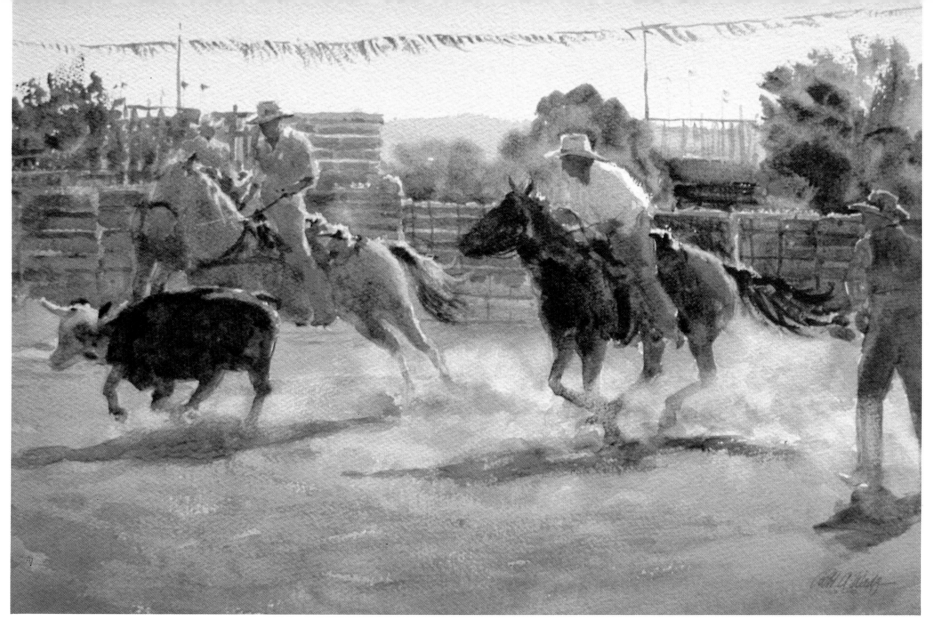

Rodeo, Lang Lang (15x20). *This was an action painting that I enjoyed. I spent a summer afternoon at the rodeo, sketching the animals, the cowboys, the handlers, the hustlers, and the spectators. Time flew, so I took a roll of slides to help recreate the atmosphere when back home in my studio. After drawing it up and painting the horses, it looked boring. So I dampened a rag and rubbed vigorously to remove paint and suggest dust. Suddenly the shapes began to have movement, and action started to happen. Even the flags seemed to flutter.*

Key Thoughts

Perceptive observation involves seeing with your brain by understanding your innermost thoughts about a subject, feeling the shapes and forms with your eyes, and then allowing your heart to tell you which way to go.

• Figures and animals give life, scale, and action to your work.

• You have models anywhere there are people, so get the sketchbook habit now.

• Don't avoid figures because you think they are too difficult.

• Think of figures as shapes. Leave out detail in the facial features and just try to capture the essence of the gesture.

• Don't worry if your final result doesn't resemble your model. If it's in proportion, it won't matter because you're the only one who'll know.

• Invent, experiment, and practice, practice, practice!

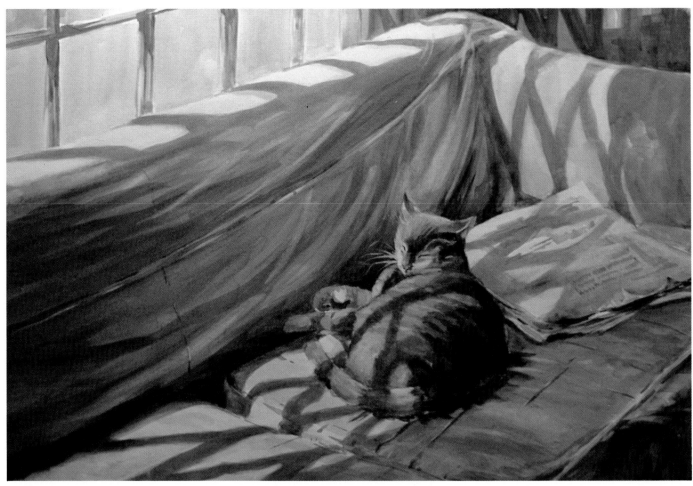

Catnap (20x30). In this painting, I really got too caught up in all the textures which presented such interesting challenges. The cat's fur contrasting with the linen covers of the chair, the newspaper, the wooden frames of the windows, and so on, all intrigued me. However, I think it would have been a better painting had I just concentrated on Felix and merely suggested the other areas. I painted this about eight years ago, and my painting thoughts have changed quite a lot since that time. It's interesting to look at works we've done some time back and think how we'd tackle them now. If you look at them and don't wish you could change them in any way, then something is wrong. You're not growing! I can't see a painting I did only last year without thinking that I should have treated some area of it in a different way. We must never become complacent or we will just stagnate.

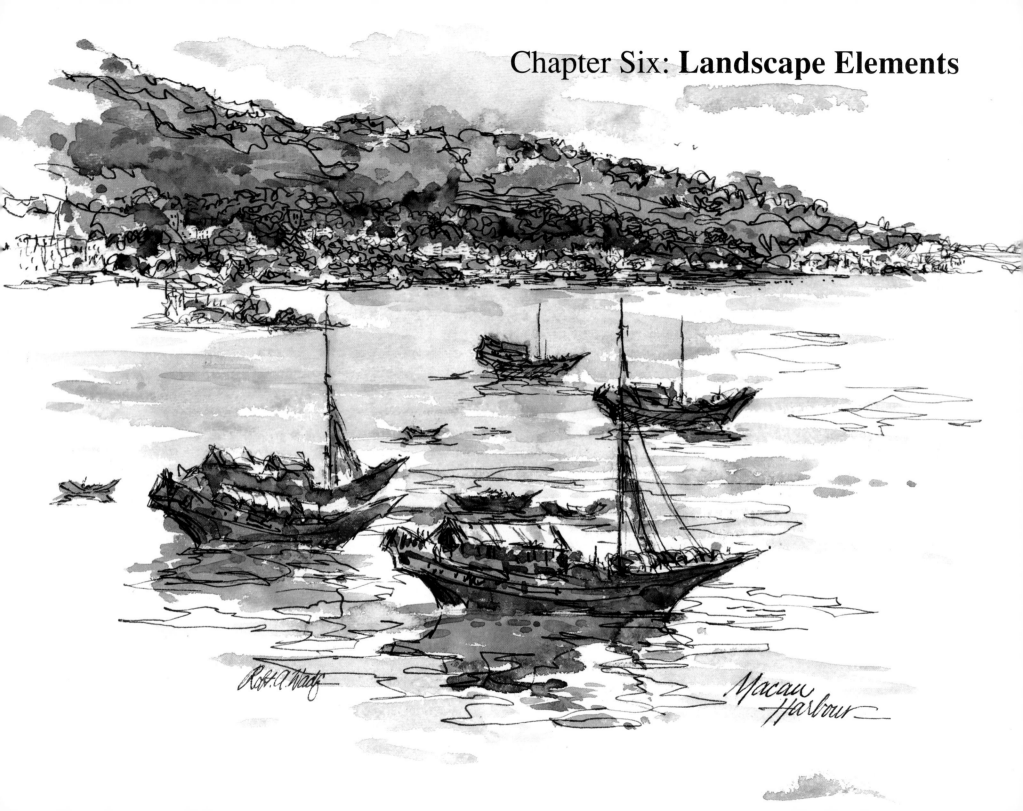

Growing as an Artist

Postcard-size sketches like these are great fun and also the best possible practice. If you were to produce one or two every day, just from imagination, the improvement in your work after a month would be enormous. Your ability to handle watercolor with some degree of control, no matter what subject you attempt, is extremely important. The confidence you gain from these exercises will soon be reflected in your work.

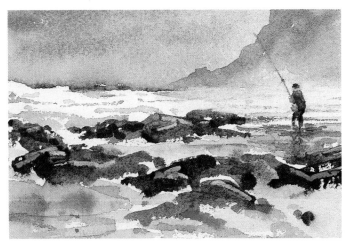
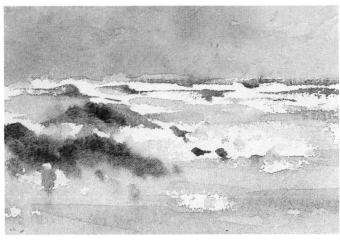
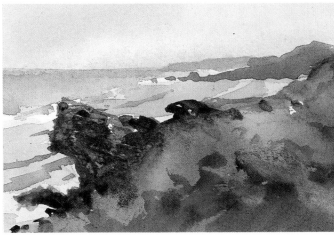
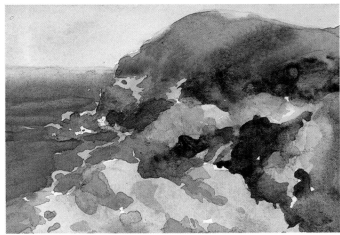

Postcard size quickies—each 6x4. These are great fun to do and also great practice. Try to do one or two each day, allowing only seven or eight minutes each at the most.

You probably learned a musical instrument when you were a kid. Remember how boring those enforced hours of practice were, when you desperately wanted to kick a football or play with the other kids? Well, I'll bet that most of you are sorry now that you didn't keep it up! As artists, we must have hours of practice, too. However, that time can be a real pleasure. It never really becomes a chore, and meanwhile it adds to our artistic growth while improving the quality of our lives.

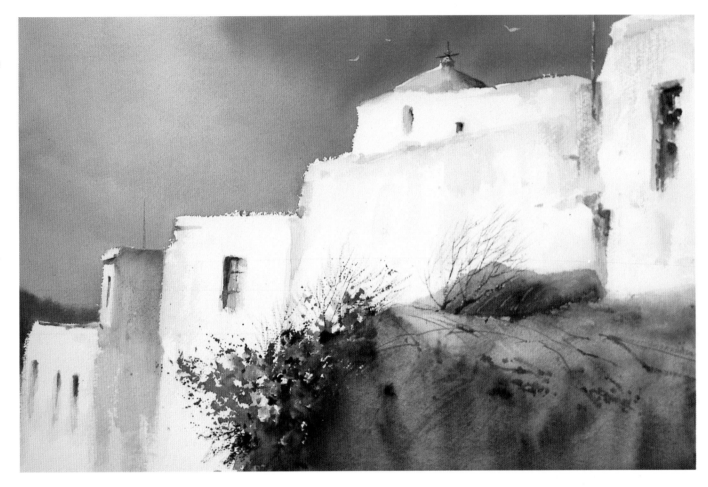

Patmos Church, Greece (15x20).
Very simple shapes like this are simple to draw. There's very little detail here, just a big abstract pattern. Stick to simple subjects until you gain experience.

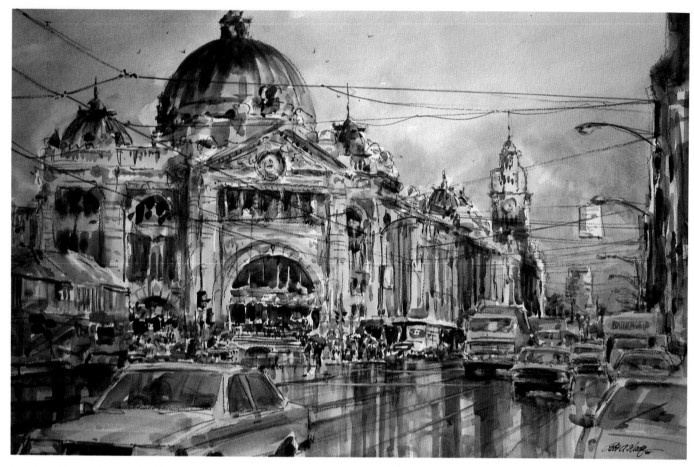

Flinders Street Station, Melbourne
(20x30).
PROBLEM: *There's so much activity in the scene I want to paint. Where do I start?*
SOLUTION: *I almost doodled with my carbon pencil here, letting it find its own way out of the problem. It gives a rougher line than graphite, helping to bring about a sense of immediacy and movement. Even with washes over it, the pencil drawing still stands up in its own right. I drew all the immovable objects first, then sketched cars, trucks, and so on, as they stopped for traffic lights. Although there is so much happening in every part of the picture, nothing has been treated in a detailed fashion so it all hangs together quite well. It was rather an exciting sketch, even if hazardous!*

You'll find that my continual stressing that drawing ability comes only from constant practice will stand you in good stead if you've heeded my advice. If you can draw in a reasonably competent fashion, you're home free, and you'll be able to take on almost any subject that appeals to you. I must seem a tough task-master, always wanting to drive you harder and harder. Up until right now, I haven't revealed my secret to you, but here it is—I have never attended art school or art classes! Whatever I have achieved, I've done by working my fingers to the bone. I've practiced until my eyes were so sore I couldn't see straight. I've driven myself to keep on going when I could cheerfully have dropped with exhaustion at some weird hour of the morning.

Dedication pays off. The harder we work then the better we get, and the more we achieve the more we want to achieve. I've really let my hair down, but I hope that by doing so, I may have inspired a few of you to work at it harder, set higher goals, and achieve a new level of dedication. If that happens, then I would judge the book a success. That's enough of the preaching, folks, it's back to work again.

Let's take a look at ways to handle specific subjects— namely, skies and the sea (boats and water).

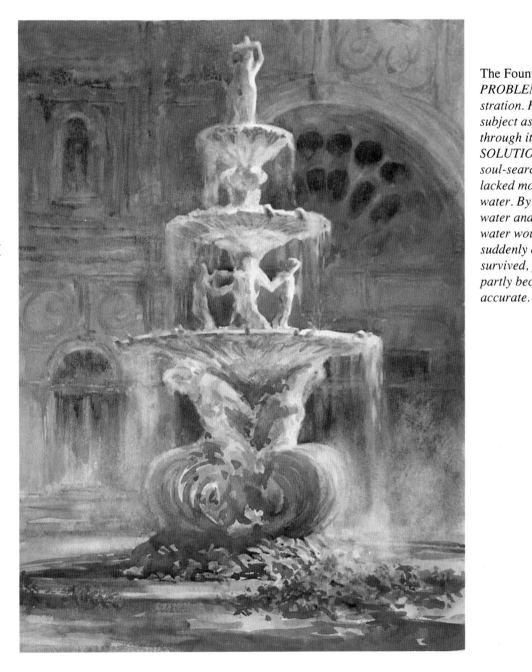

The Fountain (30x20).
PROBLEM: This was a class demonstration. How stupid I was to tackle a subject as tough as this one! I struggled through it, but it lacked feeling.
SOLUTION: That night, after a lot of soul-searching, it hit me. The painting lacked movement. I had to turn on the water. By wetting each area with clean water and wiping away the bits where water would be cascading down, it suddenly came to life. The painting survived, partly because I gambled and partly because the drawing was so accurate.

Skies

Skies are a magnificent manifestation of the wonders of nature. Sculptured masses of vapor and dust, changing minute by minute in shape and color, they are a never-ending source of inspiration for artists and are particularly suited to rendering in watercolor. Moreover, you don't need to travel to find this subject. Just take a look out your window and there you have it.

Skies set the mood and feeling for the entire painting, so you need confidence when you tackle them. If you feel that the sky is worth featuring, then give it room. Use a low horizon so the sky will look as big as all outdoors.

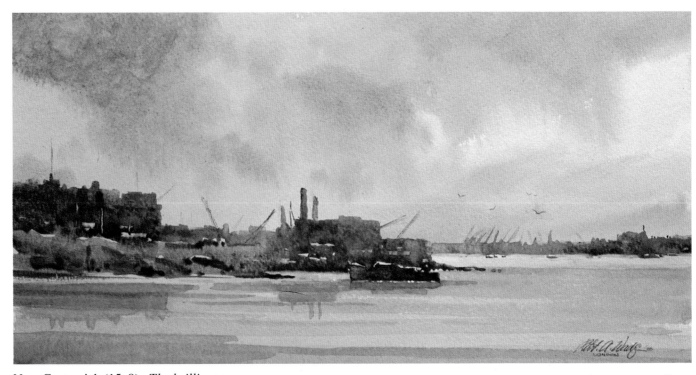

Near Greenwich (15x9). *The brilliance of the late afternoon sky allows the contre jour silhouettes of the industrial skyline and the barges to pick up little highlights which create a real sparkle in this small painting.*

Sultry Day, Blinman, South Australia (20x30). *The sky doesn't take up much more than one-third of this painting, but it definitely sets the mood for this "outback" Australian painting. The empty road together with the threatening sky give it an air of desolation.*

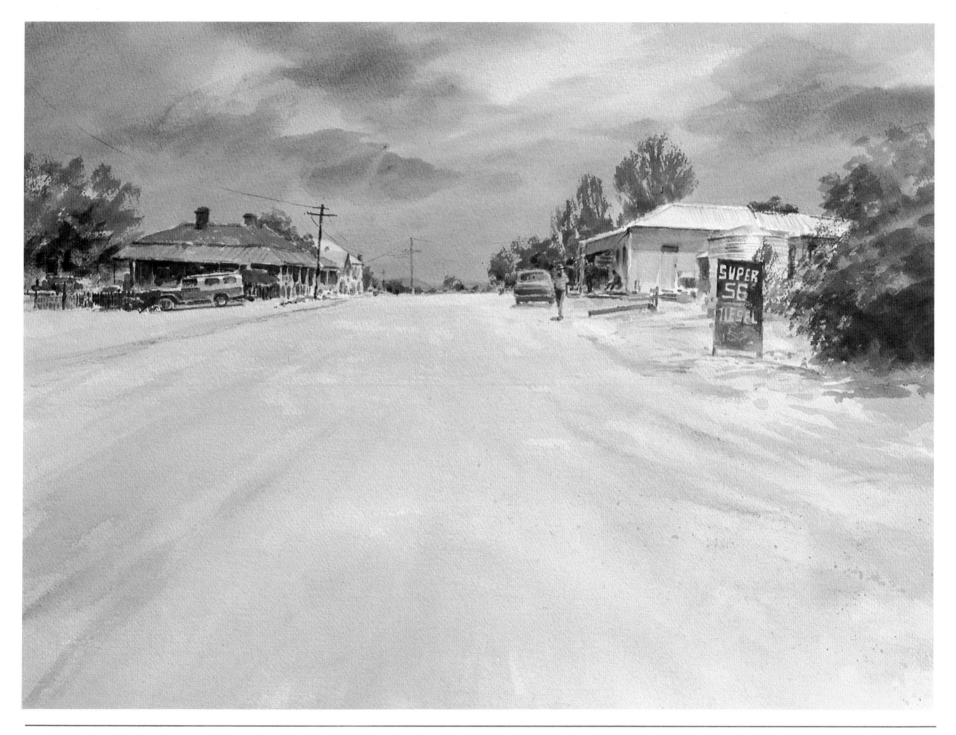

If you can handle skies, then you can handle watercolor! I love painting big, juicy, wet sky washes. This is the time to use a two-inch wide brush, heaps of water, and plenty of big, sweeping strokes. There's no room for niggling little brushes and small strokes if you want a sky so juicy you could drink it.

Usually I prefer to paint skies wet-in-wet, but I don't follow this pattern religiously (remember, no rules!). I like to wash clear water over the whole surface of the paper, then when the shine has disappeared, blot up the excess moisture from just below the horizon right on down to the bottom of the sheet. This prevents too much wash from dripping down into the areas where I'll need to paint other shapes later. Having figured out how I'm going to design the sky, I can sail in confidently, laying big washes where I want them, blotting a few hard edges of cloud tops, softening undersides of clouds with clean water and brush, working the sky as a whole, not in isolated small areas. My brush is flying to

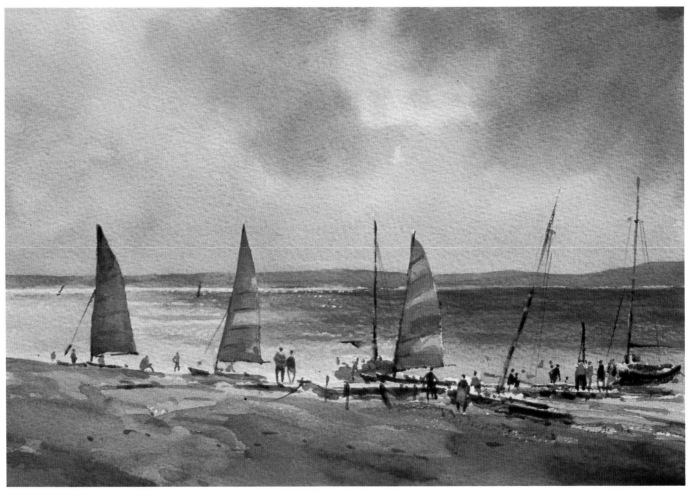

The Cats, Philip Island (11x14).
PROBLEM: There's a beautiful sky here, but I'm not sure how putting in a low horizon to show if off will affect my center of interest, the catamarans.
SOLUTION: The sky has to be secon- *dary to the beached catamarans. However, it is critical in setting the mood for the painting. The delicate blush of rose madder genuine and the subtle influence it has on the color of the sea is almost subliminal, but it is so important to the overall effect of the watercolor.*

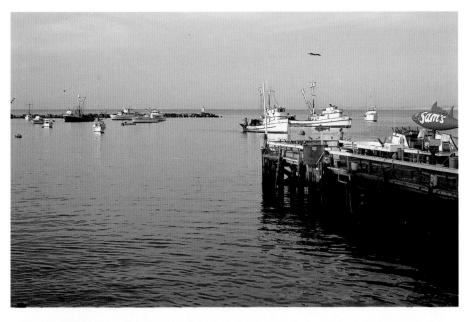

Actual shot of a day at Monterey. You can see that it really was sunshine and fair sailing, but in my mind I always pictured California's Monterey Peninsula as foggy, so that's how I painted it.

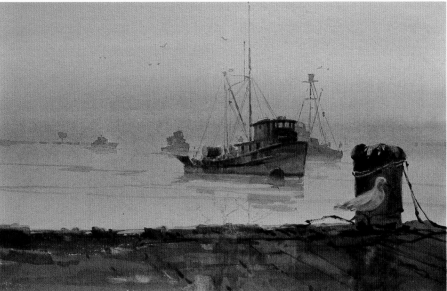

Monterey Mist (20x30). *By closing my eyes and visualizing the scene the way I wanted it to look I knew where to go with it as soon as I started to paint it. A wash of raw umber and cobalt blue was laid down over the paper (except for that stupid gull which I should have drawn facing in to the picture. See? We must never stop using our noodle). Fog is lighter at the top and heavier as it gets lower, so more color was added as I brought the wash down. I changed the boats from being light shapes against mid-value to dark mid-value shapes against light mid-value, and then let the picture tell me which way to go, even though I like to be boss. (I guess that I'm a typical Leo, King of the Jungle. All I need is a stage and an audience and I'm in my element.) However, there are times when natural instincts must be suppressed!*

ensure that I keep the total sky wet, which enables me to move it around as I want.

If the sky should happen to dry in one area, as it often does in the 100° heat of an Australian summer, then critical decisions must be made. Can I spray water into it without losing the lot? If I turned my board upside down would I have more hope? Should I wait until it's all dry and see how it all looks then? Can I possibly push some stiffer paint into that wet part or will that muck it up?

Oh! There's a great bit over there—it happened all by itself while I was worrying about the other part! Holy Moly, how can I risk losing that bit? Uh-oh! Now it's all dry! W-e-e-e-ll, it doesn't look too bad after all that. Why was I so worried? That other bit seems O.K. Luckily, I didn't have time to touch it! If I put a couple of birds over in that spot, it will work just fine. These are the traumas of watercolor. Decisions, decision, decisions. If only my daily dilemmas were confined to whether to have mustard or pickles on my sandwiches!

If I have done everything right, then the sky should have taken about five or six minutes to paint. You must resist the temptation to go back into it again. Resist it at all costs. Wait until the rest of your painting is completed, and you'll often find your fears were groundless. Your sky has worked.

Believe me, no sky has ever turned out exactly as I had planned it. They average about 50/50—half are better, half not as good. That's how to accept them. If one doesn't quite work, then surely the next one will.

There's no solution or recipe for painting skies. Again, it's a matter of observation. Every time you walk outside, look up at the sky. Note the cloud formations and colors, note how the blue sky overhead is warmer and stronger than the distant blue, which is paler and cooler until warmed gently near the horizon. Whenever you have a spare moment, paint some skies, no matter how small. As well as learning about skies, you'll learn a lot about watercolor.

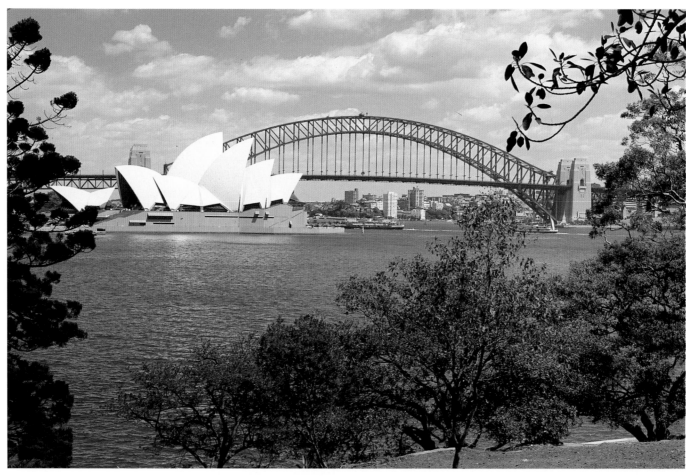

Reference photo for Sydney, The Opera House.
PROBLEM: I'm tired of picture postcard renderings of the Sydney Opera House, but it's a pretty day with a blue sky and sunshine. How can I create some atmosphere for this marvelous building? Maybe I should give it an air of mystery?

Sydney, The Opera House (15x20).
SOLUTION: Great, now you're starting to get on my wavelength! Let's make the sky a mysterious dark color, to act as a foil for the soaring sails. Although I usually use no more than two washes in sky areas, glazed washes of raw sienna, rose madder genuine, and purple will give us the kind of atmosphere we're trying for. At times like this it's important to know when to quit; too much work and you get mud instead of sky.

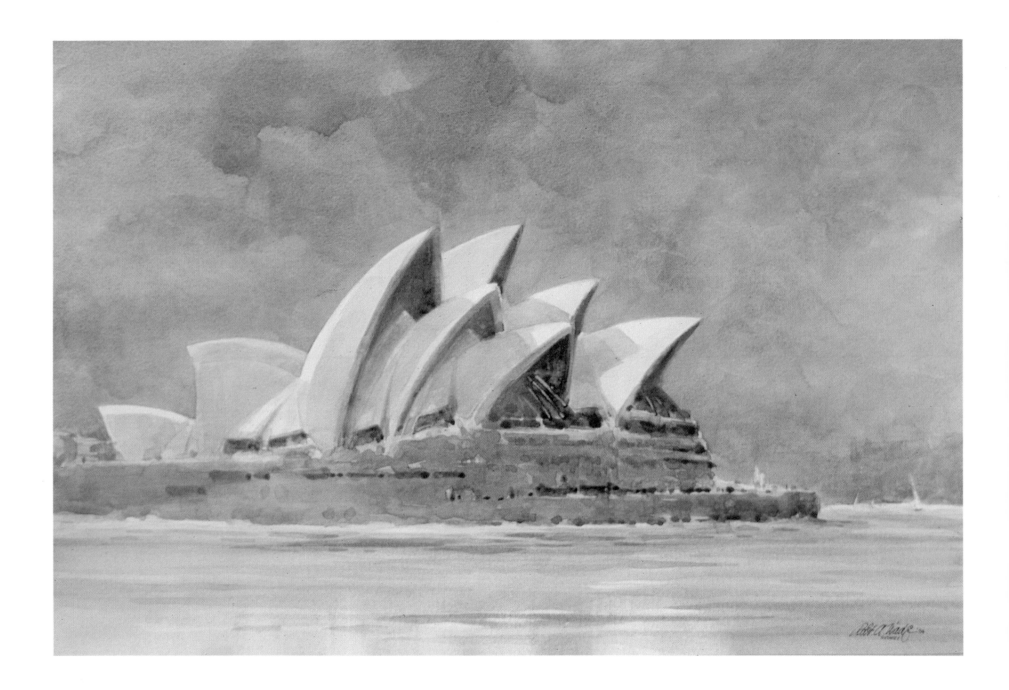

The Sea, Boats, and Water

Have you ever sat on the rocks feeling the spray of the breakers, the keen wind on your face, the squawk of the gulls, and the smell of the salt? Have you walked lonely beaches, damp sand scrunching beneath your feet as you left solitary tracks like Robinson Crusoe? Have you stood on a wind-swept jetty at break of day, awaiting the return of the fishermen so you could sketch the unloading activity? Have you completely ignored howling gales and driving rain as you tried to sketch with fingers numb and blue from cold, your sketchbook soggy and your pencil hard to hold? If you haven't, then how can you expect to get those sensations into your painting?

Bass Rocks, Cape Ann, Massachusetts (22x30). *I want you to see how cast shadows from foam and spray are just as important in a seascape as in a landscape. Note the runoffs and back runs of the foaming surf. Also look at how effectively the rough brushstrokes show the texture of the rocks. Wow! Mind the splashes!*

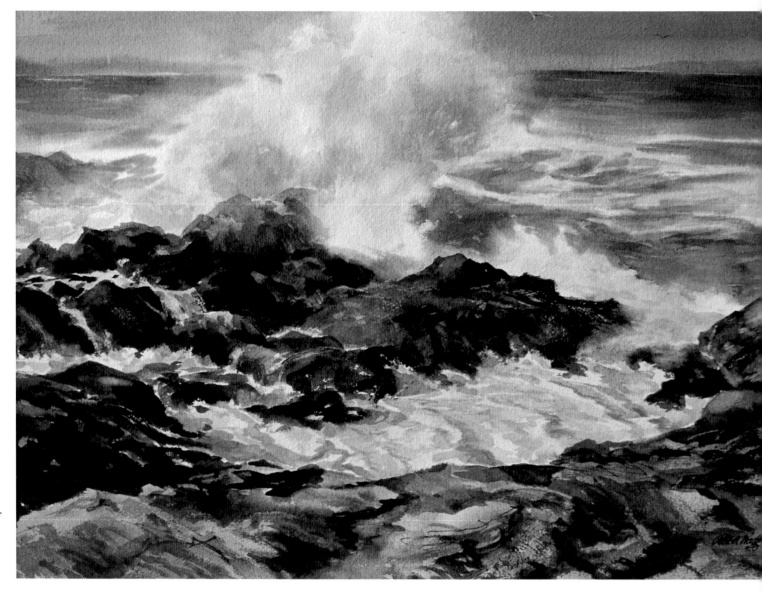

Painting is very much a feeling situation, not just a looking and doing activity. Remember, your camera doesn't have this sensitivity; that is the artist's sole prerogative. If boats and marine subjects are your interest, then you must frequent boatyards, coastal villages, piers, jetties, beach resorts—any place close to the objects you wish to paint. You must study the construction of boats in dry docks or on the slips so when you see them in the water, you will know that there's a lot of boat under there. That way there's a chance your painted boats will sit in the water naturally.

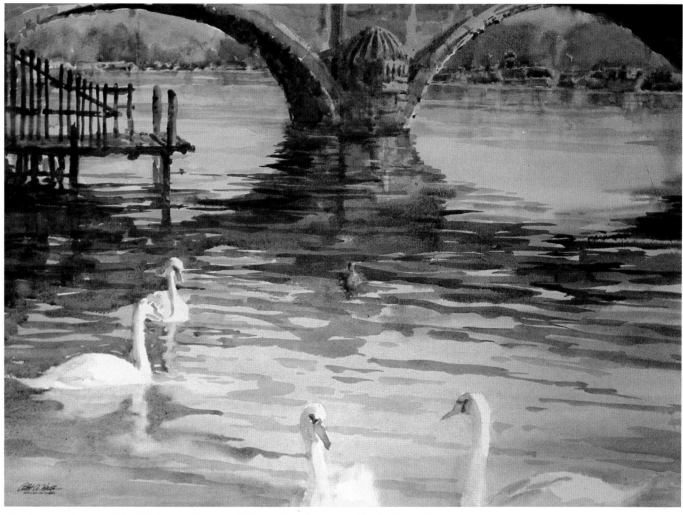

Henley on Thames (20x30). *My subject here is the gently moving water of the Thames. The reflections of the graceful arches of this elegant stone bridge are broken up by the water's movement. The colors reflected by the water are a little darker than the objects themselves. See how the soft edges of the swan don't intrude on the center of interest?*

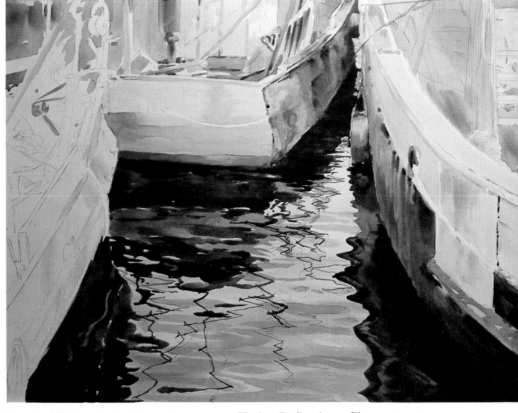

When you're studying boats and marine areas, take scads of photographs to record facts you can study later in the comfort of your home. And draw everything. Don't waste a minute while you're surrounded by subjects that interest you. (If you don't know what I think about drawing by now, then this book is a failure!)

Value sketch for Harbor Reflections. *Some years ago, my old pal, Tom Nicholas, NA, took me for a short tour around Cape Ann, visiting many of his favorite painting spots. Here's how this Gold Medal watercolor started. The strong abstract patterns created by the boats and their reflections grabbed my attention immediately so I put down the simplified shapes in felt pen, and there was my basis.*

Detail of Harbor Reflections. *Because my whole painting depended so much on the reflections, together with the feeling of looking down into the water under them, I decided to paint the water first. Incredibly it worked first up for me! Quickly I masked that whole area out with clear plastic so that I wouldn't be tempted to fiddle with an area that needed to be left alone!*

Harbor Reflections, Gloucester, Massachusetts (20x30). *This painting needed a lot of simplification in the transition from color slide to watercolor. That's where value sketches come in handy. You wouldn't try to find your way around a strange city without a map, would you? No way! This situation is no different; you must know where you are trying to go! Note how important the rigging lines are in conveying the information that the boats continue beyond the picture plane.*

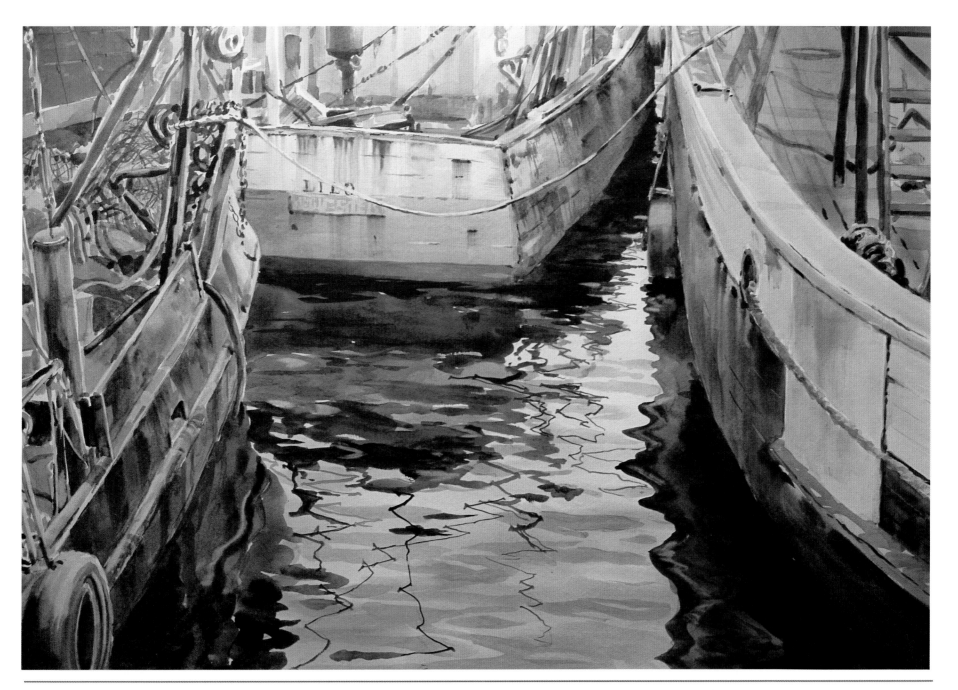

As in every area, perceptive observation is important in marine painting, too. There's no use looking at seas, boats, rivers, brooks, or bridges unless you can look with an artist's eye. As artists, we're fortunate to see things other people miss. We can discover beauty and interest in all kinds of diverse forms, but mind you, this only happens when we look with the right mindset—perceptive observation. Seek the highlights, search for the pattern, relate shapes and forms, then examine your reaction to all these elements and you'll finally make your own decision as to how you will portray it.

Much can be learned by simply watching water and learning how it is affected by different lights, winds, and locale. For example, lakes and rivers are very different from the sea. The sea is never still. Even on the calmest day there's some movement of waves. Lakes and streams, on the other hand, can be so motionless that reflections can be mirrored on them almost without ripples.

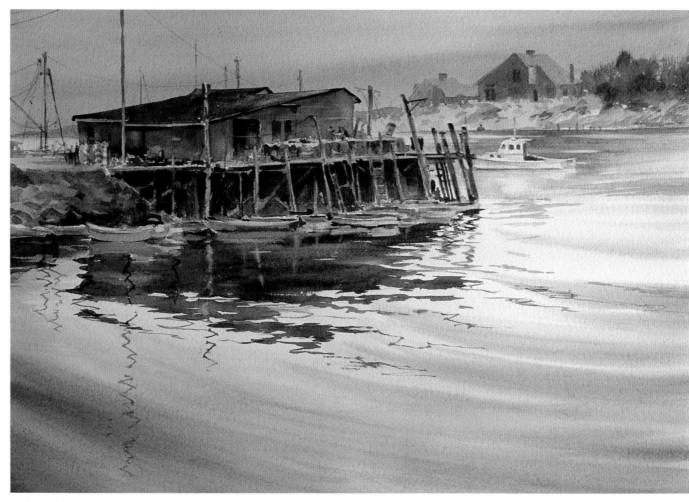

Gray Day on the Kennebunk, Maine (22x30). *The soft, sweeping ripples were painted while the underwash was still wet to blur the edges. I ran the reflections over this only when it was completely dry.*

If there are docks or piers near you, set off early one morning with sketching gear and a box of sandwiches and dedicate an entire day to learning. Don't think of turning out a masterpiece, only note down important facts to help you in future paintings through first-hand knowledge of the real thing.

Find a good spot with interesting boats and reflections for your center of interest, then get comfortable, and just watch for at least an hour. Note the reflections and the way they change with the differing light; how they'll diffuse as a current of air disturbs them, how they'll break up in the wash of a passing boat, how they'll generally be darker than the light objects and lighter than the dark objects they're reflecting. See how the reflections of verticals, such as masts, are longer near the object, and get increasingly shorter and more broken up as they come nearer to you. There's so much to watch that the day will pass so quickly you will wonder where it went.

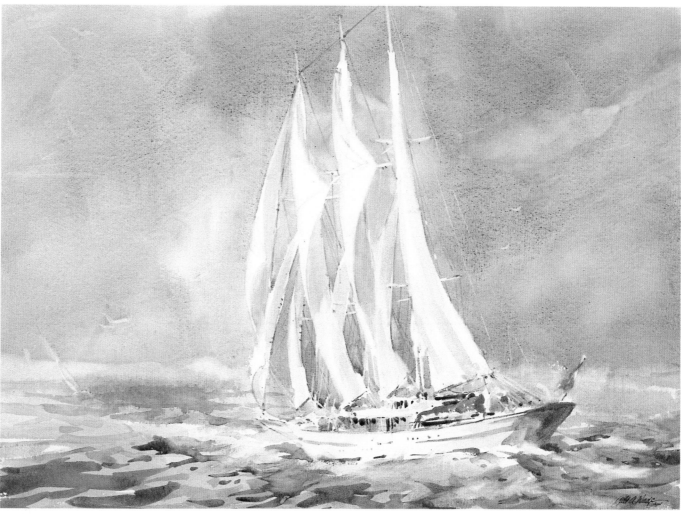

The Tall Ship (20x30). *Simplicity is the keynote. The sky is a wash of varied intensities of French ultramarine and raw umber flooded onto my paper, allowing me to perform some pretty fast brushwork around those seemingly intricate sails. There was no masking out done anywhere here. All white areas were reserved by cutting around them with a 1-1/2 inch flat, which was used for the entire painting, except for the rigging lines right at the end. For the sea I simply used the sky colors with more pigment added. The upthrusting darks in the water indicate the swells; there are only a few to give the feeling and nothing more. The boat was treated as broadly as I could, leaving much to the imagination, but the darks of burnt sienna with French ultramarine were accurately placed to give shape, form, and credibility.*

Stretch your legs for five minutes, select another boat, and draw it in your mind. Try to feel the pencil encircling the silhouette of the vessel, while taking careful note of the main features such as the mast, cabin, funnel, and lifeboats. Also note where they are in relation to each other and the rest of the boat. Squint and view it through your eyelashes to eliminate extraneous detail. By doing this exercise, you are programming your mental computer.

Dry Dock, Gloucester, Massachusetts (12x12).
PROBLEM: How do I know what a boat looks like under water? I can't get under there and look for myself.
SOLUTION: Boats out of the water allow more careful study of their construction. Look for them in dry docks or on the slips so when you see them in the water, you will picture the rest of the boat under there. Besides, they make interesting shapes in a painting, too.

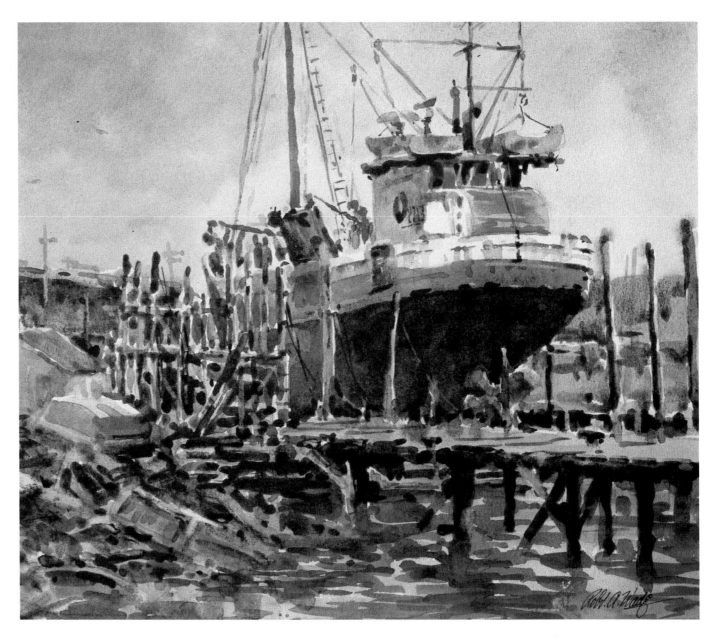

Misty Blues, Portsmouth, New Hampshire (12x18).

PROBLEM: You keep talking about "abstract qualities" in paintings, but your work is really so traditional. I'm confused.

SOLUTION: Abstraction is the process of reducing subjects almost to blobs of color, then building up interesting patterns by all sorts of devices—that's my interpretation of it anyhow. The placement of shapes creates movement and direction by the juxtaposition of color, texture, and value. It's important to get a good pattern going in your paintings, too. So start off by seeing your subject in abstract terms to help you arrive at a strong pattern for your picture and simplify all the elements in it. Squint through your eyelashes, hold the picture upside down, then sideways to see the pattern and its design. Note the aerial perspective, the very simple water wash, the way I've suppressed detail, and the gentle color scheme.

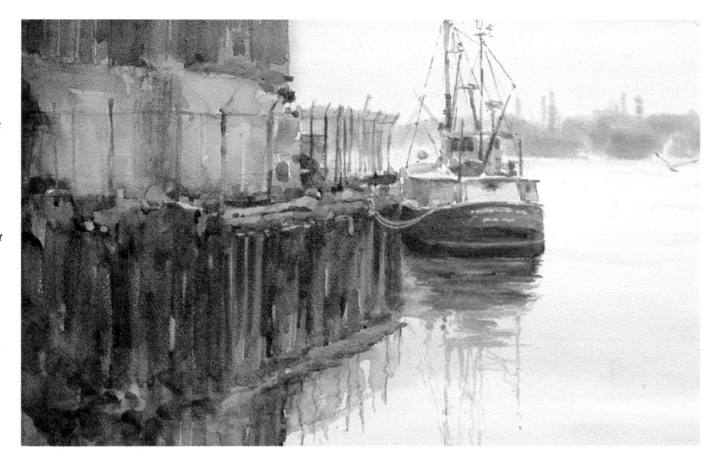

Later on, when faced with the need to draw a boat, your experience will help you in turning out a boat that looks like a boat.

Time's up—move on to another boat, preferably a different size and shape, and repeat the exercise. When you're done, return to your first vantage point and notice how the reflections have changed in the hour or so since you last observed them.

By now you should feel hungry and mentally fatigued after all that concentration, so take a lunch break. It's a good idea to return to your car, listen to the radio, and switch off mentally from the morning's activity, giving your batteries a chance to recharge. This afternoon, plan to make some sketches to reinforce the information gleaned from this morning's session. Don't try for finished work, just take sketch notes. Work in any medium you're comfortable with, though I'd prefer you to paint the reflections in watercolor because the wash retains some of the character of the water. Keep your sketches small, no larger than 10x8.

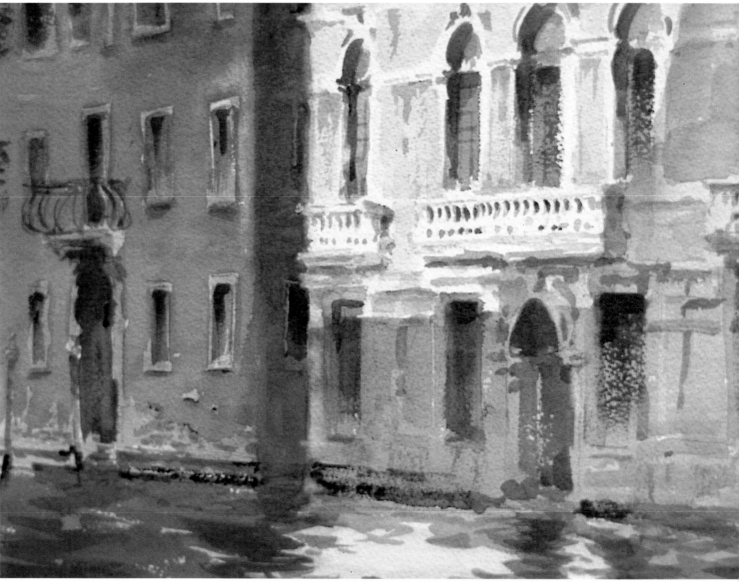

Venetian Facades (10x14). *The golden color of the facades appears in the murky waters of the canal, so you must paint it there first, before you attempt to* *lay the darker colors over the top of the water. Make sure that the underwash is bone dry before you do it.*

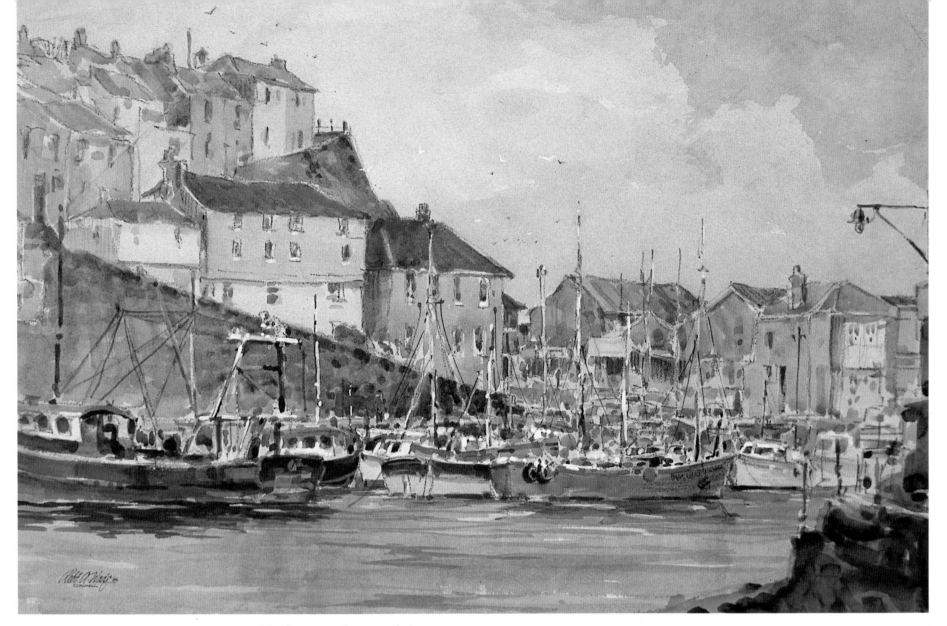

Mevagissey, Cornwall (15x20).
This is one of those busy Cornish fishing harbors. There's so much to paint that it's a toss-up where to start! I used a Turner gray-tinted paper, drew with a brown carbon pencil, then dropped in the washes of watercolor. I've really oversimplified the shapes of buildings and boats to avoid confusion.

When you finally gather up your gear and return to your vehicle, put a spring in your step and a smile on your face, because today you have made a positive step toward understanding some of the problems confronting marine painters.

There are so many wonderful subjects wherever water and boats are to be found—large boats, ships, sailing craft, boat sheds, dry docks, rowing boats, lobster pots, and the people who build, maintain, and sail the boats. If this is your scene, you'll never be short of a subject.

Swanson Dock, Port Melbourne (20x30).
PROBLEM: How does the movement of waves, such as when the wind's blowing, affect reflections?
SOLUTION: When wind causes ripples across the water's surface, there can be no reflections in that spot. And that's what happened here. The otherwise mirrorlike images are lost in the disturbed surface. Comprendez?

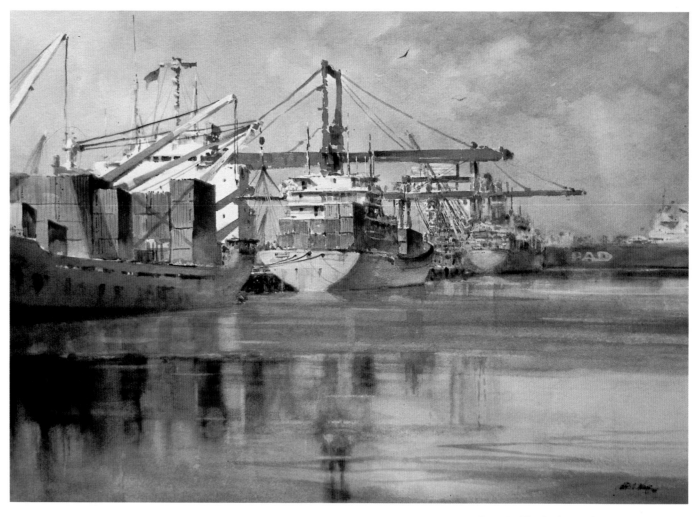

Fish House Morning (10x14).
PROBLEM: Here's a very simple, small scene—the sort you'd see along the coast anywhere in the world. Is there anything different I can do with it?
SOLUTION: Make a lot out of the warm light bounce from the sand. It has a lovely effect on the shaded side of the boat and the wall of the fish house. I'd
play up those warm lights to give the painting a good feeling. Highlight on the beached boat is very important here, too, to catch that strong line running through the sketch. Look at the placement of the boat in relation to the dark shape of the doorway, which needs to be broken with some invented shapes to prevent it being boring. I guess that's
about it. No, I almost forgot to point out how some soft wet-in-wet trees in the distance help to create the morning mood and how the sign breaks up that boring wall.

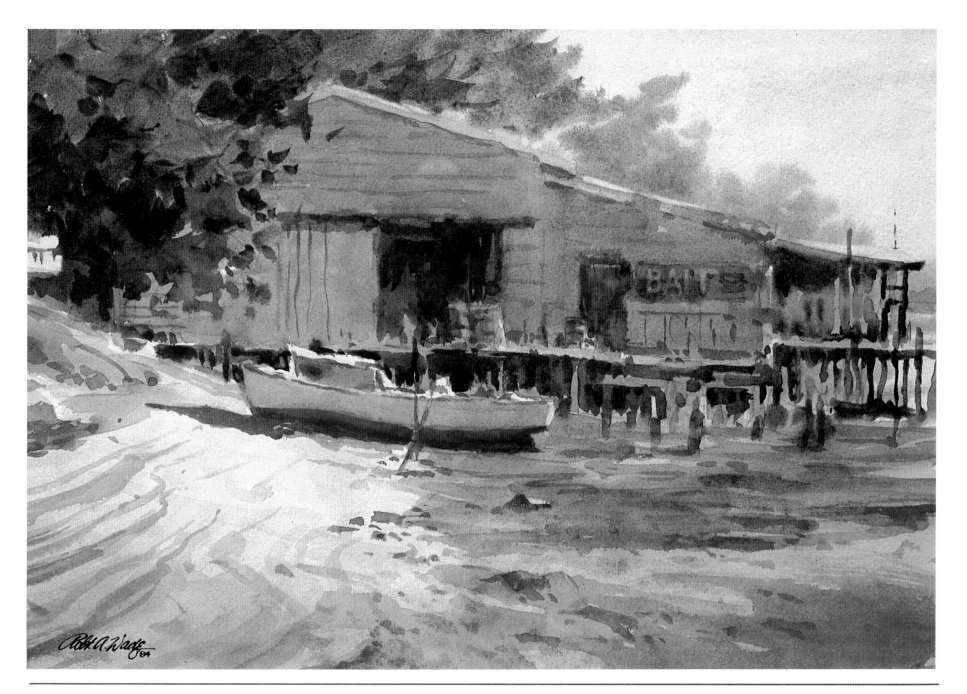

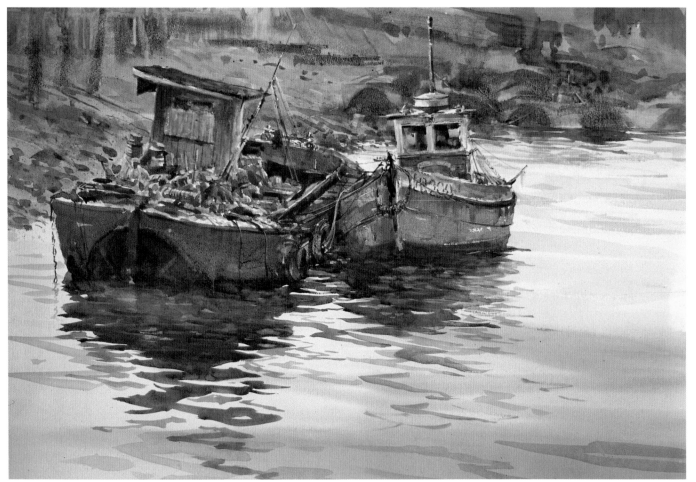

Key Thoughts

• Paint a lot of postcard-size sketches. They're great fun as well as a great way to boost your confidence in your painting skills.

• Don't fiddle—fussing won't make your skies any better and may make them worse!

• You can't paint what you don't know. You've got to go down to the sea if you want to paint it with conviction.

• Good painting is not a matter of fashion, formula, or fantasy; it is the expression of honest emotions.

Thames Veterans (20x30). *These battered old hulks don't rate a second glance from the average tourist or passerby. However, artists will jump for joy at such an interesting array of shapes and textures. The water was treated simply to act as a foil to the busy areas of the barge shapes.*

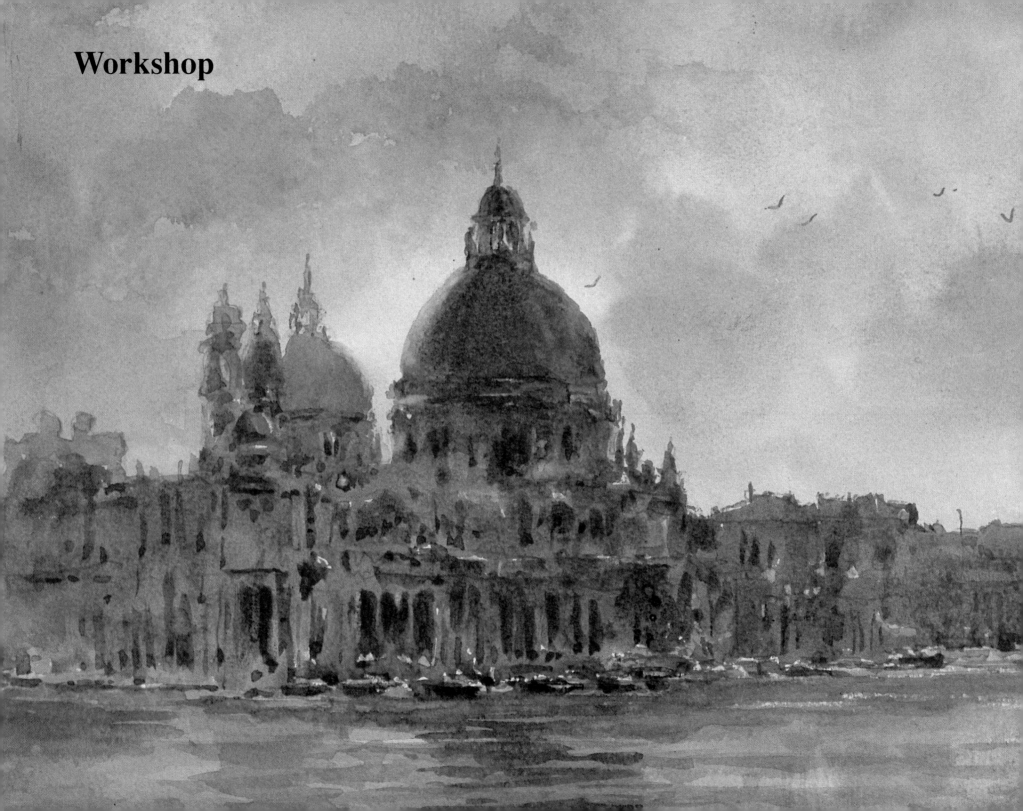

Workshop

Ship's Painters

I chanced to see this subject at the Container Terminal at Sydney Harbor, and almost fell out of the ferry in my excitement! I believed this was going to be such a great subject that I thought about it for at least six months before I was game to tackle it. I was terrified that I would ruin it unless I'd mentally painted it over and over to clarify exactly what plan I'd adopt when the time came to confront that hideous blank sheet. It went almost as planned, but only because of all the mental preparation that preceded the painting.

Here are my reference sketches for each of the six painters. Notice how I've suggested each one rather than putting in a lot of detail.

Details of pencil drawing.
This is one of the very rare occasions
where I've used a masking medium.
Because of the many variations I
wanted to get in the hull, there was
really no other way I could have cut
around ropes, figures, rollers, and
planks. First I made a very precise
drawing from my sketchbook notes.
When I finally rubbed away the masking
solution, it was like rubbing off the
silver on a lottery ticket and finding a
big prize underneath!

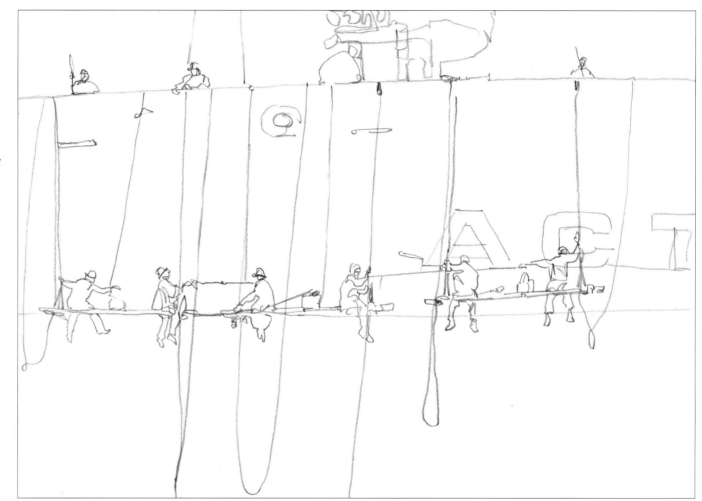

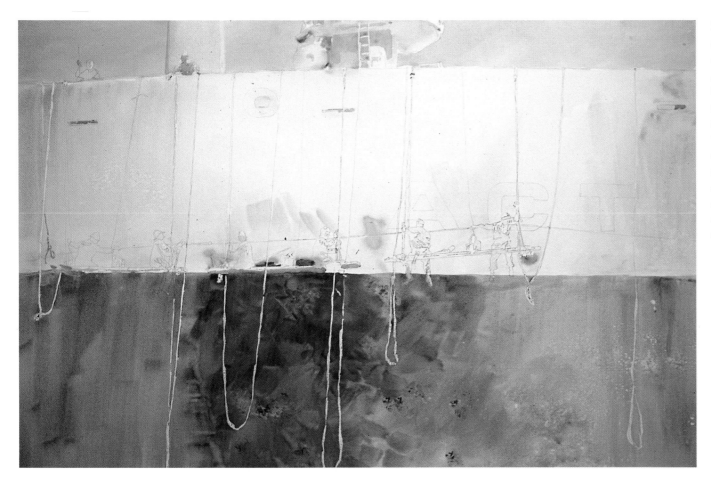

The completed underpainting.
Note the warm sky wash. When I put the blue over it, the result was a beautiful glow. I sloshed color very freely onto the dark, rusting hull, making no attempt to smooth out the marks of my brush. At this stage I sprayed clean water over the wash, encouraging runs and dribbles by tilting and twisting my board. I added more color into this liquid here and there, and when it seemed to be settling the way I wanted, I dropped salt into the drying wash to obtain more texture.

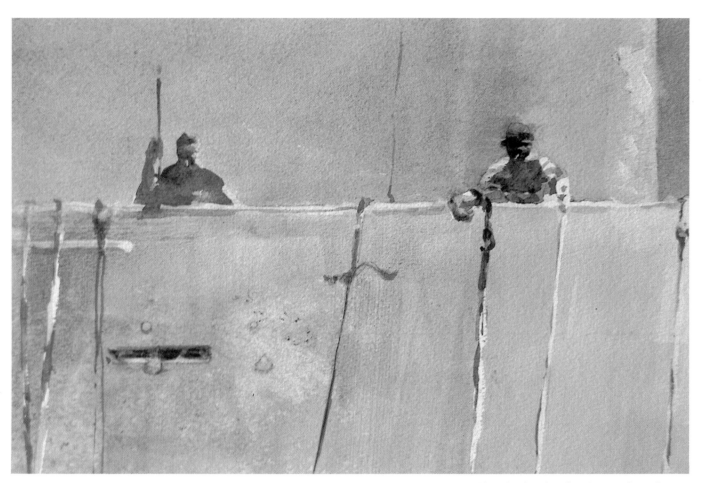

There's the sky glow I was after, from cool blue over warm orange/red. See the variety of edges in just this small section of the painting?

Ship's Painters (30x40). *This is larger than I normally care to paint, but it was such an outstanding subject that I felt it warranted a big treatment. Apart from the figures, my brushes were two-inch and one-and-one-half-inch Robert Simmons Skyflow flats. This painting hung in the American Watercolor Society's Annual Exhibition at the National Academy, New York, in 1981, and is now in the Australian Maritime Art collection in Sydney.*

Note the texture from the salt at the lower left where I let it stay until bone dry. I rubbed the salt away in the rust area while it was still a little soft and damp. Some of the wet color was soaked up by the absorbent salt, leaving a beautiful, mottled texture. I removed the masking fluid and added subtle shadows to the dangling ropes.

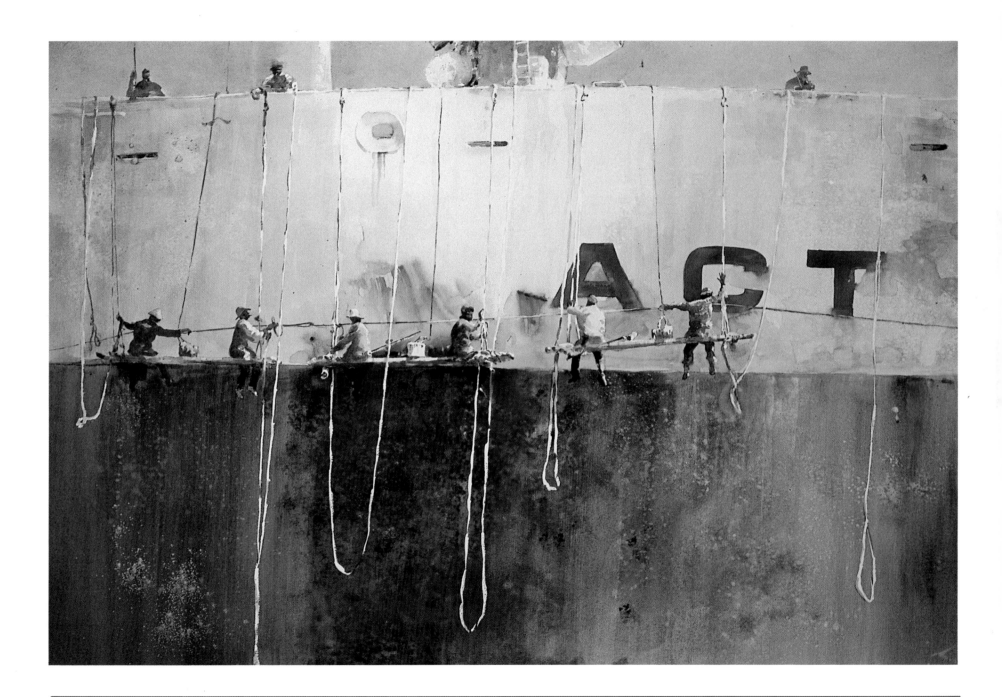

Pulpit Rock

Charles and Judith Reid recently came to Australia to visit us, and while we were all staying at our summer house, Charles and I painted for several days on the magnificent Cape Schanck, which is only five minutes away from the house. On this particular day, we climbed down the wooden walkway to the end of the cape and clambered over the rocks to reach the little cove. There before us was this great view of the wild seas with Pulpit Rock towering above all.

The waves came crashing right up the rocky beach, then gurgled and sang as the water ran back down through the stones to find its way to the sea again before the next wave repeated the process. Gulls screeched, the wind screamed, the foam flew, and we had to yell to each other in order to be heard—a magical time. I found a good spot away from the wind and guessed from the sky that we probably had about forty-five minutes before the weather turned nasty. Exactly forty minutes later I'd finished my half-sheet and, looking again at the

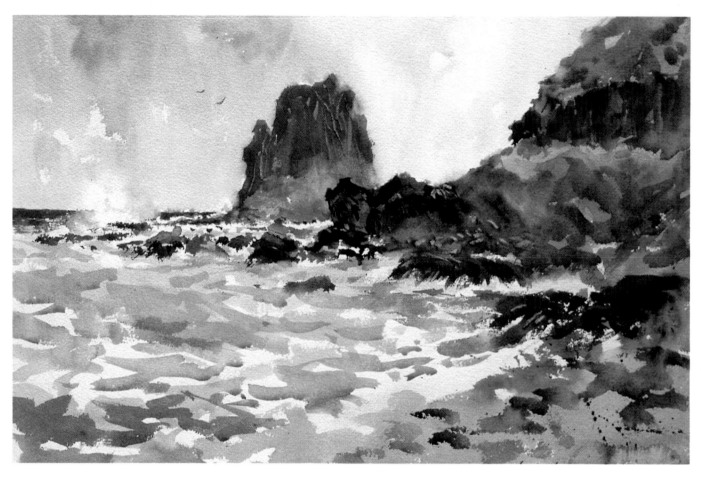

ominous sky, called out to Charles, painting about twenty yards away from me, "Come on, Carlos, let's get out of here fast!"

Within five minutes, down came the rain. We struggled up the cliff, holding paintings face down to protect them from the rain, while trying to hang onto our hats at the same time. My hat blew off. Charles had to protect my watercolor while I climbed over the safety fence and rescued the hat before it went sailing over the cliff. Then we continued our climb.

We paused at the top, water streaming down our spectacles and dripping from our noses, and Charles remarked, "This is what painting is all about. If you haven't experienced

This is the half sheet, painted in forty minutes from "go" to "whoa."

something, how can you hope to paint it?" I couldn't have agreed more—and it's something for you to think about. At any rate, it was an unforgettable experience, one we'll both treasure.

A week later, back in the studio, I thought I'd like to try it again for this demonstration. I felt upon reflection that the original watercolor seemed too warm. Probably I was influenced by the events after I'd painted it, so I decided to recreate the feeling for the Cape which I now had in my mind. I lifted the horizon about an inch on the paper so I could dramatize that almost sinister-looking rock. I also enlarged that big burst of spray. The shapes are roughly indicated in pencil, but with no detail since I planned to draw with my brush in this case.

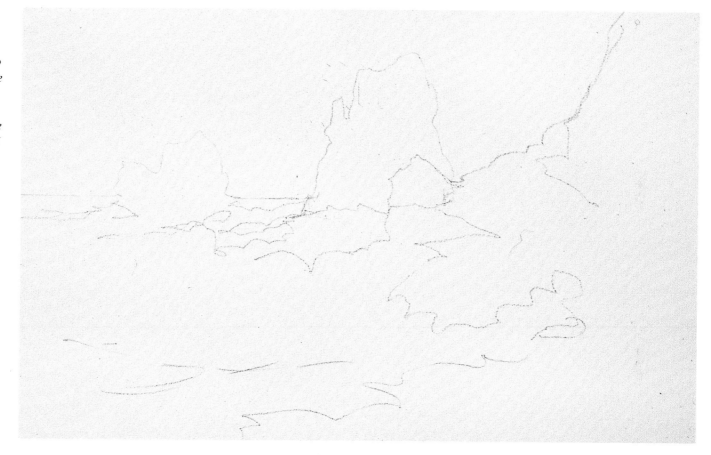

I wet the sky area with clean water and laid the dark clouds in with cobalt blue and a touch of light red, adding heaps of water to let the color run down the sheet and right under the rock shapes. A patch of blue on the right gave the feeling of clouds scudding with the wind. After the sky had almost dried, the top of the rock silhouette was painted in with a good stiff mix of cobalt blue and burnt sienna. Then a lot of water was added to the color as I continued down into the form. I blotted some areas with tissues in order to get the feeling of mist between the two rocks. At this stage I decided to drybrush a few of the small rocks below so that their darker values would start to set up the correct value pattern through the painting. The dark sea was also touched in, indicating the horizon. Now the mood was established, even at this very early stage of the painting—this had taken only about ten minutes.

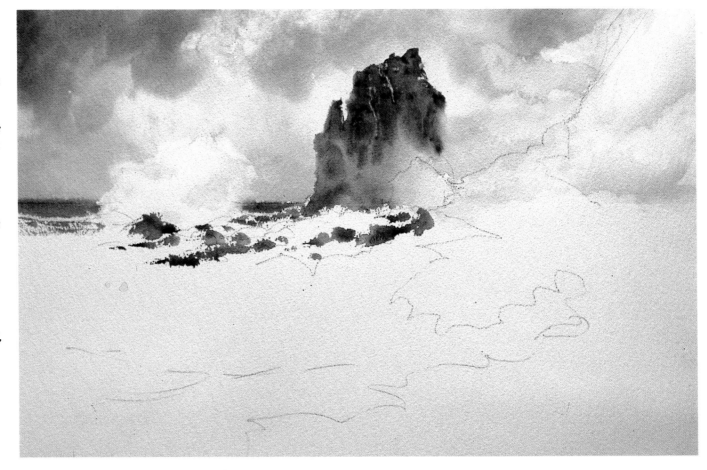

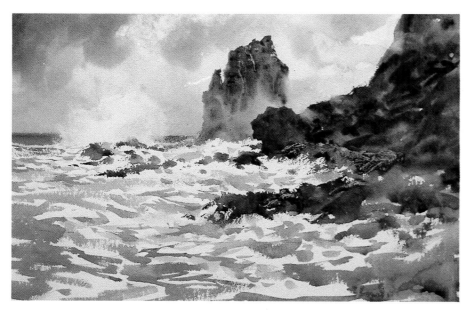

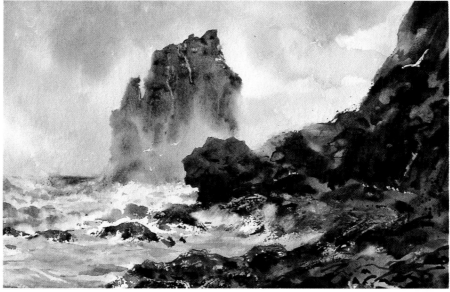

The cliff was painted boldly, allowing the French ultramarine and burnt sienna to mix right on the paper. Here and there I wiped with tissues to create light planes or to lose edges. I dashed in the sea, trying to get the brush to follow the action of the surf and waves.

Notice how the rough drybrushing gives a great feeling of the surf, even though later on I will probably soften some of those edges.

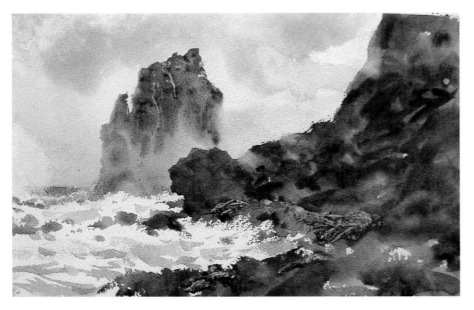

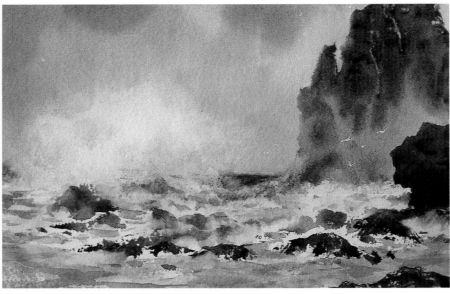

Here you can see where I have softened some of those edges.

That big burst of spray works because all the edges are very blurred.

To complete the painting, I worked on edges with a clean wet brush and facial tissues, softening wherever I felt it was necessary. I added a few rocks on the left in order to balance the big mass on the right, put some color variation into the sea, added some gulls with opaque white, then came the hardest part... stopping before I fiddled with it too much!

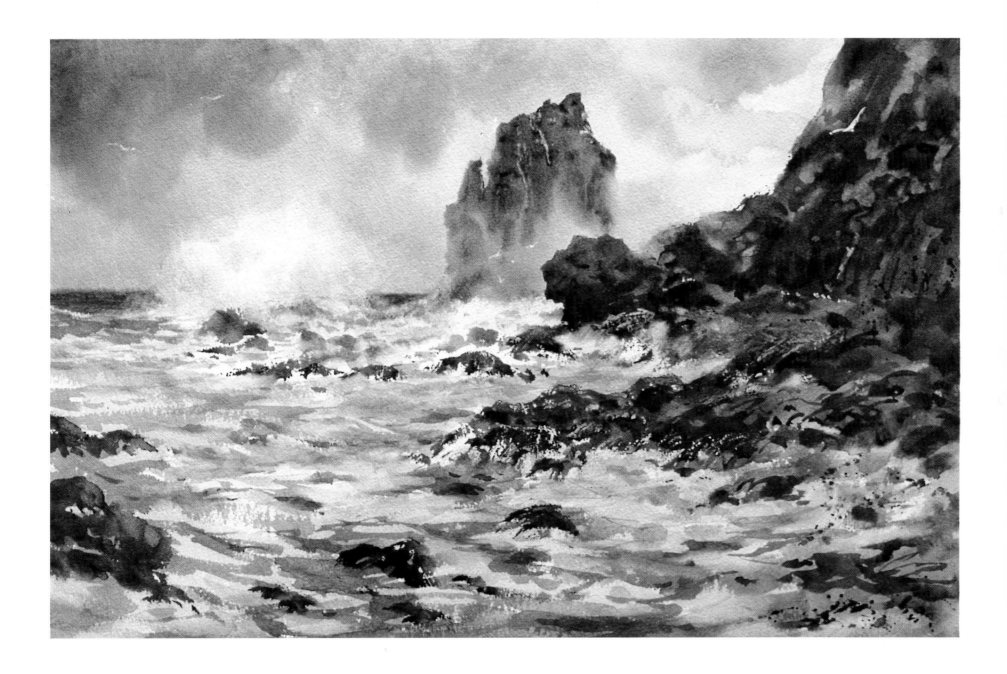

Venetian Skyline

The superb glow of the Venetian evening sky is just a perfect subject for wet-in-wet watercolor. Looking toward the entrance of the Grand Canal from the Lagoon, the beautiful sky is silhouetting the wonderful shape of Santa Maria Della Salute's dome and towers, which at once identifies the setting as Venice....Where else?

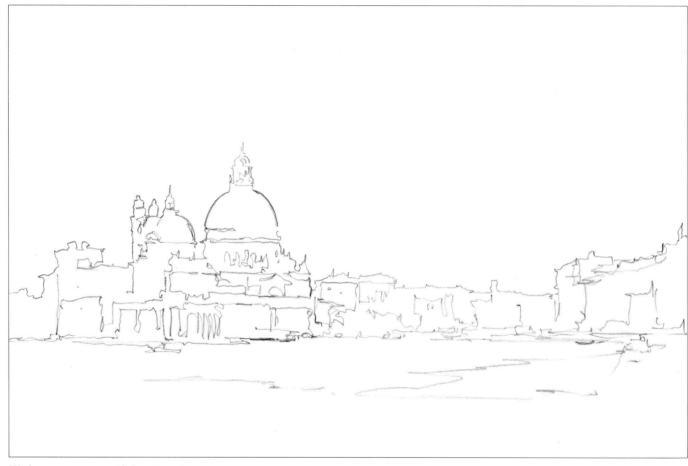

With a contour pencil drawing, I indicated the shapes of the buildings roughly, although I had to be reasonably accurate with the shape of Santa Maria, one of the world's best-known buildings.

I wet the sky area on my half sheet of Lana Rough paper with clean water, brushing it on freely with a two-inch flat. Then I dropped areas of aureolin, rose madder genuine, plus touches of cobalt blue into the damp surface. I encouraged these colors to flow and run of their own accord by tipping and tilting the board while the washes were very wet. I also used these colors in the water of the Lagoon, blotting it quickly.

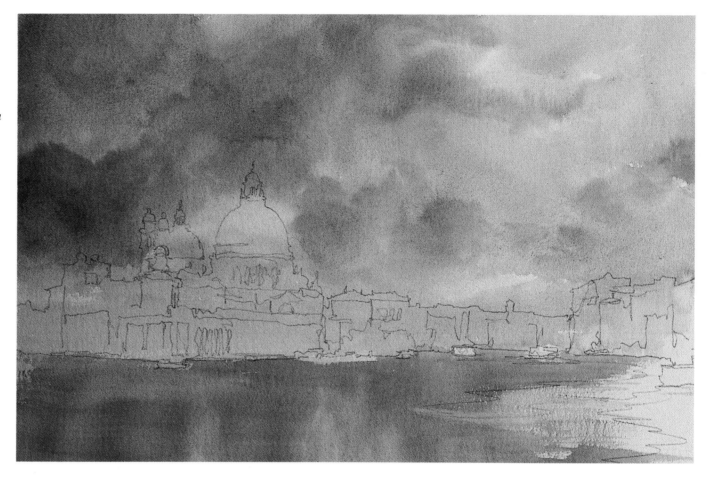

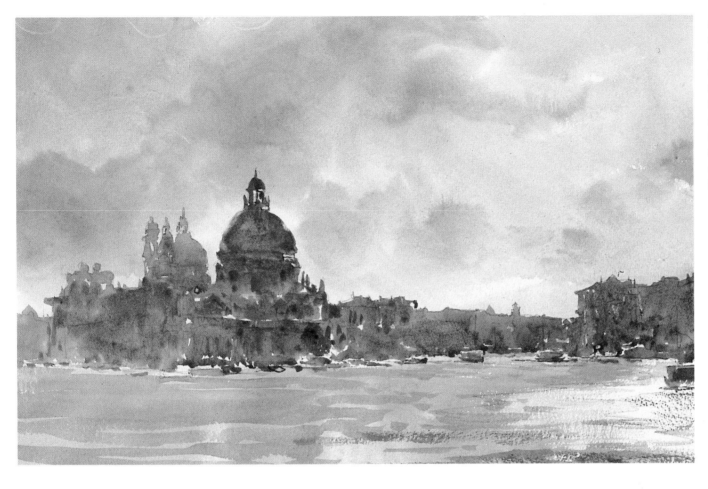

Can you see how much lighter the sky is now that it's dry? This is a characteristic of the watercolor medium you must always bear in mind. Working on the dry paper, I brushed in the buildings, making frequent color changes of contrasting warm and cool to ensure that the buildings joined into one continuous shape. I also remembered to leave spots of white paper here and there for highlights.

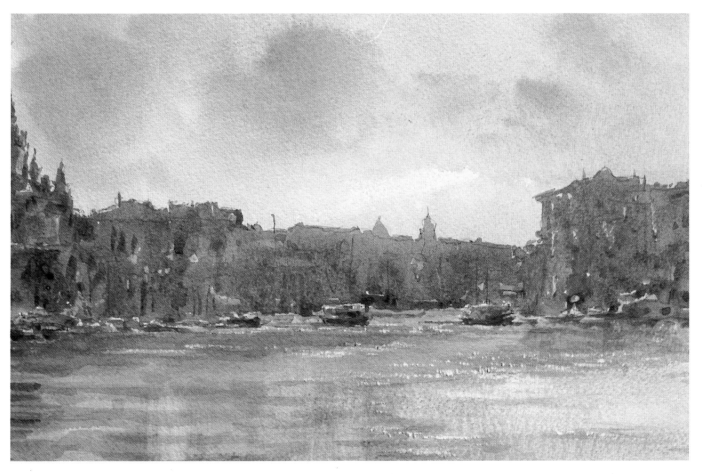

Note the color changes. All were worked in while painting the buildings in one hit. Can you feel how they glow? I lifted out the sparkles on the water with an X-Acto knife.

Venetian Skyline (15x20). *I picked out a few lights with an old X-Acto knife and touched the edges of buildings with cadmium orange to give them highlights from the setting sun. Now there's a bit of a shimmer. I sprayed some clean water from my spray-bottle right over the top left of the sky area, blotted off the excess water, then dropped a few more clouds into the now damp paper. Then I put in a few dark details broadly to indicate boats, doorways, pillars, and so on—and I stopped.*

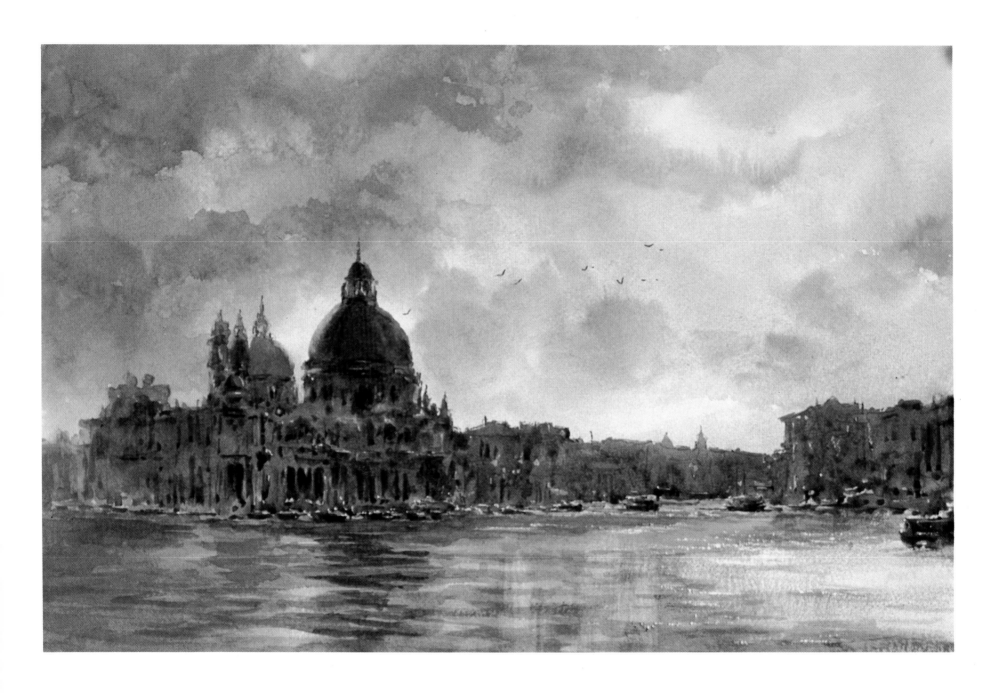

Conclusion

My sincere hope is that this book will be of everlasting value to you and a reference source in your quest to be an artist. John Pike's book *Watercolor* was an inspiration and motivating force to me many years ago. It still stands on my studio bookshelves to be thumbed through regularly, as I remember some observation he made.

I guess I have just about every watercolor book published in the last thirty years or so. I enjoy going through them regularly, trying to envisage the methods and thoughts of the authors. It's a great way to learn. The business of learning goes on forever. We are lifetime students, because we must never find the ultimate solution. Degas said it all, "I must impress upon myself that I know nothing at all, for it is the only way to progress."

I have this strong feeling that somehow I was meant to do what I am doing. Even on my birth certificate the word "artist" appears under my father's occupation. So right from my first moments, I have been associated with art, and if I'm lucky, I'll continue to be right up until my last.

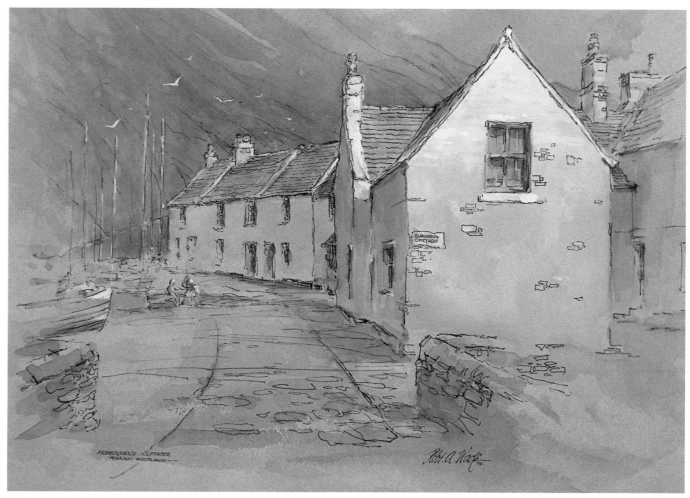

Cottages, Pennan, Scotland (11x14). *I am working on tinted paper—Turner Gray again—drawing with a waterproof felt pen. I followed that with subtle watercolor washes, and finished with touches of opaque white softened with clear water. It's a simple subject but has charm because of the selection of this personal range of materials. We have many options available, so never tackle any subject without thinking a great deal about different approaches to it. Try it your way!*

How has it all happened? I don't know. It's all a bit of mystery really. I think it has a lot to do with making the most of oneself, because talent is relative only to the use you make of it. The most naturally gifted artist of all time could waste that talent and it would mean nothing. On the other hand, a far less gifted artist could maximize that talent to its very limit, gaining a deal of success and making a big contribution to art in general.

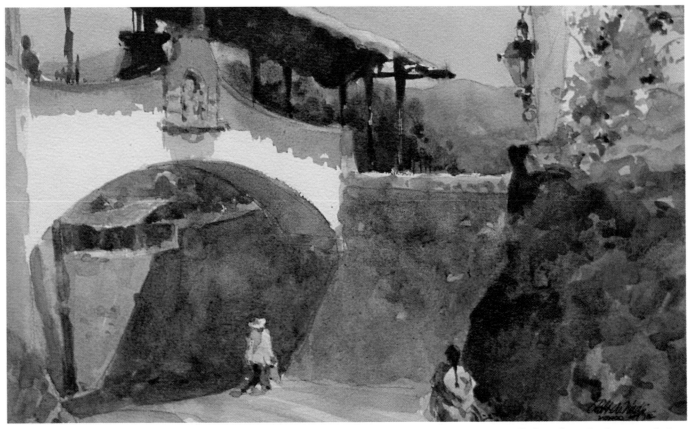

Rancho Victoria, Taxco (11x14). *Here are some more examples of how our senses have been heightened through perceptive observation. We see the highlight reservation of the bridge over the roadway, on the edges of the walls, and around the figures. We also see the glow of light bounce in the underside of the arch. The texture of the Roman tiled rooftops is shown at their edge and again defined by the shape of their cast shadow. Observe the way the peon carrying his heavy parcels up the hill leans forward and sideways, and the blurring of edges of the figures, allowing them to fit naturally into their environment.*

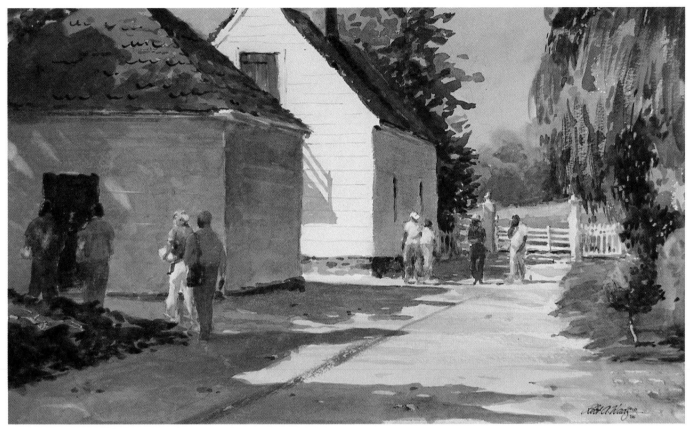

Robert Henri once said, "A great painter will know a great deal about how he did it, but still he will say, 'How did I do it?'" The real artist's work is a surprise to its creator. This is because a great painting almost paints itself. The artist feels like a spectator as the painting unfolds despite all efforts to control it. This happens on very rare and precious occasions in one's painting life. When and if it does, savor every moment, for it may never happen again. And accept it as a reward for your devotion to art and dedication to success.

Mt. Vernon, Virginia (15x20). *George Washington's home on the Potomac attracts thousands of tourists. No wonder! I could feel the atmosphere so strongly that I expected a fife and drum band to march around the corner at any minute. Look here for so many of the things we've discovered in this book—Value Range, Highlight Reservation, Light Bounce, Figures, Shadows, Textures, Gesture, and Pose—all in one painting! With perceptive observation you can see things that "normal people" just never notice. (Gosh, I wish I'd made the edges of the foliage a bit softer....)*

It's the concept that makes a painting great. Neither the subject nor the artist's technical expertise can make it happen without that spark of vision that transforms the ordinary to the extraordinary. It stems from the initial perceptive observation of the artist. That's what will decide the painting's ultimate destiny.

Whenever Ann and I sit down to dinner on our travels, we give thanks that we are in whatever country we happen to be by raising our glasses and drinking a toast. And now I can't think of a more appropriate way to end this book. So, here's to watercolor. May magic flow from your brush and may your water jar runneth over!

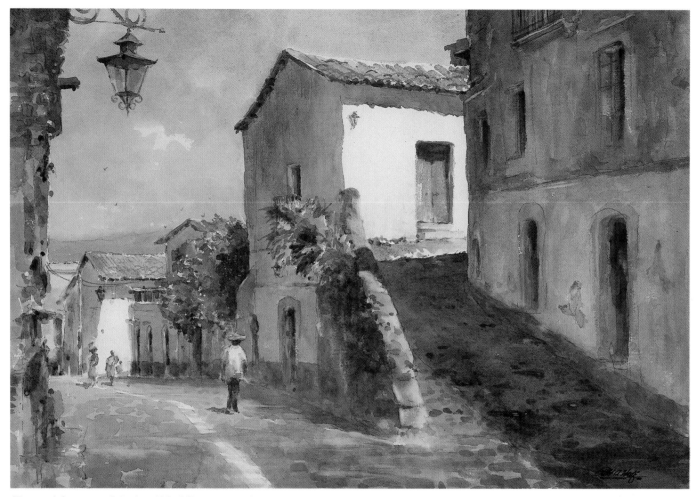

Taxco Afternoon, Mexico (20x30). *Working with perceptive observation, I noticed the light bouncing into colorful shadow. I also noticed the slight forward lean of the two small figures as they push up the hill and decided to include the lamp because it says "Mexico." (It was actually way back of this spot.) I also moved the clump of bougainvillea into the scene from around the next corner to add a touch of color, and finally included a few darks inside the shadows to show their transparency. That's how you must think it out before you begin.*

Index

abstraction, 14, 115
Afternoon Shadows, 27
animals, 92-95, 96
Arabs, Egypt, The, 94
architecture, importance of, 76

Barge Nocturne, 53
Barge on the Thames, 8
Basilica, Mexico City, The, 75
Bass Rocks, Cape Ann, Massachusetts, 108
Bazaar at Meerut, India, 6
Bazaar, India, The, 58
Bearer, Nepal, The, 76
Beggar, Meerut, The, 59
Belfry, Elvas, Portugal, The, 74
Bells of Patmos, Greece, The, 38
Blue Funnel, The, 26
boats, 109-110, 113-114
Brownstone, Soho, New York City, 61

Cannery Row, Monterey, 34
Casbah, Tangier, The, 90
Castle Coombe, Wiltshire, 24
Cathedral Doors, Toledo, 74
Catnap, 96
Cats, Philip Island, The, 104
center of interest, 5, 10
Charpoi, India, The, 47
clouds, 11
color, 23-25, 28, 54
 designing with, 40
 selecting, 42
composition, 77
contrast, 8, 10, 11-14, 20
contre jour viewpoint, 20
cool colors, 25, 30

Cottages, Pennan, Scotland, 139
Crail Harbor, Scotland, 11
crowds, 79

darks, 6
depth, 3, 29, 30
Derelict, The, 84-85
Dicko's Chooks, 28
Dolgellau, Wales, 16
drawing
 contour, 61, 134
 importance of, 56, 58-62, 98, 100
 preliminary, 4
 translating to painting, 76
drizzle, 33
Dry Dock, Gloucester, Massachusetts, 114
Durbar Square Temple, Katmandu, 57

Eros, London, 49
Eros, Piccadilly, Piccadilly Circus, 56
errors, correcting, 49, 59
Estremoz, Portugal, 7
Estuary, Staithes, The, 14

Family Group, New Delhi, 57
figures, 78-79, 86, 96
Fish House Morning, 119
Fishermen's Cottages, Pennan, Scotland, 10
Flinders Street Station, Melbourne, 100
Flock, Northumberland, The, 93
Flower Market, Portugal, 82
fog, 49
Fountain, The, 101

Game Season, Leadenhall Market, London, 70-71

Goatherd, The, 5
Goolwa, South Australia, 62
gouache, 48
Grand Canal, The, 48
grass, 28
Gravel Truck, New Delhi, The, 81
Gray Day on the Kennebunk, Maine, 112
Gray Day, Staithes, North Yorkshire, A, 8
grays, 44
Greek Sunlight, 14
Green Park Morning, London, 88

Harbor Reflections, Gloucester, Massachusetts, 111
heat, 3
Henley on Thames, 109
highlights, 4-5, 6-7, 15, 20
 X-Acto knife and, 137
horizon, 3

In the Nepalese Market, 58
interpretation of subjects, 16-17, 18-19, 54

Jenny, 91

Kay, 91

lakes, 112
Late Afternoon, Macduff, Scotland, 60
Launching Pad, Cape Canaveral (demonstration), 64-67
Leadenhall Market, London, 20
light, 2-8, 11-20, 32
 altering, 16

bounce, 24
color and, 23-25
direction of, 15
intensity of, 6-7, 27
reflected, 24-26, 27, 29
of sun, 38
Light at Lindos, Rhodes, Greece, 3
limited palette, 2, 40, 42-44

Macao, Harbor, 63
Manila Cathedral, 62
Market in Katmandu, Nepal, 20
masking, 123
Meeting at Meerut, 83
Mevagissey, Cornwall, 117
Mill, Maryborough, The, 17
mist, 3, 15, 32
Misty Blues, Portsmouth, New Hampshire, 115
Misty Grays, 54
Misty Venice, 15
mood, 15
Monterey Mist, 105
Morning Riders, Epsom, 80
mountains, 39
movement, 95
Mt. Vernon, Virginia, 141
muddy colors, 6, 43
Muntham Barn, Casterton, Victoria, 45

Near Greenwich, 102
night, 19, 49, 134
Nubble Light, 49

On the Grand Canal, Venice, 18
opaque watercolor, 48-50
Outback Station, Australia, 3

overcast skies, 13

painting
 designing, 40
 guidelines for, 82
Patmos Church, Greece, 99
pencil value sketches, 86
perceptive observation, 2-3, 80-82
perspective, aerial, 29, 30-32
photography, as painting aid, 62, 72
Polperro, Cornwall, 41
Polperro, Cornwall, England, 32
practice, 98-101, 113-114, 116

Rancho Victoria, Taxco, 140
realistic paintings, 75
Red Sails, 52
reflections, 2, 118
Reflections in a Venetian Canal, 9
Roadside Figure, India, 4
Rodeo, Lang Lang, 95
Royal Exhibition Buildings by Night, 19

San Xavier del Bac, Tucson, Arizona,
 62
Sargent, John Singer, 23
sea, 108, 112
Seahouses, Northumberland, 13
Seekers, Queenscliff, The, 22
Sentinel Rock (demonstration), 128-133
shadows, 6-7, 15, 20, 24-28, 108
Sheringham, Norfolk, 31
Ship's Painters (demonstration), 122-
 127
Singapore Harbor, 62
skies, 17, 26, 38, 39, 54, 102, 104-106,
 125, 130, 135, 136

smoke, 10
Soho, New York, 33
Staithes, North Yorkshire, 73
streams, 112
street scenes, 72, 73-74
subject, various approaches to, 52-59
Sultry Day, Blinman, South Australia,
 103
sunlight, 3, 11, 27, 34
Swanson Dock, Port Melbourne, The,
 118
Sweeper, The, 81
Sydney, The Opera House, 107

Tall Ship, The, 113
Taxco Afternoon, Mexico, 142
Taxco Steps, 25
Taxco II, 25
Telegraph Station, Alice Springs, The,
 44
textures, 45, 47, 54, 108
 created with salt, 124, 126
Thames Veterans, 120
Thimi Village, Nepal, 29
tinted paper, 53, 54
Towards Ben Attow, Scotland, 39
Towards the Salute, 30
transparent pigments, 52
Tuileries, Paris, The, 79
Turbat's Creek, Maine, 17

Uncle Bruce's Cows, 92

value sketches, 7, 110
values, 6-8, 10-15, 17, 27
Venetian Facades, 116
Venetian Skies, 51

Venetian Skies—First Attempt, 50
Venetian Skyline (demonstration), 134-
 138
viewpoint, 20
visioneering, 36

warm colors, 3, 25, 30
wash, 4, 5, 10, 43, 70
water, 23, 101, 109, 135
Water Lady, Tangier, The, 89
Waterboy, 5
*Watercolor Sketch for Staithes, North
 Yorkshire*, 72
Waterfront, Patmos, 12
waves, 118, 131
Weathered Doorways, Venice, 46
*Welcome Light, Kennebunkport, Maine,
 U.S.A.*, 2
Welsh Grays, Pembroke, 10
Westminster, 43
Whitby Harbor, North Yorkshire, 69
"Whitby Skyline," 68
Winter Landscape, Wales, 16

Yellow Umbrella, Cairo, The, 78